The Origins of
Christian Art

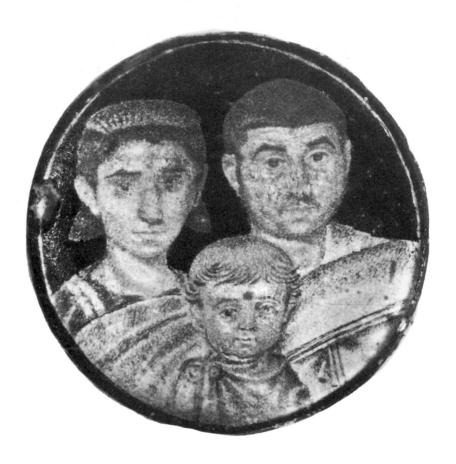

1 A Christian family of the fourth century shown on a gold glass from the Vatican Museum

The Origins of
Christian Art

Michael Gough

with 191 illustrations, 25 in colour

Thames and Hudson · London

To Bryher

© MICHAEL GOUGH 1973

Printed in Switzerland by Roto-Sadag, Geneva

ISBN 0 500 18137 3 clothbound
ISBN 0 500 20131 5 paperbound

Contents

Introduction

The story of the first eight centuries of Christian art is very complex. In time it covers the period of the Church's growth from a gathering of a hundred and twenty people in Jerusalem to a massive organization which influenced the political and social life of the new Roman empire no less than it did the religious. These eight centuries also saw the gradual conquest by Christianity of the barbarian nomads who had invaded, and later settled in, the old Roman territories in Western Europe and North Africa. In terms of geography the Church spread its message from Ireland to China and from southern Scotland to Ethiopia.

Such complexities of time, distance and historical circumstance in the study of early Christian art are matched by a fascination that belongs to the beginnings of things. For while we may be certain that the first Christian art was a by-product of the enthusiasm and piety of the followers of Jesus of Nazareth, the origins of that art and its iconography are often obscure. The choice of subjects was at first empirical, their interpretation varying with locality and current fashion. At the first Pentecost, in the presence of 'devout men from every nation under heaven', the Apostles testified 'with other tongues as the Spirit gave them utterance'. So too, when the first Christians turned their skill as architects, artists and craftsmen to the service of the Church, they could only do so in the separate idioms 'wherein they were born'.

Between representational and formal art there is an aesthetic distinction which has been likened to that existing in literature between prose and poetry. The late Charles Seltman summed it up in this way: 'Prose art is descriptive and analytic; poetic art organic and concrete.' The art of the Christian Church, never the monopoly of a single people or area, has in different times and circumstances expressed itself in both 'prose' and 'poetry', though neither is totally appropriate to the Christian religion. Better suited to the theme of God's relationship with mankind through human as well as super-

natural agencies was the compromise whereby some formal principles were applied to subjects which in other circumstances would have called for naturalistic treatment. Such a compromise produced the transcendental art of Byzantium and of medieval Europe, and the process of development towards it may be traced within the framework of earlier Christian art.

In this book the material will be presented in chapters based on historical divisions, with three very important events acting as punctuation marks. These are: (i) the Peace of the Church proclaimed by Galerius in 311 and confirmed two years later by Constantine and Licinius at Milan; (ii) the accession of the Justinian dynasty in 518; and (iii) the coronation of Charlemagne in 800. This is not to suggest that the development of Christian art was episodic, for it was obviously a continuous process; a chronological framework does, however, have its advantages. For example, after a brief survey of the Hellenistic background, Chapter II covers the art of the primitive Church, when pagan traditions were strong and a new Christian iconography was struggling to assert itself. At that time, before large churches were being built, Christian art was more often associated with funerary rites than with day-to-day religious life. Chapter III is devoted to the art of vital and expanding Christian communities during the two centuries separating Constantine the Great and Justinian I. Undoubtedly this was a most important period, for from the diversity and experiment of those days emerged a recognizable Christian art which reached its apogee in what is commonly known as the First Golden Age of Byzantium. A chapter on that golden age needs no apology, and the last section is chiefly concerned with the art of Western and Northern Europe before the Carolingian period.

It remains for me to thank sincerely those kind friends and colleagues whose advice and constructive criticism have helped me to formulate my ideas, and also those many scholars to whose works I am indebted. I am grateful too for the sustained generosity of the British Institute of Archaeology at Ankara, of the Russell Trust, the Reid Trust and several private subscribers in supporting my research in Asia Minor, the richest field in the world for the student of early Christian archaeology. In this connexion, my debt is very great to successive Directors General of Antiquities and Museums in Ankara for permission to carry out research, and to Turkish Government

officials and private individuals for their help, kindness and hospitality at all times. I am very grateful too to my publishers for their patience and forbearance in the face of my delays, and to the Institute for Advanced Study at Princeton for giving me the opportunity and facilities for completing my task in a totally congenial atmosphere. I thank also my wife, the constant companion of my journeys and excavations, for her effective help and unfailing encouragement during the many years we have spent together in search of the early Christians and their monuments. Finally I want to place on record my sense of deep personal obligation to the late David Talbot Rice for his characteristic readiness to help a younger man share his own enthusiasm. My debt to him is one I shall never forget.

Prologue : The classical world and its heritage

Over twenty-four centuries ago, Pericles appointed Phidias overseer of a scheme for the development of the Athenian Acropolis. Today the Parthenon, in which Phidias' gold and ivory statue of Athena was dedicated in 438 BC, still survives as witness to a period of unique human achievement. The statue perished long ago, but most of the sculptured frieze that ran across the porches and down the sides of the temple *cella* is still preserved. This frieze, depicting the people of 2 Athens in procession on the occasion of the Panathenaic festival, is certainly not the work of a single sculptor; equally certainly, however, it is the inspiration of a single man, possibly of Phidias himself.

Individual taste, preference and prejudice aside, the Parthenon frieze represents the high-water mark of Classical art, a unique phenomenon confined to a few decades of the fifth century BC. Nothing comparable had ever been known before it, and it has since remained without rival. The word 'classical' is sometimes used loosely – as it is in this book, but without a capital letter – as descriptive of a tendency towards naturalism in Graeco-Roman art. It will thus be useful to establish a stricter definition of the term. True Classical art is representational, though free from emotional tension or illusionism. Completely unselfconscious, it ignores the viewer while inviting his closer inspection and appreciation. Unaffected by considerations of time and place, it thus possesses a basic validity for each successive age.

The frieze of the Parthenon was carved between 442 and 438 BC, before human anatomy was well enough understood to make illusionism a practical proposition. Thus one observes a certain generalization of anatomy and even of features which makes for an impersonal, almost icy discipline which effectively bars any emotional contact with the spectator. Also, in the absence of a time factor, or of any background which might limit the scene in terms of space, this frieze captured for all time a spirit of national self-confidence which, for once, was not misplaced.

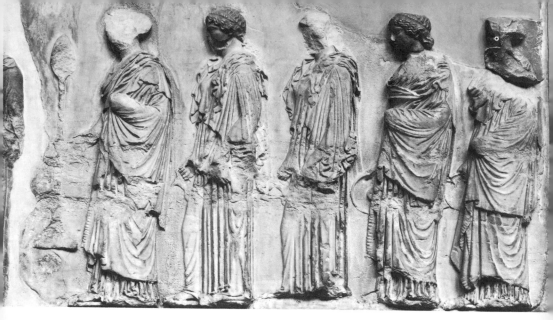

2　Panathenaic procession depicted on the Parthenon frieze

Towards the end of the fifth century BC new trends appeared in
Greek sculpture, and later on the pace of change quickened as, with
the conquests of Alexander the Great, a new era began which carried
Greek speech and culture to the farthest bounds of the old Persian
empire and even beyond it. The very style of Lysippus, a Sicyonian
whose career spanned the closing decades of the fourth century, is
somehow symbolic of the dramatic change from the inward-turning
concept of a Hellas divorced from, and superior to, the rest of
mankind (lumped together indiscriminately as 'barbarians') to the
new and expansive idea of a Hellenic commonwealth. Earlier free-
standing figures had been so posed as to provide only a limited
3　number of satisfactory viewpoints. Lysippus' Apoxyomenus, a
young athlete scraping oil from his extended right arm with a strigil,
suggests a body moving freely in space which can thus be appreciated
from any position. The escape from past convention is further stressed
by the illusion of life in the restless feet and of an imminent shift of
weight from one to the other.

During the Hellenistic period, art was more vigorous in the cities
of the Eastern Mediterranean than on the Greek mainland. At

Alexandria, Rhodes, Antioch, Tralles, Pergamum and Magnesia on the Meander there were important schools of sculpture, and surely of painting too, though for these the evidence is more elusive. In sculpture, technical expertise made new ventures possible to suit every taste. That this was not the taste of the fifth or fourth centuries is not a matter for surprise or even for regret. In the new urban centres of the Hellenistic world, changes in line with the spirit of the age were inevitable. Studies of the human body in health or in sickness, even in ugliness and deformity, followed an increased knowledge of anatomy. Religious scepticism was reflected in the waning popularity of gods or heroes as subjects, though Aphrodite and Eros – now portrayed as the mischievous urchin of all later ages – came into their own. But even if some competent work was still being done in the first century BC, a new impulse was needed if Hellenistic sculpture was not to peter out in sheer triviality. This impulse came with the rising power of Rome and the new imperial idea fostered by Augustus and manifested in public and private patronage of the arts.

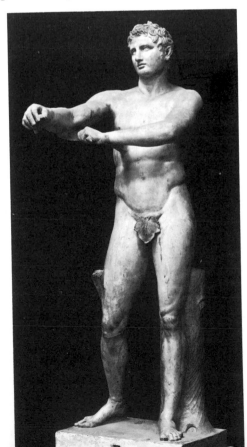

3 The sense of free movement in space expressed by this figure of a young athlete, the Apoxyomenus of Lysippus, marks a new departure from the conventional poses of the past

If the importance of classical sculpture, rather than of painting, has so far been emphasized, it is because the history of Greek painting is so much harder to evaluate. Of the painting of the earlier period there is no trace, since it was executed on perishable materials. Our knowledge of it depends on ancient commentaries and the inadequate evidence to be gleaned from some red-figure pots painted in the 'grand manner'. Polygnotus of Thasos, the representative master of Classical painting, is known to have chosen moments of drama like the Capture of Troy or Odysseus' Descent into Hades as subjects for his work. His style was primitive, for he made no attempt at perspective, but arranged his figures in registers without a diminution of scale to indicate distance from the foreground. His use of landscape as an accessory is said to have been restricted. A wan reflection of his style may perhaps be seen in the work of the Niobid Painter who in *c.* 460 BC painted two scenes on a large calyx-crater, the first of 4 Heracles among the Argonauts, and the other of the Slaughter of 5 Niobe's Children by Apollo and Artemis.

4, 5 Two scenes from the calyx-crater of the Niobid Painter, whose style is said to have resembled that of Polygnotus. Below left, Heracles among the Argonauts; below right, the slaughter of Niobe's children by Apollo and Artemis

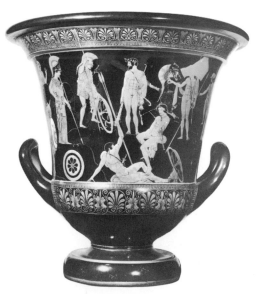
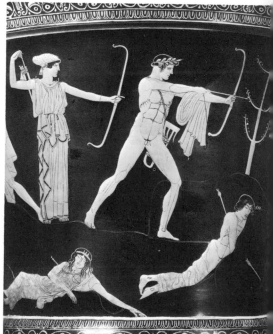

In the fourth century Apelles of Colophon and other masters were at the height of their genius, and it is sad indeed that nothing survives from what was generally recognized as the greatest period of Greek painting, though one yardstick for the enthusiasm of ancient commentators exists in the so-called Alexander Mosaic from the House of the Faun in Pompeii. This mosaic, probably based on a picture by Philoxenus of Eretria, is a powerful composition even in its present damaged state. The violence of the battle is conjured up by the bristling spears, the startled horses – one of them wounded and collapsed beneath his rider – and by the contrast between Darius, his dark eyes rolling in anxiety, and the relentless determination of Alexander. The mastery of line, the spatial illusionism of figures advancing and receding from the foreground, and the studied contrast of light and shade may give some idea of the picture in its original medium. To the right of Alexander's horse the bare branches of a tree point starkly to the sky, a small enough move – but a positive one – towards the inclusion of landscape in later painting and relief sculpture. Since landscape is an important element in some of the earlier Christian paintings in the Catacombs as well as on some early sculptured sarcophagi, it will be useful to consider its origins in Hellenistic art. The Alexander Mosaic is based on an early Hellenistic painting, but it was only in the first century BC that landscape was commonly used as a background to painting or relief sculpture. Thereafter it was eagerly adopted by the Romans.

Little is known of late Hellenistic painting, and for that little we are chiefly indebted to the wall-paintings which survived in Pompeii and Herculaneum after the eruption of Vesuvius in AD 79. Apart from Rome, there is little evidence elsewhere. To judge from subject-matter and style, it is likely that the originals of many of these pictures were painted in the Hellenistic cities of the Eastern Mediterranean. An Alexandrian influence may be reasonably supposed for the many compositions which include wild animals and birds native to North Africa and, more specifically, to the area of the Nile. What other explanation is there for the painting in Naples of pygmies in a fight with a hippopotamus and crocodiles, or for the floor mosaic in the Palazzo Barberini at Palestrina with its scene of the Nile in flood and of the hunting of wild animals in the desert beyond?

A variant on the picturesque style is impressionism with a touch

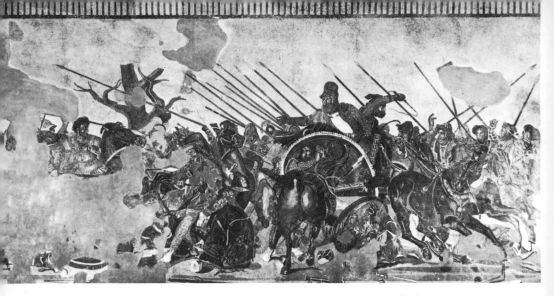

6 The Alexander Mosaic (from Pompeii, but based on a Hellenistic painting), an imaginative and energetic battle-scene. A suggestion of landscape is introduced

of fantasy. It is seen in its extreme form in some illustrations of scenes
7 from the Odyssey which were painted during the first century BC on
the walls of a house on the Esquiline in Rome. Circe's isle and the
Land of the Laestrygonians are places of enchantment and fairy-tale,
and in these pictures human figures are as unsubstantial as the sea,
rocks or wooded landscape which quite intentionally were imbued
with a strange dreamlike quality. Towards the end of the first
century BC, pictures featuring architectural façades became very
popular as wall decoration in the houses of Pompeii.

The heritage of Greece and Rome, however, was not the only
influence that was to have its effect on the new art of Christianity.
Beyond the Eastern Mediterranean coastal fringe, which was cultur-
ally a part of the Graeco-Roman world, were the lands of the true
Orient – Anatolia, Persia, Syria and Mesopotamia. All these, with
Egypt to the south, had been overrun three centuries before Christ in
the advance of Alexander's armies, and had been subjected to 'cul-
tural imperialism', i.e., to the imposition of Hellenistic fashions on
the conquered peoples. But though such fashions were accepted for a
while in the larger cities, the penetration of alien manners and ideas
was never more than skin-deep in societies with long-established and

7 Odysseus in the underworld, a scene with a strangely impressionistic quality, from a series of wall paintings in Rome illustrating the Odyssey

vigorous national traditions. This was true of art as well, and outside the cities Greek influence was negligible or non-existent. The appeal of classical art to the viewer's closer inspection was, and still is, subtle and indirect. The reverse is true of most of the Eastern art of the early Christian period, for the artist's instinct was apparently to make an immediate psychological impact and to reject the sort of naturalism that might have dimmed or obscured it.

Typical of an Eastern school which influenced Christian and – more specifically – Byzantine art is a painting of the late first century AD in the temple of the Palmyrene gods at Dura Europus, a Syrian frontier town on the Euphrates. Known as *The Sacrifice of* 8 *Conon*, the picture represents three priests in ceremonial dress standing side by side, the central figure in the act of sprinkling incense on a burner. Seemingly unaware of each other they face the spectator, their penetrating gaze fixed on him alone in an almost personal confrontation. There is no illusion of a third dimension to distract the eye and to reduce the emotional impact, while an air of religious mystery is enhanced by the levitated feet of the participants. Technically well executed and undeniably effective, the picture is basically primitive, not through incompetence, but because the artist freely

15

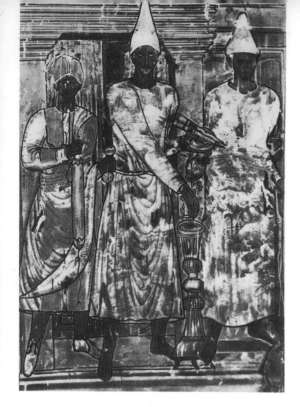

8 Eastern influence dominated early
Christian, and particularly Byzantine,
art. In *The Sacrifice of Conon*, a
pagan painting from Dura Europus
in Syria, the deliberately primitive
two-dimensional style is suited to the
theme of ritual

chose this style in preference to classical naturalism. Before the end of
the second century AD this style had become a recognized alternative
mode in the art of Rome itself.

In Egypt, the subjugation of an ancient and civilized nation first by
the Macedonians and later by Rome led to a sharper contrast in the
political status of victors and vanquished than in countries where the
conqueror had less to fear from cultural or intellectual competition.
Thus in Ptolemaic and Roman Egypt a great gulf yawned between a
privileged community of (usually) urbanized Greeks and, at the far
end of the social scale, the indigenous peasants and artisans who were
little more than serfs. In the first three and a half centuries AD this gulf
between the native Egyptians and their masters was emphasized
further; for while the Greeks continued to pay lip-service to pagan-
ism, the Copts gradually abandoned their ancestral religion and
embraced Christianity. This was probably a spontaneous conversion
of a people whose interest and belief in personal immortality had

always been strong. It is also likely, as K. Wessel (quoting Harnack) wrote, 'that the great mass of the Copts went over to Christianity between 250 and 350 because their own religion had been destroyed or undermined by Hellenism. They took to Christianity in opposition to the religion of their oppressors, the great Hellenic landlords.' The divergence between the two communities was further underlined in their approach to art. Alexandria, earlier the home of a flourishing Hellenistic school of great originality, had become the centre of Greek Christianity in Egypt by the end of the second century; but elsewhere the survival of paganism in the cities expressed itself in an art based on mythological scenes of a blatantly voluptuous kind. In these works a convention of rendering the human body in terms of flesh unrelated to the underlying bone structure gives a rubbery effect to sculpture. This is clear in the ivory plaque in Ravenna depicting the myth of Apollo and Daphne, and in the relief from Ahnas of Aphrodite displaying her charms in a scallop shell. For 9 the authors of such works as these, pagan mythology had nothing to do with religion; it simply provided themes suitable for the entertainment of a permissive society.

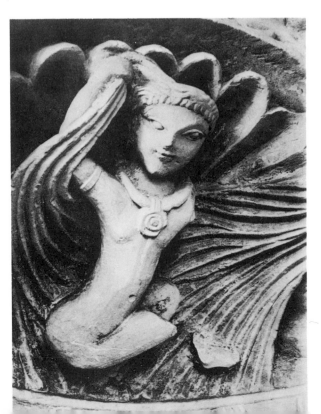

9 Even after the conversion of the native Egyptians to Christianity, mythological subjects were usual in the art of their pagan Greek masters. A sculpture of Aphrodite expresses sensuality with no devotional overtones

Paganism baptized : Christian art before Constantine

Graeco-Roman paganism was the source of much of the earliest Christian iconography. This may be ascribed to the intelligible nostalgia felt by converts for familiar pictures and symbols which were not in conflict with their new faith, and also to the need for discretion in a predominantly pagan society where persecution for unorthodox beliefs and behaviour was an intermittent threat to the Christian community. Stigmatized as atheists, as morally depraved, and even as cannibals through pagan misunderstanding of the Eucharist, the faithful had to be very circumspect and to avoid flaunting their religion. Thus the cross, now the universal symbol of Christianity, was at first avoided not only for its direct association with Christ but for its shameful association with the execution of a common criminal also.

Among frequently recurring motifs in early Christian art are the *11, 13, 12* peacock, the dove and the athlete's palm. For a Christian the peacock with its supposedly incorruptible flesh symbolized immortality. The dove was both a reminder of Noah's deliverance from the Flood and a symbol of the Holy Ghost, and the palm of victory denoted the martyr's triumph over death. The Seasons, personified with their attributes, also occur as symbols of abundance, with an implicit promise of renewed life after winter in the spring to come. Even the solar pantheism introduced by Aurelian (270–75) was turned to account by Christian artists, for a striking mosaic in the Tomb of the *10* Julii in the Vatican depicts Christ in the guise of Helios driving the sun chariot across the sky.

An early sarcophagus in the Lateran Museum in Rome shows two *15* perfectly inoffensive pagan subjects. One is the vintage feast which, though part of the Dionysiac funerary cult, was also a reminder of Christ's metaphor of the vine and its branches (John, XV, 1–5); the other is the shepherd who carries a lamb across his shoulders. So familiar is the shepherd in early Christian art that it is easy to lose sight of his pagan origin; yet in Greece the Hermes Criophorus (the

10 In this mosaic in Rome Christ is identified with 'Christos Helios', the Sun-god driving his heavenly chariot ▶

+HIC REQVIESCIT IN PACE THEODORVS V.B. ARCIHEPISCOPVS+

11, 12, 13 The peacock (above), the athlete's palm (below left) and the dove (below right) were all frequent symbols of Christian themes: immortality, triumph over death, and deliverance

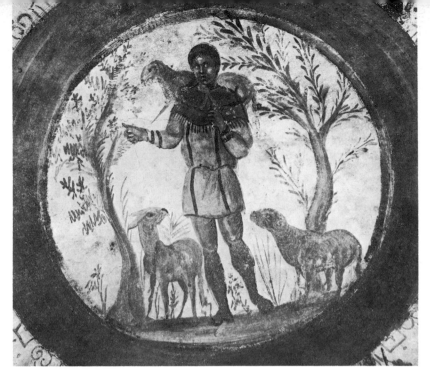

14 Christ as the Good Shepherd, a youthful figure in a picturesque rural setting

ram-carrier) is known very early as a subject for sculpture, and his
'adoption' by Christians would probably have passed unnoticed by
pagan neighbours. Thus, in some of the earliest catacomb paintings
in Rome and in a third-century baptistery at Dura Europus in
Syria, the shepherd symbolizes Deliverance as prefigured in
Psalm XXIII. The Gospel reference that comes first to mind is the
parable of the Good Shepherd (John, X, 11–16), but in early Chris-
tian art the shepherd is more likely derived from the reference in
Luke XV, 4–7 to the finding of one lost sheep in the hundred in the
flock: 'and when he hath found it, he layeth it on his shoulders,
rejoicing . . . I say unto you, that likewise joy shall be in heaven over
one sinner that repenteth, more than over ninety and nine just
persons which need no repentance.' In some early paintings and on
sculptured sarcophagi the shepherd is portrayed against a background

14
27

of trees and flowers, sometimes attended by his sheep, sometimes by figures with their arms raised in prayer. Such scenes symbolize the paradise of the elect, that domain of 'peace, light and refreshment' which is mentioned in the Canon of the Roman liturgy. Another figure commonly depicted in a pastoral setting is the seated man with a scroll, the follower of the True Philosophy and so of the company of the faithful. He is represented on a third-century sarcophagus *16* from Santa Maria Antiqua in Rome; this originally 'neutral' subject developed later through an association of ideas into the standard *17* portrayal of an Evangelist.

The fish was an early symbol of Christianity. Some of its associations with the religion are obvious enough, for Christ promised that he would make the Apostles 'fishers of men', and the Gospel accounts of the Miraculous Draught and the Multiplication are both connected with fish. Also widely accepted is the theory that the fish is a cryptogram in which the letters of the Greek are the initial of a

22

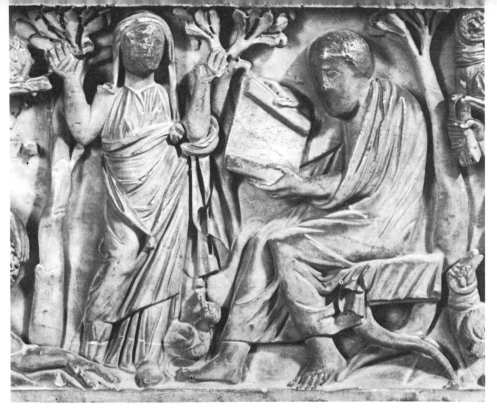

15, 16 Christian sarcophagus reliefs often used symbols with pagan associations, to avoid undue attention. Left: the Good Shepherd and the vintage feast. Above: the philosopher with a scroll, symbolizing a follower of Christ, accompanied by an *orans*, or praying figure, the soul of the deceased

17 A tombstone with the cruciform anchor of hope, and two fish, another Christian symbol

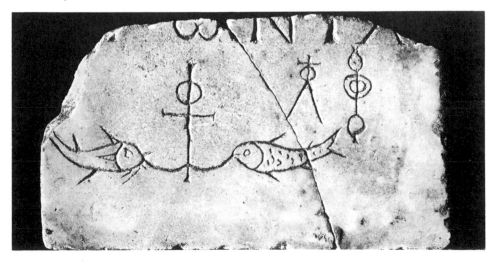

profession of faith Ἰησοῦς Χριστὸς Θεοῦ Υἱός Σωτήρ – Jesus Christ, Son of God and Saviour. If such a cryptogram looks over-contrived, except as the rationalization of an already existing symbol, we may find an origin perhaps in the notion of a Divine Fish assimilated by early Christian converts in the Eastern Mediterranean area. It might be explained perhaps in the Semitic cult of Dagon and the goddess Atargatis, both of them represented in art as fish and whose powers might be assumed by the devotee who ate a meal of fish. If some converts, in Syria for example, transferred to Christ the reverence and worship they had given once to these fish deities, the rather sophisticated cryptogram theory may surely be accepted.

During the second century – exactly when is not known – the Church's bias against representational art broke down, and some pagan myths and symbols were adopted by the Christians; a few, like the fish and the peacock, are still in use if somewhat self-consciously. However, in the long run Christianity could only express itself in its own terms, and before the Peace of the Church in 311 an iconography based on the Old and New Testaments already existed. Much of our knowledge of this comes from the survival of works in or near Rome, but this is not the disadvantage it might appear to be, for the cosmopolitan nature of the city ensured that the earliest Christian art was represented in its full diversity.

18 The Catacombs, subterranean galleries cut into the tufa beds outside Rome, were not apparently used by the Christians before the end of the second century. Roman law protected all tombs from violation (since tombs were private property), so that the ultimate choice of the Catacombs as a Christian cemetery was not due to a need for secrecy as has sometimes been wrongly supposed; actually such an idea would have been inapt, for the Catacombs were no secret to anybody. Most likely the real reason was the Christian belief in the resurrection of the body giving rise to an idea that if they were physically united in death as they had been in life, the Last Day would find them somehow better prepared. The painters who decorated the Catacombs were certainly all Christians.

During the first three centuries AD there was usually a difference in quality between Christian sculpture and painting, just as there was a difference for each in the choice of iconography and the degree of Christian emphasis. In Italy the sculptured sarcophagus had a long

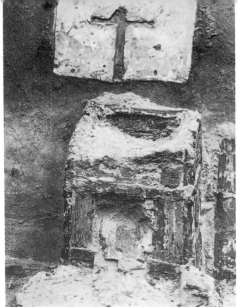

18, 19 Left: the Catacomb of St Domitilla at Rome. Right: an early example at Herculaneum of the cross used as a Christian symbol

tradition of skilled craftsmanship behind it, and the rich Christian who ordered such a tomb would expect good value for his money; but the fact that sarcophagi were often set up in surface cemeteries and so exposed to the view of pagans as well as Christians, limited the scope of religious subjects to be portrayed. Early Christian funerary relief is therefore usually, though by no means always, well executed, if non-committal in content.

Before the Peace of the Church, the symbol of the cross seems to have been generally avoided or at least disguised, though the sparseness of the evidence makes it difficult to be sure. That Christ had died a criminal's death must have seemed to many a prospective convert to make a mockery of His claim to be the Son of God (though after 315, when Constantine abolished crucifixion, the stigma attached to it was gradually forgotten). The first use of the cross as a Christian symbol is uncertain. A group of crosses, incised or drawn in charcoal on some Jewish ossuaries in Jerusalem, antedate the sack of the city by Titus in 70, and the single example at Herculaneum is earlier than the *19* eruption of Vesuvius in 79. None of these need be Christian, though it may be remembered that St Paul found a Christian community at

Puteoli, only a score of miles from Herculaneum, when he was on his way to Rome to appeal to the emperor (Acts, XXVIII, 13–15). But even if it is unlikely that the cross was used in the first century as a Christian symbol, its open appearance as such in Asia Minor during the third century is an established fact.

Heresy, religious or political, is often to be recognized in a vehement affirmation of principle, and in this the Montanists of Phrygia were no exception. Their heresy, first expounded in the second century by three self-styled prophets – Montanus, Maximilla and Priscilla – was based on the conviction that a second Christian revelation was to be made in the obscure Anatolian town of Pepuza which was destined to be the New Jerusalem. Ignoring the Church's official policy of trying to ensure survival by an avoidance of provocation, the Montanists inscribed crosses on the headstones of open cemeteries and also added a challenging formula into the epitaphs. This was 'Christians to Christians', and to stress defiance further the Montanists replaced the initial letter *chi* of χριστιανοί by an upright cross. Providentially this aggressive attitude was unusual in the early Christian communities of the West, and there the cross is rarely found before the Peace of the Church and then only on simple epitaphs. Frequently the symbol was disguised, as in the simple tau-cross which has no upright above the horizontal bar. The anchor, another cross substitute on epitaphs, symbolized hope and ultimate security,

20 while the Egyptian *ankh* (a tau-cross with a looped top) was close enough in form to be accepted as a cross by local Christians for whom its pagan origin as the symbol of life made it specially appropriate. More speculative is the theory that the mast and yard of

21 Jonah's ship were designed to be seen as a cross; in pre-Constantinian times the story of Jonah was very popular in Christian art as an allegory of death, resurrection and the life to come, so a cross was certainly not out of place in that context.

If it is true that Alexander Severus (222–35) had statues of Christ and Abraham, along with Orpheus and Apollonius of Tyana, in his private oratory (Lampridius, *Vita Sev. Alex.*, XXIX, 2), a Christian iconography must have existed in the West during the first half of the third century and probably before that. However, the first securely dated works of Christian art are the paintings in the Christian complex at Dura Europus which were completed in about 240.

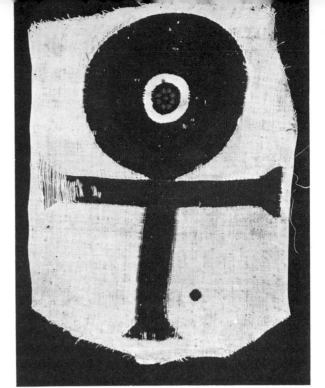

20, 21 Right: the *ankh*, an Egyptian symbol of life, was used by the Copts as an equivalent of the Christian cross which it resembled. Below: the mast and yard of the ship appear to form a cross in this painting of Jonah thrown into the sea

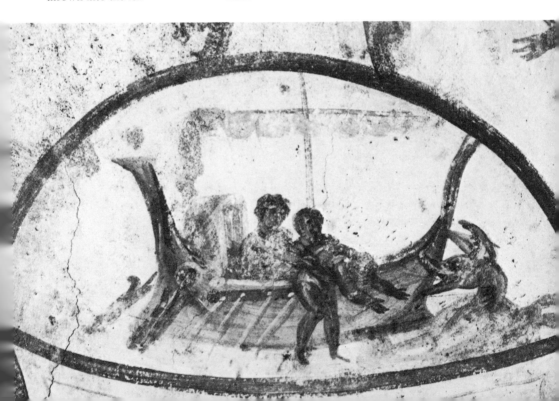

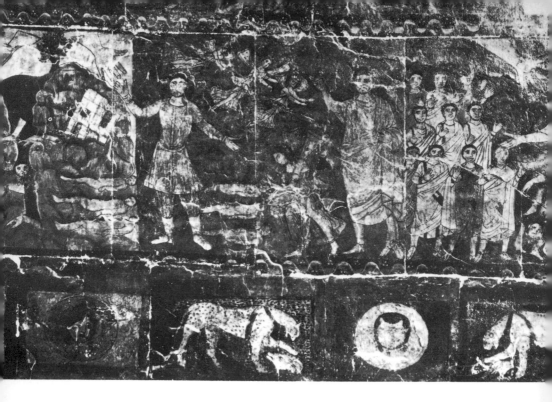

Nothing known to be earlier exists, which makes Dura a convenient starting-point for a discussion of pre-Constantinian iconography.

24 The Christian building excavated by M. I. Rostovtzeff between 1931 and 1932 was only one of several places of worship at Dura. Apart from pagan temples, like that of the Palmyrene gods and a Mithraeum, there was a finely decorated synagogue with wall-paintings that go to show that a Jewish community of the third century in eastern Syria was ready to accept representational art when it was used to interpret great events in the religious history of the nation. Like the painter of the Sacrifice of Conon in the Temple of the Palmyrene gods, the synagogue artists were familiar at long range with classical art (see, for instance, their treatment of drapery); but they still preferred to work in the native Syrian idiom, in which lack of interest in a third dimension, the principle of frontality and an intensity of facial expression were characteristic. Of the many me-

28

morable paintings in the synagogue, now reconstructed in the Museum of Damascus, two in particular burn with a strange inner life. The first is of Abraham, standing four-square and attentive, confident in God's promise that 'in blessing I will bless thee, and in multiplying I will multiply thy seed as the stars of heaven, and as the sand which is upon the sea shore' (Genesis, XXII, 17). The second is of Ezekiel's vision, as the dry bones take shape and life again in wild-eyed expectancy (Ezekiel, XXXVII, 1–8). Considering that the Jews of Dura departed so far from the letter and spirit of the Second Commandment, it is hardly surprising that their Christian neighbours went farther, and that the paintings in their baptistery were of scenes emphasizing the link between the prophecies of the Old Testament and their fulfilment in the New.

23

22

22, 23 Two paintings from the synagogue at Dura Europus, now in the Damascus Museum. Opposite: Ezekiel's vision in the valley of the dry bones. Right: a striking figure of Abraham

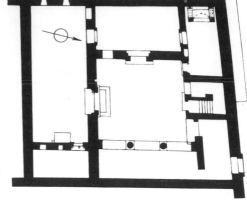

24 Plan of the Christian building at Dura Europus. The doorway, bottom right, led into the central courtyard. The baptistery, with font, was the room in the top right corner

0 5 M

0 15 F

A third-century citizen of Dura walking down the street that passed north of the Christian complex might well have gone by without a second glance. Even had the door been open, he would have seen only a colonnade with a courtyard to the west of it, for the rooms specially adapted for the use of Christians were discreetly sited away from the main thoroughfare. In the north-west corner of the block stretched a long room, with a font covered by a baldaquin at its western end. The wall-paintings from this baptistery (now reconstructed in the Gallery of Fine Arts in the University of Yale) illustrate the Fall and Redemption of mankind. South of the baptistery and opening out of it was a room possibly used for the instruction of neophytes, and still further south was a long hall on an east-west axis, with a raised platform at the east end, possibly to be used for the celebration of the Eucharist.

The earliest Christian missionaries were concerned with two very different categories of potential converts. First there were the Jews, of whose nation Jesus was Himself a member, and whose religion already claimed to have a monopoly of the truth; second, there were the Gentiles who had none of the Jews' religious background to help them understand Christianity. However, the approach to Jew and Gentile had to be the same, and at Dura the Christian paintings draw on both the Old and New Testaments, since it had to be shown through them that God's new covenant had been foreshadowed from the beginning. For the Jewish catechumen this reassurance was vital, for without it his ancestral Judaism might have appeared irrelevant. As for the Gentile, a religion no less than a man was the more respectable for a distinguished pedigree, though it must have

30

been hard for some to digest the fundamental premise that the God of the New Testament had first revealed Himself to mankind by the agency of a stiff-necked, doctrinaire and exclusive people. However that may be, the message of the two paintings above the font at Dura was the same for all men, Jew or Gentile. One was of Adam and Eve beside the Tree of Knowledge, the other of the Shepherd and His flock. Together they recall St Paul's words: 'For as in Adam all die, even so in Christ shall all be made alive' (I Corinthians, XV, 22).

Most paintings in the Dura baptistery are of Biblical episodes which illustrate the fact that baptism itself is the guarantee of a new life. Such are the scenes of the Healing of the Paralytic, St Peter's *28* rescue from sinking into the Sea of Galilee, and Christ's conversation with the Woman of Samaria; from the Old Testament the story of David and Goliath makes a unique appearance in this context. On a lower register of the north wall the painting of three women standing beside a sarcophagus has been interpreted as the visit of the three Marys to the Holy Sepulchre on the first Easter morning.

Even further removed from the Hellenistic tradition was the art of the earliest Christian communities in Egypt, the Copts. Anything Greek was alien to them; it is no surprise that monasticism was first established in Egypt, almost as a spiritual revolt of the oppressed against their decadent and worldly masters. Of their art K. Wessel has written that it was 'hard, frightening and deliberately unbeautiful, like the Coptic monks themselves.' This is an exaggeration, for it was essentially the art of peasants who, since they had forgotten or rejected their Pharaonic tradition and were outside that of Greece, had to improvise something new. Coptic art was eclectic, often *25* vigorous and surprisingly inconsistent. In sculpture the Copt's *26* special skill lay in the carving of foliate and geometric motifs into intricate patterns depending for their effect on an interplay of light and shade. Indeed, the ground was so well prepared for this short of abstract art in Egypt before the Arab conquest that it is small wonder that some of the world's finest Islamic monuments are to be found in its territory.

The doctrinal stress of the first Christian art was on Deliverance. The Old Testament is rich in examples of God's intervention on behalf of His people, and many of these stories were physically as well as spiritually relevant when the Roman authorities decided to

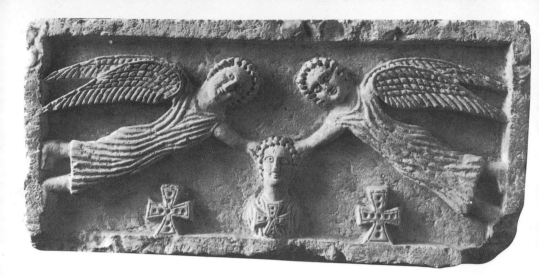

25, 26 Two Coptic tombstones,
one (above) depicting the
Ascension, the other (right)
incorporating crosses in an
elaborate decorative design
reminiscent of later Irish work

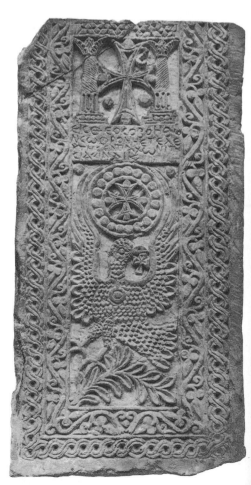

27, 28 Opposite: two paintings
from the baptistery at Dura,
the Fall and the Good Shepherd
and his flock (left) and Christ and
St Peter walking on the water
(right). Both scenes express the
theme of salvation through Christ

32

harass the Christians. So, under such emperors as Decius (249–51) and Valerian (253–60), and even more during the persecution initiated by Diocletian in 303, the fate of Daniel and the condemnation of the three Hebrews to the Fiery Furnace for refusing to worship the image set up by Nebuchadnezzar must have struck an almost topical note.

The Fall is among the earliest of the Old Testament scenes to be depicted in Christian art; in the West at Naples, in the Catacomb of Januarius, in the East in the baptistery at Dura, and considering the vast distance separating the two places the iconography is remarkably similar. At Naples the guilty couple turn away from each other, and Adam's gesture of dismissal towards Eve shows the moment to be that of his ignominious excuse, 'The woman whom thou gavest to be with me, she gave me of the tree, and I did eat' (Genesis, III, 12). At Dura, however, the Fall is balanced by the Shepherd, symbol of the Redemption to come. *27*

Noah's rescue from the Flood was also a story of deliverance, as well as a symbol of the conviction of some Christians that their own salvation would be suitably associated with the discomfiture of the Church's enemies. The same spirit was evident after Constantine's victory at the Milvian Bridge, when Maxentius' troops were drowned in the swollen waters of the Tiber; for soon afterwards the engulfing of Pharaoh's armies in the Red Sea became a popular subject for

33

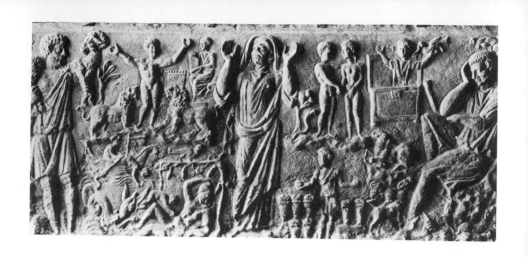

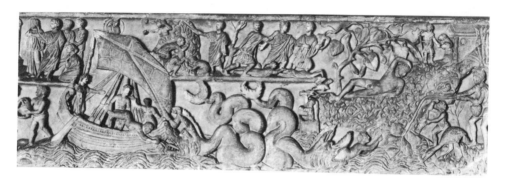

29, 30, 31 The theme of
deliverance : these sculpted sarco-
phagi from Velletri (top) and the
Lateran (centre) show scenes from
the stories of Jonah and of the Flood,
with Noah's ark curiously reduced
to a small lidded chest. Right :
a detail from the Lateran
sarcophagus

Christian relief. On two sarcophagi, one from Velletri and the other 29 in the Lateran, Noah is depicted standing in a small chest fitted with a 30, 31 lid and lock – a far cry from the great ship described in Genesis, VI, 14–16. In this way the great drama of the Flood and of Noah's providential escape was reduced to a simple pictogram. This tendency towards compression, often to the detriment of the story, seems innate in the first Christian art, probably because elaboration would have been thought meretricious or distracting.

In the *cappella greca* of the Catacomb of Priscilla in Rome is an early painting of Moses striking water from the rock, the miracle 32 that saved the Israelites from dying of thirst in the desert (Exodus, XVII, 1–6). Again the story is rendered as a pictogram, so that the elders of Israel, who should have been part of the composition, are omitted. That this picture symbolized the two indispensable prerequisites to salvation (Christ Himself and the sacrament of Baptism) is made plain by St Paul's reference to the Israelites who 'were all baptized unto Moses in the cloud and in the sea; and did all eat the same spiritual meat; and did all drink the same spiritual drink: for they drank of that spiritual rock that followed them: and that rock was Christ' (I Corinthians, X, 2–4). In the same way the story of Isaac's sacrifice by his father symbolized deliverance no less than it prefigured the sacrifice of Christ on the Cross.

32　A simplified rendering of Moses striking water from the rock, in a painting from the Catacomb of Priscilla

The Book of Daniel and the Story of Susanna provide the themes of three scenes which recur rather often in pre-Constantinian art. All are colourful tales of deliverance, but the dramatic element was nearly always minimized. As depicted in the Catacombs, the ghastly fate prepared by Nebuchadnezzar for Shadrach, Meshach and Abednego, and by Darius for Daniel himself, are depicted almost as conversation pieces. In the Catacomb of Priscilla, the demeanour of the three Hebrews who stand on a monstrous gridiron betrays no emotion; while Daniel's ordeal is presented in the Crypts of Lucina as a perfectly rehearsed circus act, with the prophet attended by two docile seated lions. As for the story of Susanna and the Elders, the artist in the *cappella greca* chose to portray the climax of the unfortunate woman's ordeal. The elders are stabbing with their fingers at Susanna in accusation, while Daniel, who is later to convict them of lying 'out of their own mouth', watches silently as he decides on the innocence of their victim. Although one of the more elaborate third-century paintings, this is still economical of drama and subdued in tone.

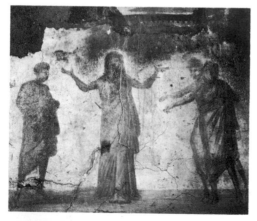

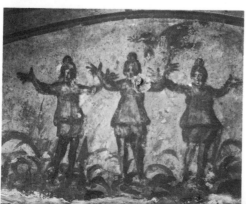

33, 34, 35 More stories of deliverance, told in a deliberately subdued fashion. Left: Susanna accused by the Elders (above); the three children in the fiery furnace (below). Opposite: Daniel in the lions' den, in the centre of a ceiling painted to suggest a dome

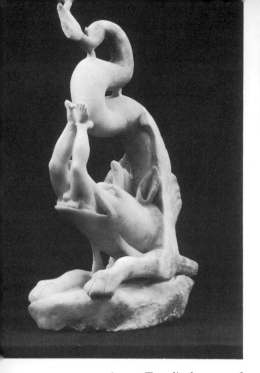

36, 37 Two lively scenes from a group of marble statuettes depicting the cycle of Jonah. Left: he is swallowed by the sea-monster. Right: he is cast up again

The extraordinary adventure of Jonah was understandably popular with early Christian iconographers, since it provided them with a symbolic parallel for the Fall, the Redemption and a final reward in Paradise. Like Adam, Jonah disobeyed God's command and was duly punished; but once the prophet had shown repentance, mercy was no less swift to follow. 'Then Jonah prayed unto the Lord his God out of the fish's belly. . . . I will pay that that I have vowed. Salvation is of the Lord. And the Lord spake unto the fish, and it vomited out Jonah upon the dry land' (Jonah, II, 1–10). The gourd tree which later spread its shade over the sleeping prophet clearly prefigured the bliss of Paradise. So eventful a story could not easily be compressed into a single scene, and was usually represented in the form of a trilogy, provided there was room enough. In the first scene Jonah is hurled by sailors into the waiting jaws of a sea-monster; in the second he is disgorged onto the land, and the last shows him reclining in the shade of the gourd, symbol of the heavenly banquet (*refriger-*

ium). The Jonah cycle is often met with on pre-Constantinian Christian sarcophagi, as being 'neutral' enough from the pagan point of view and yet full of significance for the believer. With the Shepherd and the Philosopher, the cycle is portrayed on a sarcophagus in Santa Maria Antiqua; this has been dated to about 270 and is of exceptionally high sculptural quality. On a late third-century sarcophagus in *30*
the Lateran, the scene gets much fuller treatment, and each episode in the story is dramatically exploited. Even so, the Jonah cycle really needed a surface larger than the side of a sarcophagus to be comfortably accommodated – in the Catacomb of Callixtus the story is not telescoped because the sequence of events could be reasonably spaced. Also of the late third century, but of dubious provenance, is a group of marble statuettes representing the constituent elements of the Jonah *36, 37*
cycle, as if intended to be set up after the fashion of a modern Christmas crib as an aid to religious contemplation.

The Old Testament was a rich source of early Christian iconography, especially to illustrate the theme of Deliverance; but scenes derived from the New seem to have been designed to stress the fulfilment of prophecy. Thus many of the earliest Catacomb paintings portray Christ's infancy, since for Christians God's promise of a Messiah to redeem Israel was fulfilled in the birth of Jesus Christ. A mid third-century painting in the Catacomb of Priscilla, commonly known as the Prophecy of Isaiah, illustrates this point. Here the artist portrayed a seated Virgin holding a lively infant in her lap; to the right of the group is the figure usually identified with Isaiah, his right arm raised towards a star which shines over the mother and child. If the interpretation of this picture is correct, the Epiphany painted *38*
nearby in the same catacomb is its natural corollary as the symbol of Christ's universal sovereignty. The Adoration of the Magi achieved very early popularity in art, probably because it appealed specially to the Gentiles, to whom Christ had manifested Himself symbolically in the Epiphany. The treatment of the subject, with the Magi advancing in single file towards the Virgin and Child, remained canonical until the Middle Ages, and especially in the art of the Eastern Church.

Very few episodes drawn from the life of Christ exist from pre-Constantinian times, and the Passion and Crucifixion seem to have been almost totally excluded. The Catacomb of Praetextatus, however, contains a badly damaged painting of Christ crowned with

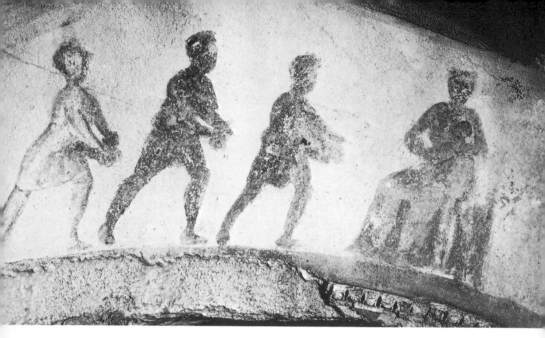

38 The Adoration of the Magi, a theme popular among the Gentiles

39, 40 The salvation of man-
kind and the guarantee of im-
mortality were suggested by such
miracles as the Raising of Lazarus
(left) and the Healing of the
Paralytic (right)

thorns and struck by the soldier with a reed. However painful, this subject was perhaps thought admissible, for any Christian would have seen beyond the act of mockery to the reality of Christ's kingship. Of His miracles none made a deeper impression on the faithful than the raising of Lazarus, accompanied as it was by the words reported in John, XI, 25–26: 'I am the resurrection, and the life: he that believeth in me, though he were dead, yet shall he live: And whosoever liveth and believeth in me shall never die.' In the Catacomb of Callixtus, and also to the left of the upper register on the Lateran 'Jonah Sarcophagus', we encounter its familiar iconography, with Christ standing before a columnar niche in which is the swathed body of Lazarus. Another miracle of which early paintings survive is that of the Healing of the Paralytic. The oldest is in the Dura baptistery, but the version in the Catacomb of Callixtus can only be a few decades later. In both cases the story is very simply told; it must have been so familiar that it needed no special embellishment to convey its message of forgiveness and renewal. Even so, the similarity of approach by the two painters to the subject leads one to conjecture a common iconographical source. Christ's meeting with

39

40

41

the Woman of Samaria is likewise depicted with an overall uniformity of treatment at Dura and in the same catacomb. Stylistic differences are only to be expected, and while the paintings in Rome are in the tradition of Late Hellenistic impressionism, those at Dura are in the stark frontal style of much Syrian work. This has already been discussed in connexion with the far more sophisticated paintings in the temple of the Palmyrene gods and the synagogue at that site.

Episodes from the Old and New Testaments form the basic subject-matter of Christian art; but before the Peace of the Church only a selected few seem to have been in everyday use. Because several of these are found together on a single object, a gold glass from the Pusey collection in the Ashmolean Museum at Oxford is of special interest and importance. Gold glass, which was most commonly a product of the third and fourth centuries, was made by decorating glass drinking-cups with figures in gold leaf which were then engraved, possibly coloured and then lightly glazed. A large number of examples, nearly all fragmentary, have been found, and it is probable that they were used at the wakes which took place in the Catacombs and elsewhere on the anniversaries of the dead. The busts of a husband and wife decorate the tondo of the Pusey glass, with the common Greek invocation *Piē Zēsēs* (Drink up and long life to you!) spaced round the heads of the couple. Five scenes ornament the bowl of the cup beyond the two busts; these are the Fall, the Sacrifice of Isaac, Moses striking the Rock, the Healing of the Paralytic and the Raising of Lazarus. The iconography is exceptionally interesting, for although it is exactly the pictorial shorthand used in the frieze sarcophagi of the immediate post-Constantinian period (below, p. 102), no episode occurs which is not found before that time. If, as is not improbable, the Ashmolean cup can be dated to the beginning of the fourth century, it is of some importance in relation to the origins of Christian iconography.

Although the rite of baptism was depicted in Church art before the fourth century, the scene was quite generalized, as it was in the baptismal relief on the Santa Maria Antiqua sarcophagus and in two paintings in the Catacomb of Callixtus. In all these examples only two persons are involved of whom the one baptized is the smaller and – in the Catacomb paintings – standing at a lower level than the other. Overhead hovers the Holy Ghost in the form of a dove. Even

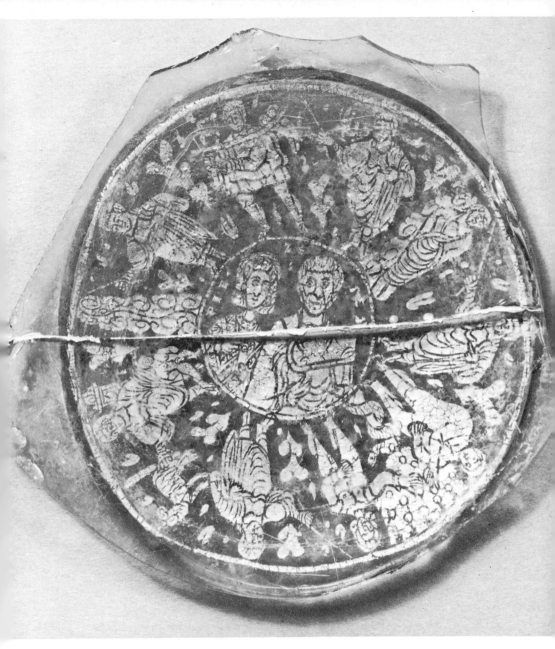

41 Several Old and New Testament scenes, as well as the busts of a husband and wife, are shown on this gold glass from the Ashmolean Museum

42, 43 Two baptism scenes
from the Catacomb of
Callixtus. Those being
baptized, though adult, are
shown as smaller figures, since
in the spiritual sense they
were children

44

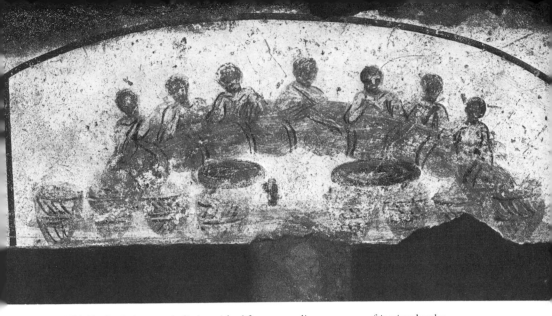

44 This Eucharistic scene is distinguished from an ordinary pagan *refrigerium* by the presence of baskets of loaves and fishes (on the plates), recalling two of Christ's miracles

before the baptism of infants became normal, the catechumen of whatever age was known as *infans* (unable to speak for himself), and the diminutive figures in these primitive baptismal scenes may be explained as spiritually still children.

For Christians the miracle of the Multiplication of the Loaves and Fishes has always been thought to prefigure the institution of the Eucharist. Yet in pre-Constantinian art it can be identified in a few cases only; on the sarcophagus of Velletri, for example, where we see a frontal Christ with arms raised and a crossed loaf in either hand, and seven baskets of fragments before him. The same miracle is probably also the subject of a third-century painting in the tomb of Clodius Hermes near the Appian Way. Generally, however, the Last Supper was disguised in early Christian art as a *refrigerium*, the originally pagan 'refreshment meal' eaten by relatives and friends at the tomb on the anniversary of its owner's death. This was the subject of two noteworthy paintings, of which the first (in the Catacomb of Callixtus) shows seven figures seated at a crescent- *44* shaped *sigma*-table on which are two platters of fish; eight baskets filled with bread are in the foreground. This is no ordinary *refrigerium*,

45

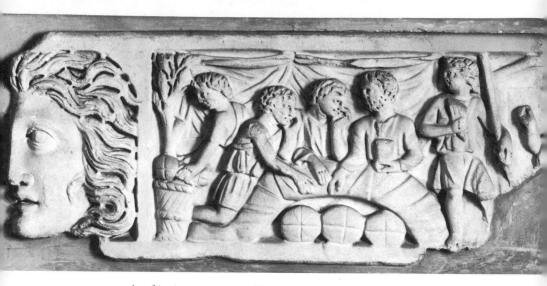

45 A *refrigerium* at a *sigma*-table; five figures partake of bread and wine. On the right, the Shepherd and one arm of an *orans*

for it directly recalls the events related in John, XXI, 2–13, when Jesus appeared to seven of His disciples – 'There were together Simon Peter, and Thomas called Didymus, and Nathanael of Cana in Galilee, and the sons of Zebedee and two others of his disciples' – and gave them a meal of fish, miraculously caught, and bread. The number of baskets is also significant for its reminiscence of the story of the Multiplication as recounted in Matthew, XV, 37, and in Mark, VIII, 8. The other picture, in the *cappella greca* of the Catacomb of Priscilla, has a more devotional atmosphere, and has been thought to represent the moment of the breaking of bread at the Last Supper.

45, 46 Two late third-century reliefs in the Museo delle Terme in Rome are only less explicit. The first, on the sarcophagus of Baebia Hermophile, represents another company of seven at a meal probably of bread and wine; only the accompanying relief of Jonah on the opposite corner of the sarcophagus ensures its Christian content. Subtly different is the *refrigerium* on a sarcophagus fragment now in the Museo delle Terme, Rome. Here apparently only five persons are involved in the meal, for the arm of the figure on the right must belong to a figure in an attitude of prayer (*orans*). But whereas the

46

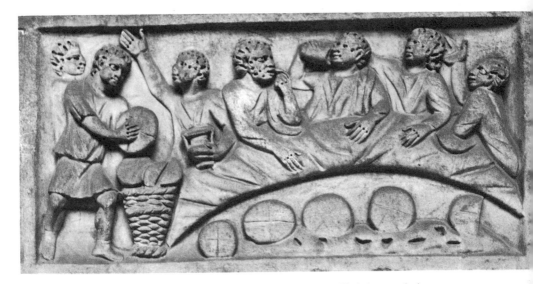

46 A more light-hearted *refrigerium* scene on a sarcophagus. Its Christian symbolism emerges from its being linked with a relief of the Jonah story

emphasis is on conviviality in the Baebia Hermophile relief, it is the love and understanding linking the figures on the fragment that makes the greater impression. There can be little doubt that for believers *refrigerium* scenes like these symbolized the Eucharist. Of course the 'common meal' had its part in Judaism – the Last Supper was itself one – and in the religious life of some Gentiles too. So for a while the practice continued in early Christian communities, and a passage in Pliny's famous letter to Trajan in 112 (*Letters*, X, xcvi) seems to refer to it. Of the Christians in Bithynia he wrote that 'it was their custom... to reassemble to partake of food – but food of an ordinary and innocent kind.' However, by the late third century when the *refrigerium* appears as a popular subject in Christian art, the practice had almost certainly lapsed, and the Eucharistic meaning was the dominant one.

Early Christian iconography is remarkable for its consistency; it can hardly be by chance that in the third century the same subject should suggest the same pictorial image, however different the stylistic conventions, in areas so far apart as western Italy and eastern Syria. The Fall, the Healing of the Paralytic and the Woman of

47

Samaria as illustrated at Dura, Naples and Rome have a strong family resemblance. Moreover, when the Peace of the Church enabled artists and sculptors to produce work enough to ensure a representative survival, the iconography is so consistent over a wide geographical area as to suggest an already long-established tradition. That there is no David and Goliath in the West and no Susanna in the East does not invalidate this proposition. That the survival of works of Christian art during the first three centuries AD was a matter of chance renders complicated, but not necessarily hopeless, a search for the origin of pre-Constantinian iconography.

During the third century BC a group of seventy-two Jewish scholars assembled in Alexandria to settle on an official Greek translation of the Hebrew scriptures. Beginning with the Pentateuch, generations of translators worked on the text; it was not until the second century AD that the Septuagint (so named from the number of scholars originally assigned to the task) was completed. In the opinion of many modern art historians, among them the late David Talbot Rice, the volume in its final form was illustrated. This attractive probability could account for the stability of Old Testament iconography as incorporated in the earliest Christian art. The Jews probably objected less to a violation of the Second Commandment, concerning graven images, by Gentiles than by their own people. At Dura, for example, Gentiles very likely worked on the wall-painting, as inscriptions in the synagogue are in Persian, not in Hebrew. The hypothetical illustrations of the Septuagint would surely have been the work of Hellenized artists. The theory does not, however, explain a similar uniformity where New Testament iconography is concerned. At this point the Ashmolean gold glass may provide a possible clue to the problem. *41*

From Constantine to Justinian

In the spring of 311 the Great Persecution was drawing to an end in rather macabre fashion. At Nicomedia, the steep hillside town overlooking the Sea of Marmara, the Emperor Galerius lay dying. An implacable enemy of the Church and by now convinced that the God of the Christians had singled him out for special vengeance, the emperor announced that the Christians might once again practise their religion, hoping perhaps that this act of appeasement might save him from an agonizing death. Galerius, however, was suffering from an incurable cancer and died shortly afterwards. Such was the beginning of Christian emancipation. Less than two years later, in an announcement at Milan, Constantine and his colleague Licinius ratified Galerius' decision in precise terms and restored full civic rights to the Christians, including the ownership of property confiscated under the persecution. The year 313 is rightly remembered therefore as a great turning-point in the history of the Church.

That there was no real return afterwards to the bad old days was in large measure due to Constantine's personality. Although not baptized until on his deathbed, once he had decided to champion the Christian religion and to make it the driving force of a new Roman empire, he put the full weight of his authority behind it. The Church accordingly grew greatly in power and prestige. Even before Constantine become sole emperor in 324, while persecution smouldered on in the eastern provinces under Maximinus Daza and later on under Licinius, who had gone back on the promises made at Milan, the new era was marked by the building of large and important churches. Chief amongst these was the great basilica dedicated to the Saviour in Rome on ground close to the Lateran palace which Constantine had given to the Pope in 313 in recognition of his high office. Between 313 and 319 a cathedral was built at Aquileia, and its floor mosaics still survive.

When Licinius died in 324 the pace of building quickened. In the Holy Land, places known to the contemporary Church as the sites of

Christ's birth, death and resurrection were commemorated with the finest buildings that imperial munificence could provide, while in Rome the foundations were laid of a new basilica designed to enclose and do honour to an earlier shrine commemorating St Peter's martyrdom on the Vatican hill. Nothing surely could better have emphasized the new confidence of the Church and the emperor's real concern for its welfare than these permanent witnesses to the Christian faith.

Constantine, in his efforts to enforce religious conformity, was no less ready to involve himself with the controversies of his time. Before his baptism he took his place among the bishops as of right, and actually presided over them at the Council of Nicaea, where the heresy of Arius was solemnly anathematized in 325. Just as his pagan predecessors had been deified after death, Constantine was 'canonized' and granted burial in the Church of the Holy Apostles, for all the world as if he were an Apostle himself. It was that same Constantine who took the decisive steps which changed the destiny of the Roman empire and with it the course of history. On 11 May 330, at the site of Byzantium, the old Greek city on the European shore of the Bosporus, he dedicated a New Rome, to be known, in his memory, as Constantinople. 47

The decision was symbolic but also pragmatic. For too long Rome had been remote from the military operations which were the main preoccupation of the empire. For a campaign on the Euphrates against the indefatigable Parthians, or on the Danube line facing the Goths, it was distant indeed. Moreover, the concept of an 'eternal city' was no longer a source of inspiration, but rather suggested a home of lost causes and of outdated and unprofitable ideas. Earlier Diocletian had understood this, and by the institution of the Tetrarchy, with regional seats of government at Nicomedia (İzmit), Milan, Sirmium (Mitrovic), and Trier, had undermined the primacy of Rome and effected a necessary degree of decentralization. But when Constantine became sole emperor in 324, Diocletian's policy had long been in ruins, and to stand any chance of success a new imperial order had to break with the past and with the mystique of the city and its thousand years of history. Rome's associations with paganism, for which the older and more conservative families still felt a sentimental attachment, certainly influenced Constantine in his decision to make a fresh start in new surroundings, and in any case the

Christians, on whose loyalty and support he much relied, were more numerous in the eastern provinces than in Italy and the West in general.

Byzantium was in every way fit to be the site of a new imperial capital. Endowed with a breathtaking natural beauty and located on a peninsula overlooking the gentle slopes of the Asiatic shore of the Bosporus to the south-east and the wooded islands of Marmara, its position across the main trade route between Europe and Asia made it an international emporium. Also, a natural strength of terrain combined with its control of the narrows between the Black Sea and the Aegean made the city a veritable fortress able to withstand all the assaults of its many enemies for nearly a thousand years. To judge from what has fortuitously survived (which may be misleading), Christian art before Constantine was largely funerary. After emancipation, however, an increasingly influential Christian community could call on the best architects and artists to build, furnish and adorn the churches that everywhere sprang up throughout the empire. Sculpture was an art in decline, but ivory- and wood-workers, mosaicists and painters, gold- and silver-smiths were active as never before in the service of the new state religion. This was one of the most exciting periods in the history of Christian art, one of diversity and experiment, and the fourth and fifth centuries are full of exuberant vitality. Most of what survives is preserved in churches and so is intimately associated with, or has its form conditioned by, architectural considerations.

ARCHITECTURE

In apostolic times a single room in a private house sufficed for the celebration of the Eucharist, and the author of Acts (XX, 7–12) brings vividly to life a meeting held at Alexandria Troas in such simple surroundings. The local synagogue was also used as a platform to attract potential converts, and in Athens St Paul actually preached from the Areopagus so as to reach the largest possible audience (Acts XVII, 19–34). There was at first no need for specialized churches or for structural changes in buildings already in Christian use; but with the institution of a hierarchy and of an order of service of the kind described by Justin Martyr not long after the mid-second century a fixed liturgy, demanding an organization of

space suitable to the activities of clergy and congregation, came into being. Indeed the building at Dura, with its baptistery and probable 24 provision for mass in the south-west hall, is very like a straightforward east Syrian house modified to suit the exigencies of a primitive liturgy. In Rome itself there were the so-called *tituli*, which were originally the houses, tenements – even the private baths – of prominent members and benefactors of the Church. These *tituli* sometimes preserve the name of the man in whose house they originated. Thus the *titulus* of Santa Pudenziana derived from a thermal establishment and was named after Pudens, its original owner, and not in honour of a female saint. Many churches there certainly were before the Peace of the Church, but we have little or no idea of their appearance, for the literary sources were not much interested in such details. Lactantius (*De Mortibus Persecutorum*) gives a full account of the destruction of the church at Nicomedia in 304, at the beginning of the great persecutions, but apart from the fact that it was demolished in a matter of hours and so cannot have been very substantially built, it remains architecturally anonymous. Indeed all we know is that, when large churches began to be built after Constantine had established his personal supremacy in the Roman world, they were certainly specialized, but none the less comprehensible in terms of Late Antique tradition. However, a few words should be devoted at this point to a small shrine (*memoria*) of St Peter which 48 excavators discovered in 1946 below the high altar of the present Renaissance church on the Vatican Hill. This architecturally undistinguished shrine has been associated with the memory of the Prince of the Apostles for eighteen hundred years.

Very early in Church history the urge arose to celebrate the triumphs of the martyrs who were reverenced in much the same way as once had been the heroes of pagan mythology, especially in the uninstructed public mind. It was natural enough therefore for Gaius, a priest who saw the *memoria* or *martyrium* of St Peter in about 200, to describe it as a 'trophy' – a memorial celebrating the Apostle's victory over death in martyrdom. The shrine itself (whether to be considered as cenotaph or tomb) has been convincingly dated on the archaeological evidence to the middle of the second century, and consists of three superimposed niches of which the lowest was below ground level and clearly never intended to be seen.

Separating the upper niches was a slab of travertine which rested on two colonnettes. Restoration above this point is conjectural, but an upper pair of colonettes crowned by a pediment reflects contemporary pagan usage and may well be the answer. A closure slab in the floor, which lies at an angle to the axis of the shrine, follows exactly the line of a simple inhumation grave in which, below the lowest niche, the excavators discovered the bones but not the skull of 'a person of advanced age and powerful physique'. In the first impact of this announcement it was understandably, if imprudently, assumed that the bones belonged to St Peter; painstaking research by Professor Margherita Guarducci now suggests that some other bones originally wrapped in royal purple were venerated by the earliest Christians as those of the Apostle. However this may be, it is certain that in the first half of the fourth century, while Constantine's church of St Peter was actually building, the association of the Apostle with the *memoria* was so firmly established that it was given the place of honour, at the junction of the apse and transept.

The shrine of St Peter is the earliest known monument of its kind and is typologically unique, though it is known that St Paul was honoured in much the same way at the Ostian Gate and that Constantine had a small church built round this shrine too, some fifty years before the foundation of the great basilica of St Paul without the Walls in 385.

'*O Roma felix, quae duorum principum es consacrata glorioso sanguine*' runs the hymn; 'Ah happy Rome, hallowed by the glorious blood of the two Princes!'. The theme of the Apostles' joint presence and final martyrdom in the city was celebrated by yet another *memoria* in the mid-third century, this time at a site on the Appian Way on which the church of San Sebastiano now stands. However, their association with the place is not clear at all, since a metrical inscription of Pope Damasus describes them as having 'dwelt' there, a verb which is ambiguous in a Christian context. It is therefore possible, if unlikely, that the relics of both saints were translated to the site on the Appian Way during Valerian's persecution of 258, only to be returned later to their places of burial on the Vatican Hill and at the Ostian Gate. This last *memoria* was a very simple affair, being no more than a shelter opening on to a courtyard where pilgrims

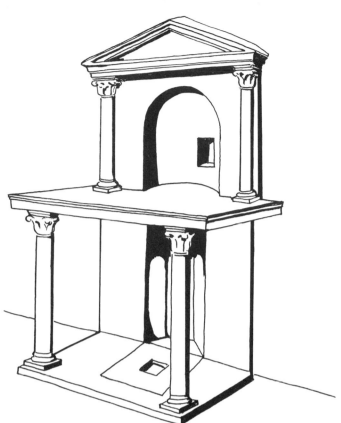

48 A monument of unique interest, the *memoria* of St Peter, discovered in 1946 below the high altar of the present church. The restoration above the central slab of travertine is conjectural

certainly celebrated *refrigeria* in honour of Saints Peter and Paul, for their two names recur in many pious invocations scratched on the walls.

Long before Constantine's day, therefore, there were churches, and in Rome at least small memorials had been set up to honour places hallowed by the blood of the martyrs. It may appear strange in contrast that in the Holy Land where Christ Himself had lived, worked and died, there was no living tradition to aid Constantine in deciding on the exact sites for the churches he had built at Bethlehem and Jerusalem to celebrate Christ's Nativity and Passion. However, as the church of Jerusalem never recovered from the expulsion of all Jews from the city after 132, it is likely that the discoveries made by St Helena during a pilgrimage to Palestine in about 326 were decisive in settling on the identity of the Holy Places. A comparison between

55

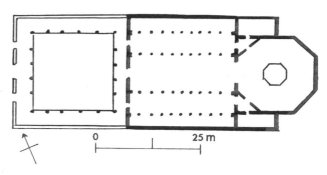

49 Plan of the Church of the Nativity at Bethlehem; from left to right, the *atrium*, central basilical hall, and octagonal *memoria*

0 25 m

Constantine's churches at Bethlehem and Calvary with the basilica enclosing the *memoria* of St Peter in Rome shows that there was not at this time any hard and fast rule governing church architecture, and that solutions to similar situations could be strikingly different.

49 At Bethlehem the focal point of the church was the Grotto of the Nativity; over this sacred spot was built an octagonal *martyrium*, in the floor of which a circular opening allowed pilgrims to look down into the rock-cut stable where, according to tradition, Christ was born. Westward of the octagon, on the same axis and architecturally integrated with it, was a basilical hall with a nave and four side aisles; this is all that now survives of the Constantinian foundation. Westwards, opening out of this hall and on the same axis, was a large rectangular *atrium* (forecourt) with a colonnade on all four sides. Here the functional distinctiveness of the elements making up the whole is clear-cut. So it was in the Church of the Holy Sepulchre consecrated in 336 on the site of Calvary, but this was a less tidy structure, since here the *martyrium* had to take in not only the tomb of Christ but also the rock of Calvary some thirty metres away to the south-east. Eusebius' testimony suggests that the building was entered, as at Bethlehem, from the east through a narrow *atrium* giving access to a five-aisled basilical hall which terminated (at its west end) in a near circular structure defined by twelve columns and probably roofed with a domical vault. Westwards from the basilica, entered from it and on the same axis, was an enclosure of which the focal point was the Holy Sepulchre, covered by a baldaquin on twelve supporting columns. In the fusion of *martyrium*, basilical hall and

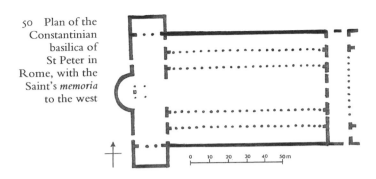

50 Plan of the Constantinian basilica of St Peter in Rome, with the Saint's *memoria* to the west

atrium into a unified structure, the two churches described have an obvious resemblance; but it is less clear in the layout of old St Peter's in Rome which, like the others, was oriented westwards. St Peter's was approached through a magnificent colonnaded *atrium*, with a central *cantharus* (fountain) for ritual ablutions; but further west the distinction between the basilical hall and the *martyrium*, in this case the setting for the second-century *memoria*, was blurred. To the modern eye, accustomed to a cruciform plan, the five-aisled basilica with its western transept and apse looks like an architectural unity, but this is not quite the case. St Peter's shrine had existed for well over a century and a half in unaffected simplicity before Constantine had it incorporated into the new church. To the newly emancipated Christians of the day it seemed to deserve a worthier setting, and the great transept east of the apse was designed to satisfy the need. In the late-fourth-century church of St Paul without the Walls this feature was consciously imitated and for the same reason. The cathedral of Rome (St John Lateran), where no *martyrium* was involved, was an orthodox basilical church, and excavation has shown that its transept was no more than a medieval addition.

While Constantine yet lived, and just afterwards, many large churches were 'composite' foundations, though no confusion existed between the purpose of a *martyrium* (designed solemnly to commemorate the site of an outstanding religious event) and of a basilical hall suited to meet the general needs, including the performance of the liturgy, of a Christian community. Imperial precedent must have influenced the use of a centralized plan for *martyria* and baptisteries. Under paganism, an emperor's tomb was not only a mausoleum, but

57

also a cult centre, and this dual role was best served by a building symmetrically ordered about a vertical axis, in this case a sarcophagus, which acted as the focus for those who had come to pay their respect and homage. Thus, the cathedral of Split, and the churches of St George in Salonika and of Santa Costanza in Rome – all of them centralized – probably began as imperial mausolea, of Diocletian, Galerius, and Constantia (Constantine's daughter) respectively. This direct, physical emphasis on the person or place to be honoured with a *memoria* was maintained in Christian times, and for similar reasons centralized buildings were preferred for the very personal and intimate ceremony of baptism. For a public assembly the long-aisled basilica was specially fit, and it may be significant that some pagan religious buildings designed for congregational purposes (e.g. the basilical *hypogaeum* at the Porta Maggiore in Rome and temples of Mithra in the western provinces) anticipated in their general interior organization the halls used by the Constantinian church as a setting for the Christian liturgy.

In the great 'composite' churches, *martyrium* and basilical hall were complementary, and so it soon became common practice for mass to be said at *martyria*, and for sacred relics to be laid below the altar stones of basilical churches. Commemoration, the original function of the *martyrium* or *memoria*, was thus integrated in the Mass; and in the Church of the Nativity at Bethlehem, where the octagonal *martyrium* was suppressed during the sixth century in favour of a trefoil sanctuary, the sublimation of two cults, that of Christ's birthplace and of Christ's personal presence in the Eucharist, in a unified whole led also to architectural unification.

Somewhat different was the case of the Church of the Holy Apostles (Apostoleion), founded by Constantine in his own capital. Cruciform, with a drum surmounted by a conical roof over the junction of the four halls that formed the arms of the cross, this was intended as a *martyrium* of the Twelve Apostles (*in absentia* as it were); but the centre of veneration, plumb below the peak of the cone, was the tomb of Constantine, a benefactor of the Church no doubt, but hardly an Apostle in the accepted sense. In 356/357, when relics of the true Apostles were deposed in the church, the emperor's body was removed and re-interred, more suitably, in an imperial mausoleum nearby. Considering that the Apostoleion in Constan-

51 The round church of Santa Costanza in Rome, probably built as an imperial mausoleum of Constantia, daughter of Constantine ▶

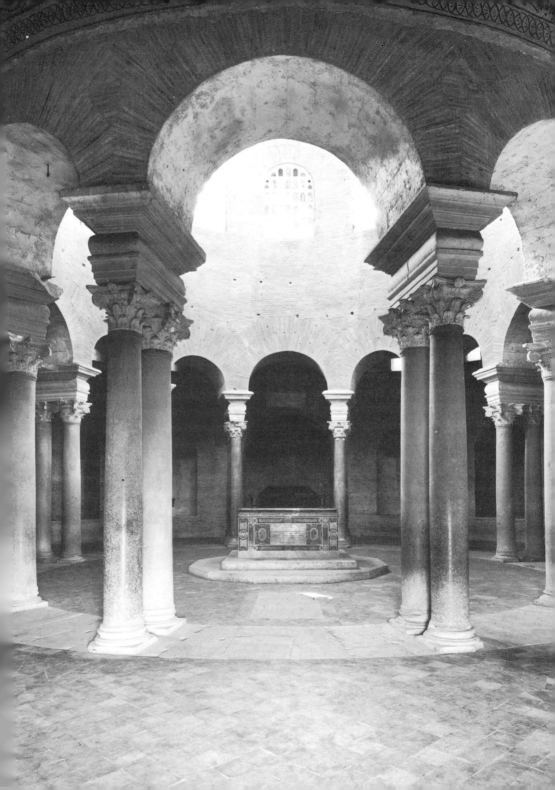

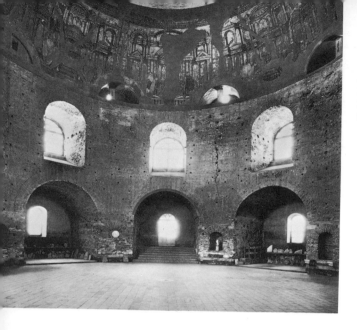

52 St George at Salonika, also a former imperial mausoleum. The view is from the apse looking north–west

tinople, with its cruciform plan and centrally sited *memoria*, was architecturally a *martyrium*, it may at first seem surprising that it should have been the model for many churches in the East in the decades following its completion. Thus the *martyrium* of St Babylas near Antioch (Antakya) on the Orontes was built in about 370 to the same plan as the Apostoleion, but was soon modified for church services by the addition of a sacristy and a baptistery. Also influenced by Constantine's foundation, but designed from the first as a church, was an Apostoleion laid out by St Ambrose at Milan in 382, while in the fifth century the cruciform plan was sometimes married into that of the long-aisled basilica, e.g., the churches of St John the Evangelist at Ephesus and of St Menas at Abu Mina west of Alexandria. Significantly, the architectural *raison d'être* was a *memoria* or a reliquary at the intersection of the arms of the cross, so that they could really be considered as *martyria* as well as churches.

In the latter half of the fourth century, there was greater diversity. The Constantinian practice of integrating *martyrium*, basilical hall and *atrium* was given up, and instead *martyria* and churches achieved structural independence. Thus the Anastasis, built in the second half of the fourth century to commemorate Christ's Ascension, was a free-standing rotunda, while a century later the Church of the Theotokos,

60

the octagon delicated by the Emperor Zeno (474–91) to the Mother of God on Mount Garizim in Samaria, was also centralized. But while a circular or octagonal plan was still de rigueur for *martyria* in the Holy Land, in central and north-western Europe church architects displayed a new flexibility, and were ready to scrap the basilical hall as an indispensable background to the liturgy. For example, the quatrefoil San Lorenzo (*c.* 370) in Milan and the slightly later St Gereon in Cologne borrow their plans from other distinctly Late Antique sources. The derivation of St Gereon is not clear, though it has many of the known characteristics of a *martyrium*. As for San Lorenzo, it has overtones of some of the audience halls incorporated in the great imperial palaces; not unnaturally, for this was a time when the line between temporal and spiritual authority was none too finely drawn, and when court ceremonial provided an obvious model for the pomp and circumstance of the divine liturgy.

53

If the late fourth century produced many churches of originality and distinction, the fifth and early sixth centuries saw the conquest of Christendom by the basilica. The basilical form flourished for such a long time and over such a wide geographical area that naturally there were considerable variations in the methods of construction and material used; yet the consistency of the basic form makes it worth considering an imaginary basilical type-specimen.

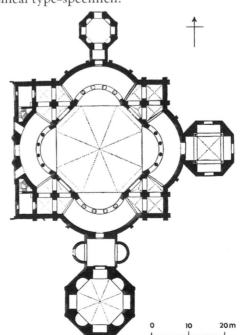

53 Plan of San Lorenzo in Milan, which has an unusual quatrefoil construction, with chapels to the north, east and south, and the entrance to the west

0 10 20 m

The Christian basilica is a rectangular building entered through one of its shorter sides, usually the west, with its emphasis on the longitudinal axis and so on the horizontal vista culminating in a semicircular apse at the east end of the building, opposite the entrance. Internally it is usually divided along the same axis by two rows of columns into a nave and side aisles, though sometimes the number of colonnades is increased to four, or even to the six in the memorial church of St Cyprian in Carthage; but whatever the number, the central nave is nearly always a lot wider than the aisles. The outer walls have no windows, and lighting comes from a clerestory above the nave. Over aisles and clerestory the roof is pitched, with a semidome over the apse, and the transition from the rectangular volume of the main hall to the semidome is effected by a transverse arch (the 'triumphal arch') which spans the width of the apsidal recess and stands to the full height of the nave. Within this bare framework there is much scope for variation; indeed few early Christian basilicas conform in every respect even to these generalized specifications.

As elsewhere, in the coastlands of the Aegean and Eastern Mediterranean, from Thrace, through Asia Minor, Syria and Palestine to Egypt, the long-aisled basilica was the typical church of the fifth and sixth centuries, and even today the traveller encounters their ruins in greater profusion than any other comparable monument of antiquity. Nevertheless, in the Levant generally, and Palestine in particular, churches were often associated with *martyria* for which the traditional architecture was generally centralized, often circular or octagonal. Centralized churches that were not *martyria* were also known early in the area, the first being the famous Golden Octagon of Constantine at Antioch. The plan of this church, known only from literature and a simple mosaic representation, may reasonably be construed as primarily influenced by the centrally planned ceremonial rooms of imperial palaces, with antecedents as early perhaps as the octagonal dining-room (*triclinium*) of Nero's Golden House in Rome. With perhaps equal assurance the Golden Octagon may be thought ancestral in planning concept to San Lorenzo in Milan and to the later, Justinianic churches of Saints Sergius and Bacchus in Constantinople and of San Vitale in Ravenna. Some other Levantine churches clearly evolved direct from *martyria*, and one already mentioned

54

53

146

54 The building on the extreme right of this mosaic of street scenes at Antioch is believed to be the Golden Octagon of Constantine, of which nothing now remains

(p. 61) is Zeno's church of the Theotokos (484) on Mount Garizim. This octagonal building has a projecting eastern apse, and at each of the other cardinal points was a shallow entrance porch of the width of one side of the octagon; each porch alternated with a little chapel on the diagonal axis of the building. Above an inner octagonal room, supported on eight piers and buttressed by an encircling ambulatory, rose a pyramid or dome of timber construction. Yet, although imaginative and original, as befits an imperial foundation, the church of the Theotokos is still essentially a centralized *martyrium*. Of possibly greater significance in the history of ecclesiastical architecture, however, is the church built under the same emperor near Seleucea on the Calycadnus (at Meryemlik).

Without anticipating a description due to follow in the next chapter, it can be said that the most striking achievement of Justinian's architects in their plan for a new Santa Sophia in Constantinople was their success in combining in one building the emphasis on the longitudinal axis proper to a basilica with a vertical stress, in this case provided by a dome, which distinguished a *martyrium*. To what evolutionary process the planning of this masterpiece was indebted is a long-standing and complex problem; while the seating of a dome over a circular, or even an octagonal, structure presents few compli-

cations, it is otherwise when the cupola has to be raised over a square bay, as it does if it is to suit the layout of an orthodox basilical plan. To the architect faced with this problem two solutions were possible; the first was the use of squinches, and the second of the more sophisticated spherical triangular pendentive. Squinches were used to transform the top of a square structure designed to be roofed with a dome, first into an octagon and then, if necessary, into a regular polygon. This was done by laying slabs across the right-angles and then repeating the process over the angles resulting from the first operation. This could also be done by building niches or arches at the corners, thus again forming the octagonal seating for a dome. Pendentives, the more graceful if more elaborate answer to the problem, are triangular segments of a sphere intended to fill the gaps, that would otherwise result from the junction of four arches enclosing a square bay, with a drum or cupola on a circular base of the same diameter as one of the sides of the square and rising from the crown of the arches.

When, and after what sort of experiment, the first 'domed basilicas' were planned is unknown, though the latest evidence suggests that by the last quarter of the fifth century the type was already established, certainly in Isauria and very possibly, indeed probably, in Constantinople. The connexion (unlikely on the face of it) between the capital and a remote, mountainous and proverbially lawless province becomes more credible if it be recalled that the Emperor Zeno was himself an Isaurian and that many of his semi-barbarous tribesmen wielded great influence at court. We need feel no surprise if in Zeno's case local patriotism, and in that of his formidable courtiers, an enlightened self-interest, had played an important role in the apparently simultaneous, or near simultaneous, appearance of three Isaurian churches of great originality and distinction.

Important in the church at Meryemlik is the square bay west of the chancel formed by four massive piers which break up the rhythm of the colonnades and divide the nave into two. The church is ill preserved; but as it is known that the side aisles and shallow forechoir were all barrel-vaulted, it was long assumed that the western nave was similarly roofed, with the square bay at the east end crowned by a stone dome. West of the church proper, but of one build with it, was a very deep apsidal court.

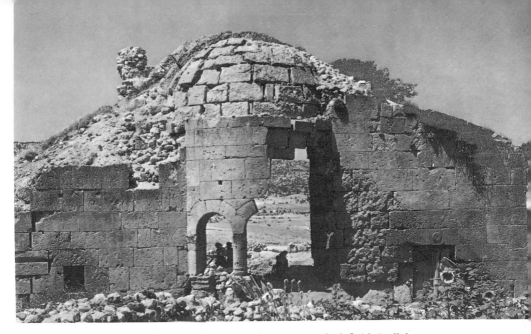

55 Apse of the church at Dağ Pazarı; the stump of masonry on the left side is all that remains of a tower which once crowned the eastern bay of the nave

Some sixty-five miles north-west of Meryemlik, a similar church has been recorded at Dağ Pazarı, a village on the north slope of the *55* Taurus. Until 1958, when the present writer made a sounding in the nave, it had been published as an orthodox basilica; but it is now known that west of the apse was a square bay defined by four piers, exactly as at Meryemlik. The roofing of aisles and forechoir is visibly barrel-vaulted, so it may be assumed that the rest followed the Meryemlik example pretty closely. An old photograph of Dağ Pazarı here provides a clue, for it shows that the square eastern bay of the nave was originally crowned by a tower of which only a stump of the east wall survives. Finally, as an aid to understanding Dağ Pazarı and Meryemlik, the eastern church in Alahan Monastery (long known as Koja Kalessi) is invaluable.

Alahan Monastery, built along a rocky ledge on the southern slopes *59* of the Taurus, is less than ten miles across country from Dağ Pazarı. Apart from its lack of a western apsidal court – present at Dağ Pazarı as well as at Meryemlik – the East Church at Alahan is not only *56, 57* comparable with the two just described, but its preservation is so good that the plan and elevation are known for certain, except for *58*

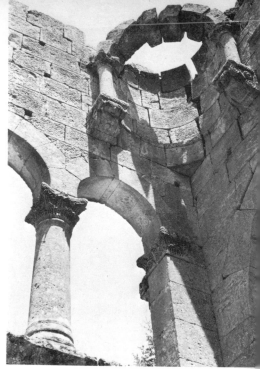

the roof of the tower supported by four piers at the east end of the nave. As elsewhere in Isauria, building stone and timber were both plentiful, so that architects could choose either material for roofing. At Alahan, pitched wooden roofs covered the aisles, western nave and forechoir; but squinch arches, supported by colonnettes on elaborately decorated consoles, at the angles of the tower, persuaded many scholars that the logical achievement was a stone dome. There are, however, many good reasons against this, and why a timber roof is to be preferred. This may be disappointing to those who like to see at Meryemlik and Alahan prototypes of the 'domed basilica'; but the probable absence of stone domes there and at Dağ Pazarı is really less important than the fact that at the end of the fifth century there were architects with the knowledge and skill to combine in one building the vertical emphasis provided by a tower, however roofed, over a square bay with the plan of an otherwise normal basilica. The squinches at Alahan are enough, in any case, to show that the architect of the East Church was at home with *one* method of domical construction.

66

56, 57 The East Church of the Alahan
monastery. Left: interior looking north-west.
Right: the north-east squinch arch

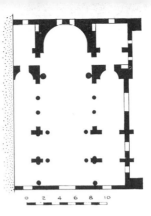

58 Right: plan of the Alahan East Church;
basically a normal Hellenistic basilica, it is
unlikely to have been domed, despite the
squinch arches. Its roof may have been of timber

59 Below: view of the Alahan monastery
from west to east, with the west front of the
church at the far end

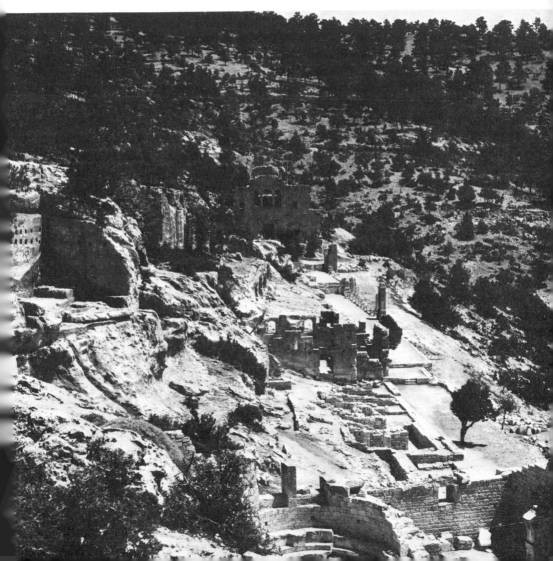

Isauria, though remote from Constantinople and with a deserved reputation for ruggedness of terrain and inhabitants, was not backward where architecture was concerned. Massive watchtowers of polygonal masonry, built during late Hellenistic times in the rocky hinterland north of the Mediterranean, survive as a permanent memorial to the Isaurian mountaineers and to their skill as stonemasons. In Roman and early Christian times they proved just as apt in turning their talents to the needs of the sophisticated urban communities that now sprang up like oases in that savage waste of ravine and crag after the birth there of a precarious *Pax Romana*. Even so, we cannot probably look to Isauria for the origins of the domed basilica; for though the fine churches just described were within the competence of native masons and craftsmen, there is an opulence in the architectural enrichment (especially at Meryemlik and Alahan) which suggests that artists from Constantinople may have been at work, as indeed is possible if Zeno himself had a direct interest in the programme. It is likely too that an imperial project in the provinces would have reflected current fashion in the capital. It may, therefore, perhaps be legitimately assumed that the 'domed basilica' of Isauria was really an import from Constantinople.

In about 480, again while Zeno was emperor, a centre of pilgrimage was established on the road that once connected Antioch and Aleppo, now in Turkey and Syria respectively. The place, Qal'at *60* Sem'an, commemorates St Simeon Stylites who died in 459 after spending nearly thirty years at the top of a gigantic column from which he derived his *cognomen*, and of which the base survives to this day. Qal'at Sem'an was a huge monastic complex, of which the church, baptistery and guest rooms still survive, as they do at Alahan in Isauria, and with which they must be roughly contemporary.

The church itself was a cruciform *martyrium* with an octagonal core, roofed with timber and enshrining the column on which the saint passed so much of his life. Four basilicas, each one giving access to the central octagon, formed the arms of the cross, and the eastern one (with its tripartite sanctuary) was of the normal Syrian type. Of the 'subsidiary' basilicas, those to the south and west had the entrance porches typical of the Levantine area.

Strong articulation is characteristic of the architecture of Qal'at Sem'an, specially notable on the southern façade where every feature

60 A nineteenth-century view of the monastery of Qal'at Sem'an; four basilicas opened off a central octagonal space

(doors and windows for example) is emphasized by rich mouldings, and on the central apse of the eastern basilica which carried two exterior tiers of columns as a means of achieving a similar articulated effect. The contrast with the usually unimaginative treatment of the exterior of basilical churches in the West is evident, and it seems a little sad that so original an architecture as that of Qal'at Sem'an had no future in Christendom. But Moslem architects in the Near East quickly adapted themselves to this idiom and not infrequently improved on it.

MOSAIC

Many fourth- and fifth-century churches have survived to this day, but very few of them have their original decoration and furnishings. Sadly this is often truer of those regions where Christianity remains the religion of the people than it is of the Near East, for example, where it has been superseded by Islam. For while in Europe changing taste led to the demolition of old buildings to make way for larger, more grandiose foundations, or for the sort of restoration or 'improvement' that has ruined many a work of art, in North Africa,

Egypt, Syria and southern Anatolia the conversion of the people to Islam led to the neglect and abandonment of churches. So in Rome Constantine's basilica of St Peter was demolished in the sixteenth century, with only scattered architectural fragments, tantalizing literary references and inadequate sketches as witness of its original appearance. At Rome too, of the mosaics in Santa Pudenziana only the one in the apse survives, and this much restored. In the Near East, however, the case is quite other. There buildings stand almost intact, and in these the archaeologist is fortunate if architecture or its enrichment is his main concern. Sometimes too a floor, whether of mosaic or of *opus sectile* (a technique similar to inlay, using pieces of stone cut to shape) still exists to stimulate the imagination; but wall decoration, the great glory of the early Christian period, has nearly always disappeared, through the action of weather, beasts and man. In Europe, then, works of art have often been destroyed in a foolish attempt to improve on the already excellent, while in the Islamic world indifference has achieved the same effect. Original Christian wall mosaic of the fourth and fifth centuries is a rarity, to be studied in possibly unrepresentative survivals. But, however incomplete the testimony, it is of unusual interest as proof of the continuity of a specialized art form, spanning two eras unalike in almost every other respect – classical antiquity and medieval Christendom. It will be shown later that wall mosaic was the art *par excellence* of the early and medieval church. Floor mosaics, however, were used less and less after the First Golden Age of Byzantium, at any rate for scenes with figures.

A floor is perhaps the most utilitarian of man–made things. Mud or plaster are adequate, but need constant attention and frequent repair. Stone endures, and needs very little upkeep at all, and of stone floors those made of cobbles are almost indestructible. The first arrangement of pebbles on floors in patterns may have been Phrygian, for the earliest known pebble mosaic, dated to the seventh or eighth century BC, was found at Gordion in central Turkey. Black and white stones only were used in its simple geometric motifs, and pebble mosaics, however competently designed, are sober affairs with a limited colour range. At Olynthus and Pella in northern Greece, however, work of high quality was being done in this medium early in the fourth century BC. The real breakthrough

came, however, with artificially shaped stones which the artist could lay more easily and to greater effect than irregular pebbles. As well as *tesserae* (generally small cubes) of stone or marble, glass was used to supply brightness and colour variations, but it was not common on floors as being too easily damaged. The best floor mosaics were Hellenistic, for the artists of that period, by skilful use of their *tesserae*, even produced figured scenes of great distinction in versions of famous paintings such as that of the Battle of Issus in the House of the Faun in Pompeii (ill. 6). Such mosaic pictures (*emblemata*) occupied the most important part (often the centre) of a room and had a white surround, as a fine rug is nowadays displayed on a plain floor of stone or wood, or on a monochrome carpet. Under the Roman Empire this simple and neat distinction between *emblema* and background was gradually abandoned for an overall decorative scheme. This was very effective when confined to geometric motifs, being just like an Oriental carpet; the simple patterns of the late-fourth-century mosaic in the *martyrium* of Babylas near Antioch is a good case in point, for no part of it attracts the attention rather than another. A variant on this scheme was a combination of geometric ornament with naturalistic motifs in an overall pattern. Kitzinger has shown that in the East these three types of floor decoration followed each other in sequence from the end of the fourth to the beginning of the sixth century, though the third could sometimes consist of birds and animals used as pure decoration, unlimited by formal composition or concession to spatial illusionism. Kitzinger's rule did not apply in the West, at any rate in Aquileia cathedral (founded *c.* 313), where the Christian element is subdued as it had been in pre-Constantinian art. Panels of purely geometric ornament do, it is true, embody the cross and its variants, though to a pagan the motifs would have had no special significance. As part of another regular geometric scheme, the Four Seasons in hexagonal frames would be equally 'neutral', and the Shepherd with a sheep across His shoulders only less so. As for the famous fishing scene, intended in context as an allegory of the Christian ministry, it could pass as pagan were the scene of Jonah's deliverance not included in it.

A later fourth-century mosaic floor, uncovered in 1963 at Hinton St Mary in Dorsetshire, is remarkable for its probable representation of a cupola seen in plan with a central roundel containing the head of

66

61

Christ, if that is the real identity of the youth with a Chi-Rho nimbus. In an adjacent, oblong panel are Bellerophon and the Chimera. The closeness of Christ Himself to so blatantly pagan a scene is possibly explicable if the Bellerophon panel be interpreted allegorically as Good's triumph over Evil. The portrayal of the sacred likeness on a floor is, however, harder to explain away, unless we accept the relevance of a decree of Theodosius II and Valentinian in 427, explicitly proscribing the *signum Salvatoris Christi* on floors, for this indicates that the cross or Chi-Rho was used *before* that date and, if so, possibly pictures of Christ also.

61 In the central roundel of this mosaic at Hinton St Mary, the figure with a Chi-Rho nimbus appears to be that of Christ, thought it is surprising that His likeness should be placed on a floor

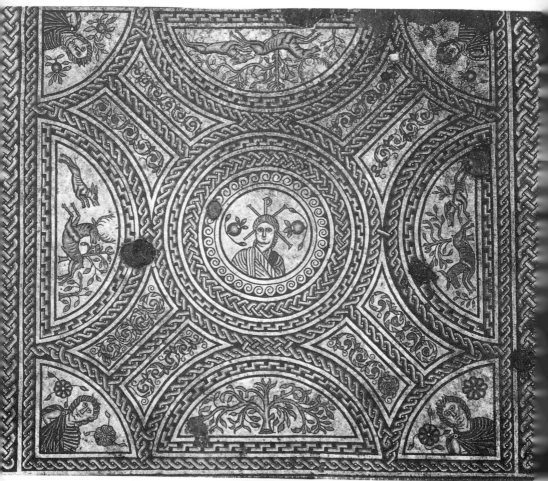

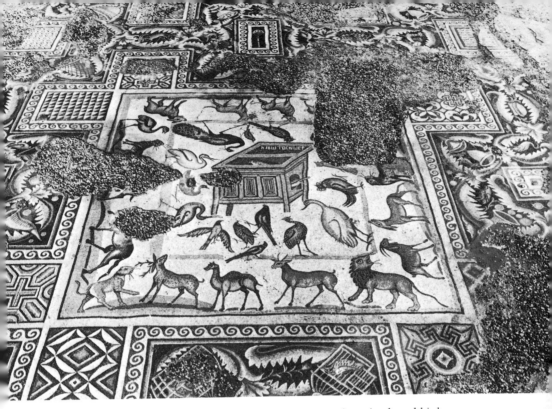

62　A 'Noah's Ark' scene from the floor mosaic at Mopsuestia; animals and birds surround a small cabinet representing the ark. The rest of the panel is filled with elaborate natural and geometrical decoration

The imperial decree was not aimed at mosaicists who drew inspiration from the Old Testament, especially from scenes involving large numbers of animals and birds. In the fifth-century church at Mopsuestia (Misis) in Cilicia Campestris, a square panel in the nave mosaic depicts a variety of creatures grouped round a little cabinet on four legs, labelled 'Noah's Ark'. There are no human figures, and the only occupant of the Ark is a bird, with another coming in through a side door. The panel is really an *emblema*, for an attempt, however inadequate, has been made to portray a scene, and birds and beasts stand on a base line for the most part, and do not float about in the disembodied manner typical of what is probably slightly later work in the same genre. Much more technically competent, however, is the ornamental background of squares filled with geometric

62, 63, 64, 65

73

63, 64, 65 Details from the Mopsuestia mosaic shown in ill. 62: above, a guinea-fowl in a cage; below, a peacock; opposite above, a fallow deer

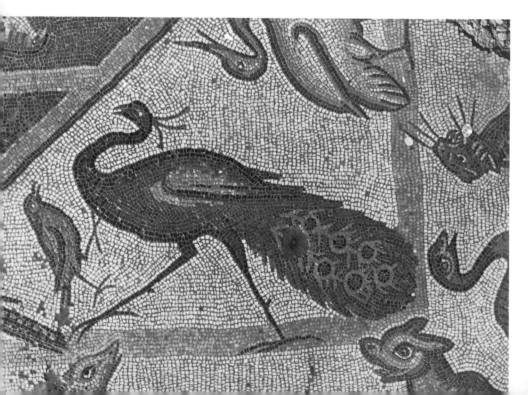

66　Below: a scene of *putti* fishing from boats in a mosaic in the cathedral at Aquileia and the dedicatory inscription

THEODORE·FELI
DIVVANTE·DE·OI
OMNIPOTENTE·ET
POEMNIO CAELITVS·TIR
DITVM·OMNIA
AFATE·FECISTI·ET
GLORIOSE·DEDICAS
TI

ornament, of rectangular panels enclosing some item of church furnishing (e.g., a candle or suspension lamp), with the rest of the composition occupied by a running acanthus scroll from which

64 emerge, like gifts on a Christmas-tree, exotic flowers, free birds,
63, 65 birds in cages, goblets, and even animals like an antelope and a fine cat with foliate hindquarters. This scroll has a plastic quality recalling the colouristic treatment of architectural sculpture characteristic of Syria and eastern Cilicia during the late Roman and early Christian periods.

Another reason for the appearance of animals on church floor mosaics is the scene of the 'Peaceful Kingdom', the fulfilment of Isaiah's oft-misquoted prophecy (Isaiah XI, 6–8) which begins with the words, 'The wolf also shall dwell with the lamb, and the leopard shall lie down with the kid.' At Karlik, north-east of Adana in the Cilician plain, the text is a part of the nave mosaic, and the

right animals are depicted between the lines which run horizontally across the full width of the nave. This was most likely the scheme, too, in the cathedral (probably dating from the fifth century) at Korykos in Cilicia Aspera, for a fragment of Isaiah's text and appropriate animals were found in a limited sounding which penetrated as far as the mosaic floor. A further mosaic with relevant animals, but unsup-

67 ported textually as the Messianic Paradise, was found in 1952 at Ayas, less than two miles from Korykos. Even without secure dating evidence, and relying only on stylistic parallels, a fifth-century date does seem feasible for these 'Peaceful Kingdom' mosaics. Is it fanciful to suggest that an ideal harmony might have been inspired by the Isaurian Emperor Zeno's Henotikon (482), which sought to reconcile Orthodox and Monophysite – especially since Monophysitism was securely entrenched in neighbouring Syria.

Animals were also depicted, apparently at random, on a neutral ground or involved in foliate scroll-work, as at Mopsuestia, or grouped within the branches and tendrils of a vine (e.g. at Dağ Pazarı in Isauria). Nilotic themes were also popular and quite acceptable if there was no suspicion of paganism involved. Indeed, Choricius of Gaza, writing in the sixth century, recommended 'the Nile... with meadows along its banks and all the various species of birds that often wash in the river's streams and dwell in the meadows.' An early example of such a scene in Christian use is the Aquileia mosaic of *putti*

67 Animals were a popular subject in church floor mosaics, probably in allusion to the 'Peaceful Kingdom' of Isaiah's prophecy, as in this mosaic at Ayaş

fishing (ill. 66); but in the Church of the Multiplication at Tabgah in 68 Galilee there is no religious overtone in the carpet-like treatment of herons, geese and other water fowl against a background of papyrus, trees and flowers. In fact the Nilotic scene in the fifth century was used purely as a vehicle for ornament, though Kitzinger believes that the Justinianic period saw a return of discipline, if not of spatial illusionism, and certainly the scene in the church of St John the Baptist at Jerash in Jordan has nothing in common with the Tabgah mosaic. At Tabgah the tower and ramparts at the upper corners are simply two-dimensional ornament, while near the centre of the scene a heron, ridiculously out of scale, perches on the roof of a tiny round building which floats, unanchored, in space. At Jerash, however, the river is the link between the buildings and human beings on its bank and the birds and water plants in its stream below. If realism was not the aim, there was probably a conscious nostalgia for Hellenism, and so it was that order at least was re-established.

77

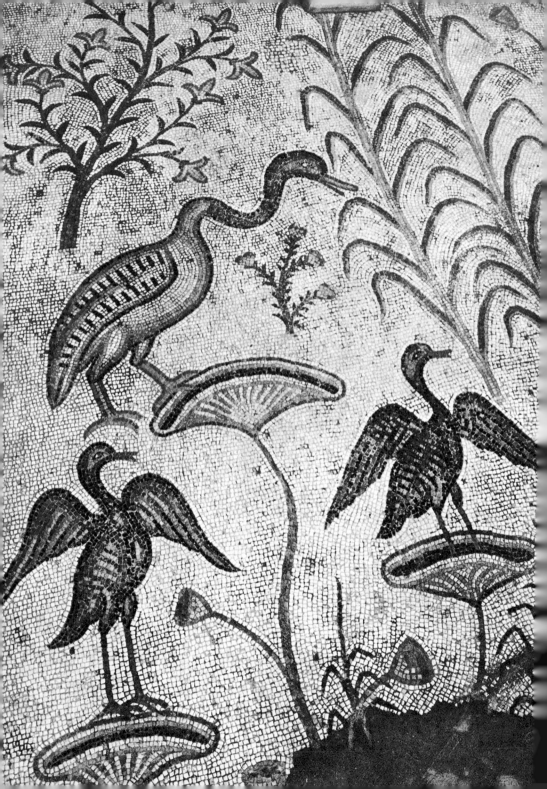

Early Christian floor mosaics are naturally commoner in lands where they had little time to be damaged before their churches were suddenly abandoned, than in countries like Italy for example, where the feet of successive generations of worshippers so wore them down that repairs and renewals were inevitable. The reverse is true in the case of wall mosaics. For while wall mosaic undoubtedly existed in pagan times, its full potential was only realized in the service of the Church, as a consequence of the importance *per se* of the interior in Christian architecture. In a pagan temple, the *cella* constituted a neutral background to the visible presence of the god manifested in a cult-statue; in a church, the unseen Presence could only be emphasized and, in a sense, localized, by wall decoration designed to inspire the faithful by a sort of subliminal process, a process greatly aided by the indirect lighting of most Christian churches. In the basilica, lit by clerestory windows, the interplay of light and shadow varied with the course of the sun, throwing first one wall, then another into prominence. At night, the glimmer of candles and lamps on the curved surfaces of arcade and semidome called for a subtler decoration than painting, which absorbs rather than reflects light. For this purpose mosaic was ideal.

A floor should be smooth and durable, so that even the best mosaic floors should be flat in the literal (if not the metaphorical) sense, as well as made of a tough material like marble, stone or terracotta – with the occasional use of glass *tesserae* reserved for extra brilliance. Such a consideration of durability was less important in the case of wall mosaic, and in a dark interior strong colours with a high potential for reflection were most suitable, so that bright red, blue, green and yellow were usually represented by coloured glass (*smalto*) whose relative fragility was trifling, since it was not subject to wear. Also, since curved wall surfaces did not need to be smooth, individual *tesserae* could be laid at different angles to their backing, and so take full advantage of the light at any given time of the day or night. An artist could even simulate texture, as notably in San Vitale, Ravenna, where the mosaic patterns in the arch soffits have the look of a rich brocade that would yield to the touch. In a background too – especially of gold – the irregular surfaces of the individual *tesserae* catch the light as it shifts, and sparkle like the facets of innumerable gems.

151

68 Nilotic water fowl were often represented, as in this mosaic in the Church of the Multiplication at Tabgah

In pagan times wall mosaic was generally reserved for somewhat specialized use, as in the small niches sheltering fountains at Pompeii or, more unusual still, as the encrustation of the interior curve of a ship's hull like that found at Nemi. As it was also used for certain in some of the large thermal establishments, it has been suggested that mosaic was considered, reasonably, more damp-resistant than ordinary plaster and was thus preferred for surfaces likely to be exposed to water. This does not explain its immediate popularity as church decoration and it is likelier that its rich, glowing quality and suitability for religious art was soon recognized.

Santa Costanza, originally the mausoleum of Constantine's daughter, was built between 320 and 330, and its earliest surviving mosaic decoration is of that date. A central drum, resting on twelve pairs of composite columns and crowned by a cupola, is surrounded and buttressed by a vaulted ambulatory, except where broken by a wide porch with semicircular ends. Opposite the main entrance a niche housed the porphyry sarcophagus of Constantia. Floor and dome mosaics disappeared long ago, but are known still from drawings. Oddly, if it was a Christian building from the first, the decoration of both was blatantly Dionysiac. On the floor was a riot of grape-vines, with Silenus on a donkey attended by a young cup-bearer. In the dome were two rows of sacred scenes, one from the Old Testament and one from the New, and a calendar of saints, but these were combined freely with subjects having no religious connotation – panels with figures of satyrs and maenads, as well as of panthers (the beasts of Dionysus), and in fact Santa Costanza was known to the Renaissance as the *Tempio di Bacco*. In the ambulatory

70, 71 mosaic, the Dionysiac theme is repeated in vintage scenes, with *putti* harvesting and treading grapes. The adjoining panels, whether geometric or of figures and animals in linked roundels, are no more Christian in tone.

So, the inescapable conclusion is that, before the establishment of a Christian funerary iconography, there was a Dionysiac cycle which, *mutatis mutandis*, was thought acceptable for the Church too.

15 The Shepherd Sarcophagus now in the Lateran Museum is further evidence of this, and Constantia's sarcophagus was itself decorated with vines and *putti*. But if paganism could impose its own iconographic convention on a Christian building, it is less surprising that

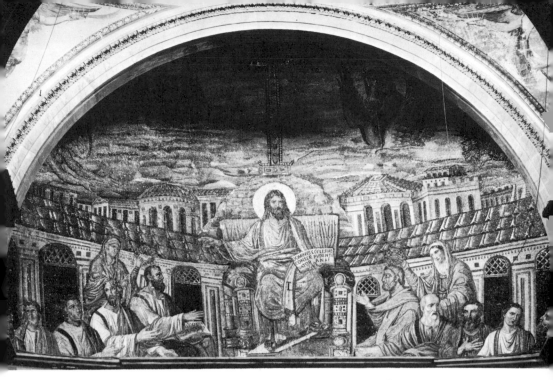

69 Christ enthroned with the Apostles, in the apse mosaic in Santa Pudenziana; in the background is the city of Jerusalem

in time Christianity itself should come up with an answer no less stereotyped.

Christian wall mosaics of the late fourth and of the fifth century are scarce, but enough survive to show that style and subject varied greatly. There was, too, a gradual change in the attitude of artists and patrons from the acceptance of an element of naturalistic realism to a preference for the fantastic and unreal.

At Santa Pudenziana in Rome only the apse mosaic survives, and even this has suffered from enthusiastic restoration. The scene is of Christ enthroned among the Apostles in a great exedra, recognizable as part of the basilica on Golgotha. Jerusalem, as it was at the end of the fourth century when Santa Pudenziana was built, is the background. Yet this factually realistic city of time and space here represents that timeless and eternal Jerusalem which is the 'mother of us all', and is the setting for the allegory of a supernatural event. The style looks back to the so-called 'Fourth Style' of Pompeiian wall

69

70, 71 Overleaf: two details from the mosaics in the ambulatory of Santa Costanza in Rome. The *putti* and bunches of grapes have Dionysiac associations; Christian themes are absent

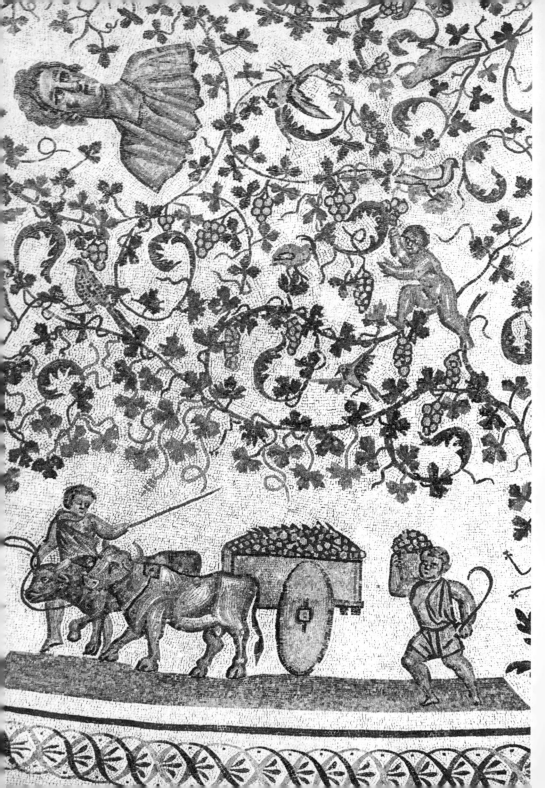

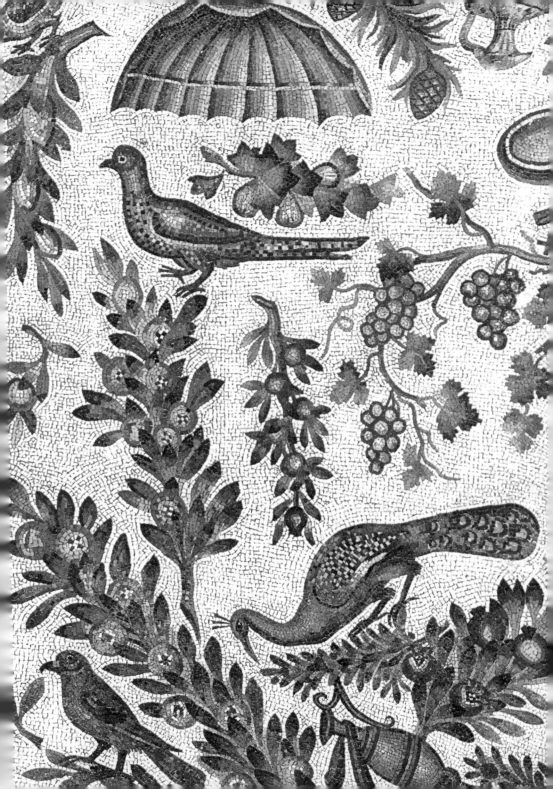

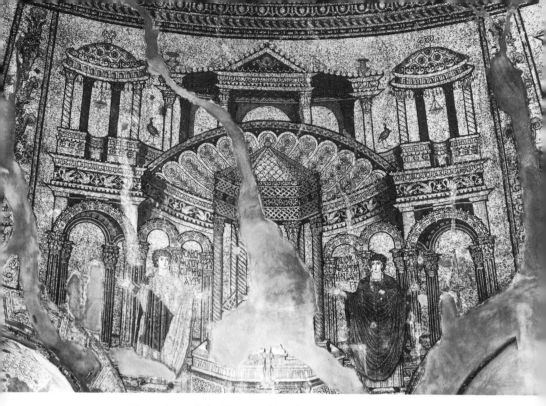

72 Two saints of the Eastern Church, Onesiphorus and Porphyrius, against a background of elaborate architecture in the church of St George at Salonika

painting. St Paul sits to the right of Christ; St Peter to His left. Two veiled women, symbols of the Church of the Gentiles and of the Circumcision, attend the Apostles, to wreathe their heads with a victor's crown. In the sky above, its luminous clouds flecked with red and pink, float the winged symbols of the four Evangelists, dark, brooding and immensely powerful; real and unreal combine to tremendous effect. However, if this Jerusalem is truly an 'architecture-scape' of the Eastern Hellenistic tradition, the background to the cupola mosaic of St George's at Salonika seems, at first glance, to be pure fantasy.

St George's, once probably the Mausoleum of Galerius, became a church at about the same time that Santa Pudenziana was dedicated in Rome. Its mosaics are important, since they perhaps reflect contemporary work at Constantinople, where nothing of comparable

date survives. Certainly the saints of the Eastern Church, depicted as *orantes*, look forward rather to the frontal, 'hieratic' figures of Justinianic art (e.g., the mosaic of the patron in the apse of Sant'Apollinare in Classe) than back to Hellenistic naturalism of the kind represented in Santa Pudenziana. Fascinating too is an architectural background of such airy lightness that it actually emphasizes the physical substance of the saints. E. Rosenbaum Alföldi, on the evidence of some Cilician tombs which were decorated externally with mosaic, has supposed that the buildings represented in the architecture-scape of St George's are less fantastic than might at first appear. Even so, it was surely the artist's intention to induce an atmosphere of spirituality in which the buildings had their own part to play. Symmetry is absolute, even to the birds perched in the roofs of the buildings and to the otherwise very realistic curtains, knotted and secured to an upright, as so often they are still in south-eastern Europe. Gold, both as a surface for architecture and the background space beyond it, heightens the sense of unreality, and so of mystery.

San Lorenzo in Milan was probably built no later than 390, a little before Santa Pudenziana or St George's, but the earliest surviving mosaic, in the apse of the chapel of Sant'Aquilino, is probably of the mid-fifth century, since the swing away from naturalism seems here

73

73 Realism is abandoned in the gold background of this mosaic of Christ and the Apostles, in San Lorenzo in Milan

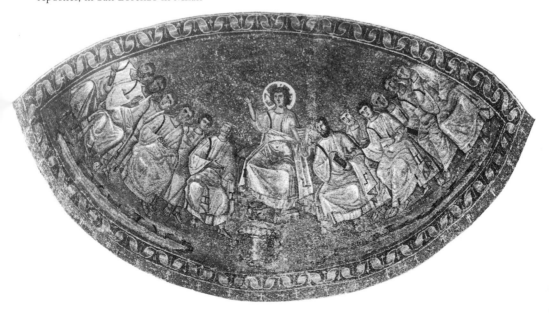

more pronounced. The composition represents an enthroned Christ flanked by the Apostles; but here realism stops short, for the figures appear to exist in a vacuum, their preoccupied outward gaze precluding mutual contact. Nor does a natural background induce any illusion of plane or occasion. Instead, the world of the senses is shut out by a background of impenetrable gold. It had early been appreciated that the sky, as a symbol of the infinite, was a most effective field for Christian mosaic composition, and blue was used to suggest the depths of the firmament in the mid-fifth century Mausoleum of Galla Placidia in Ravenna. A century later, however, blue had given way to gold as the last vestiges of realism were abandoned.

The mosaics in the nave and on the triumphal arch of Santa Maria Maggiore in Rome are most important. In the nave, between the windows of the clerestory over the Ionic colonnades, are small rectangular panels, each with a scene from the Old Testament. Such a scheme was common enough in later centuries, and probably in earlier ones too if the paintings in the Dura baptistery be admitted as evidence. The cycle in Santa Maria Maggiore is, however, the earliest one in mosaic to survive. On the triumphal arch the episodes illustrating the infancy of Christ lay a special emphasis on the role of the Virgin. The composition, arranged in the Roman manner as a continuous narrative, had a dogmatic purpose, to emphasize the victory of Orthodoxy at the Council of Ephesus in 431. This Council had been called to debate the claim of Nestorius, patriarch of Constantinople, that the Virgin Mary, though Mother of Christ according to His human nature, could not rightly be named 'Mother of God' according to His divine nature. Since such a dogma involved a division in the unity of Christ's person, Nestorianism was condemned and the Virgin's title 'Mother of God' solemnly affirmed. The mosaics on the triumphal arch of Santa Maria Maggiore, commissioned by Pope Sixtus III, whose pontificate began only the year after Ephesus, were designed to celebrate the Orthodox triumph, and so their iconography is somewhat unusual. The Virgin of the Annunciation, for example, does not so much recall the simple 'handmaid of the Lord' as the Queen of Heaven, attired as such and attended by a host of angels. In many of these scenes the influence is from Roman imperial iconography, with the Virgin taking on the role of Augusta. The Presentation too is less the intimate family

74

74 The Virgin in this Annunciation mosaic in Santa Maria Maggiore is seen humbly spinning wool, but she is robed as a Byzantine empress and attended by angels and the Holy Spirit in the form of a dove ►

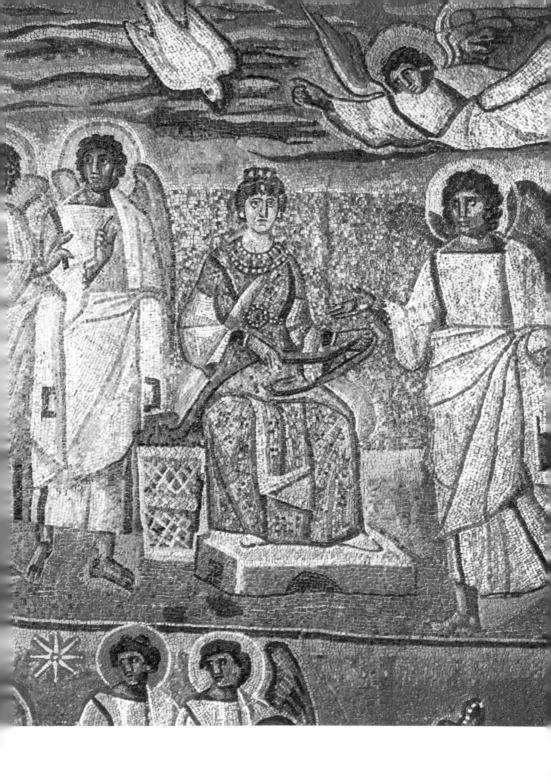

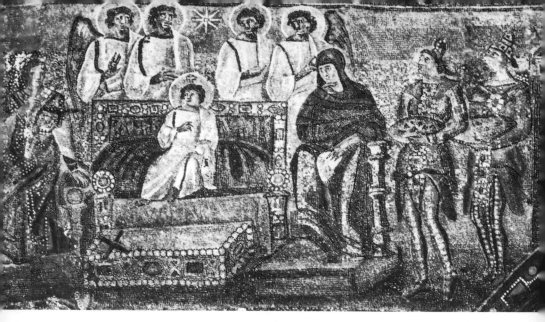

75 Another portion of the same mosaic (ill. 74), depicting the Adoration of the Magi ; Christ is shown seated on an imperial throne rather than on his mother's knee

gathering than the formal ceremony in which the setting of the scene had to be as impressive as the figures taking part, so that here the background is actually a Hellenistic temple, including even the statue of a goddess in the centre of the pediment. Also, the Infant to whom the Magi paid homage in a stable is here depicted as a Porphyrogenitus, lying on a divan and surrounded by courtiers. So strong in fact was the Eastern Hellenistic tradition that even Herod is not denied his halo, the prerogative of kingship. Gold was lavishly used as a background, much more than for the less pretentious Old Testament panels in the nave.

Of the forty-two nave panels illustrating events in the lives of Abraham, Jacob, Moses and Joshua, twenty-seven survive intact, while the Vatican Library contains copies of some of the rest. The continuity of the narrative and the frequent horizontal division of a panel into two separate registers suggests that the model for these mosaics may have been an illustrated roll (*rotulus*), later organized to suit the pages of a bound book (*codex*). In so long a series some scenes inevitably prefigured events in the New Testament or had some other Christian significance; but the lesson is sometimes so

pointed that its didactic aim is obvious. Abraham's meeting with 76
Melchizedek, who advances to meet the patriarch with a basket of
loaves, prefigures the Eucharist, and to underline this there is a goblet
of wine at the high-priest's feet and a bearded, Christ-like figure in
the sky above. Lot's parting from Abraham is also very solemn, for
this parting symbolized the choice between good and evil. The
presence of Isaac, who was not even born until long afterwards, is a
reminder of his impending sacrifice, and so of Christ's Passion. The
stoning of Moses, Caleb and Joshua by the Israelites prefigures
Christ's rejection by His people, and the fine Exodus scene is a 77
familiar reminder of deliverance. As in the much earlier rendering in

76 The Eucharist is prefigured in this meeting of Abraham with Melchisedek; the
point is made by the bread and wine, and the figure of Christ seen in the heavens

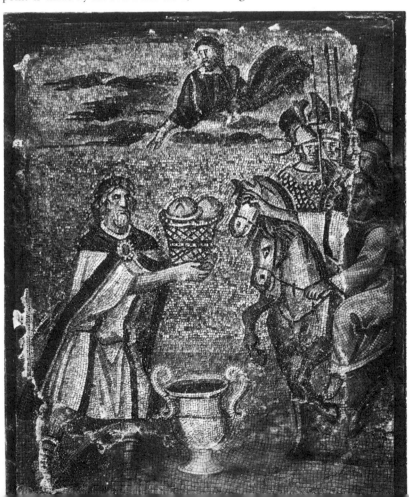

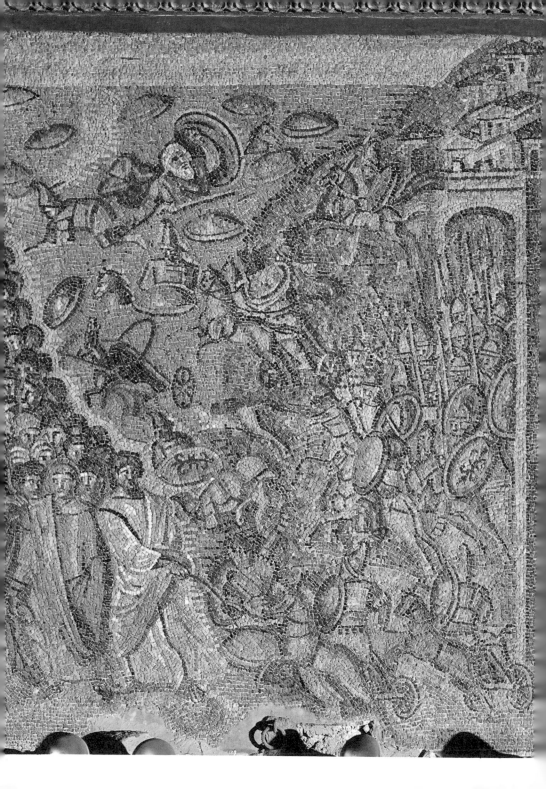

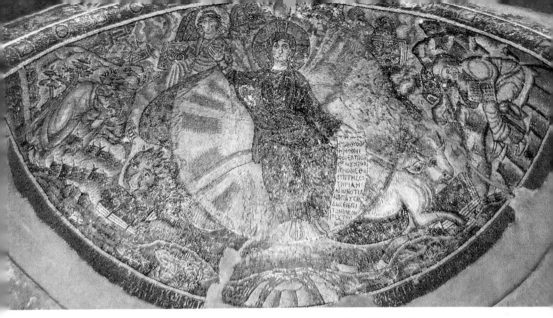

78 A youthful Christ, seated on a rainbow within a mandorla, with Ezekiel and Habakkuk, and the four symbols of the Evangelists; a mosaic from St David's in Salonika

the synagogue at Dura, one of the men holds a child by the hand so that the viewer may recall the solemn charge laid upon the Jews to observe the Passover in Exodus, XIII, 8; 'And thou shalt shew thy son in that day, saying, This is done because of that which the Lord did unto me when I came forth out of Egypt.' These nave mosaics are indeed a *tour de force*, and though the natural background is made unreal by the use of a gold margin or dividing line, and though the *tesserae* are rather big relative to the small scale of the panels, the scenes are still lively and full of movement.

Nearly fifty years separate the mosaics of Santa Pudenziana and Santa Maria Maggiore; but the same Hellenistic realism is basic to both. This is not because realism is appropriate to the iconography but rather because the models followed by Roman mosaicists of the first half of the fifth century (i.e. Imperial Roman works) included representations of nature. The counter-current from Constantinople in the mosaics of St George's in Salonika or of San Lorenzo in Milan shows greater prominence given to the transcendental, rather than to the physical aspect of Christ and His saints. So too in the little fifth-century church of St David in Salonika, the apse composition is of an 78

91

unbearded Christ seated on a rainbow and circled by a mandorla from which issue the four winged creatures of Ezekiel's vision. Shading his eyes from their brightness, the prophet kneels at Christ's right hand, while on His left is seated Habakkuk. A fantastic landscape of rocks and trees forms the background through which, at Christ's feet, flow the four rivers of Paradise. First cleaned in 1920 and never since restored, this mosaic is very well preserved. Considering the supernatural character of the scene depicted, there is a degree of realism in the figures, and even in the background, that is missing in the dome mosaic of St George's in the same city. St David's thus is a landmark, a compromise at it were between the Late Antique and true Byzantine art. There is no background colour, for the available space is entirely filled by the composition, and gold is only sparingly used, chiefly on Christ's robe and halo. The medieval story of a miracle which transformed an image of the Virgin into the Christ we see today may be traced to an insufficient contrast in the colours of the hair and robe of the central figure, and these combine to look much like the *maphorion* (veil) worn by the Virgin. That Christ is beardless would by itself be unlikely to have started the legend.

During the barbarian migrations of the fifth century, Ravenna was one of the capitals, along with Rome and Milan, of the emperors of the West; but when, after 476, Italy was in thrall to the Vandals, it was chosen as his residence by their chief, Odovacer. Within seventeen years, Theodoric the Ostrogoth had overthrown Odovacer, and thereafter ruled Italy as its king from Ravenna until 526, when the city was won back for the empire by Justinian's general Belisarius. Thus for over a century Ravenna was a capital city, during which what had originally been a simple naval base was gradually transformed by the generosity of its patrons, Orthodox and Arian alike, into a treasure-house of early Christian art. From this period of brilliant achievement the earliest mosaics, in the Mausoleum of Galla Placidia and the Baptistery of the Orthodox, date to the mid-fifth century, before the city's fall to Odovacer. Then came Theodoric, who, it is important to remember, had spent ten years at Constantinople. Towards the beginning of his long reign at Ravenna, in about 500, the new basilica dedicated to Christ the Saviour (now Sant'Apollinare Nuovo) was adorned with mosaic panels depicting the Life and Passion of Christ. These panels, which are above window

level, the figures between the windows, and the western end of the friezes below them, are of the same period. Theodoric also built the Baptistery of the Arians for his Germanic co-religionists. The third, and perhaps the greatest Ravennate era was that of Justinian, when San Vitale and Sant'Apollinare in Classe were dedicated and the later mosaics in Sant'Apollinare completed.

The Mausoleum of Galla Placidia, daughter of Theodosius I and *79* mother of Valentinian III, is a small cruciform building with interior barrel-vaults and a dome at their junction. The blue background is wonderfully effective in the dome, where it sets off a central cross *80* with the beasts of Ezekiel's vision at the four quarters. The north-south transepts are decorated with acanthus scrolls, and their lunettes with two deer facing each other across a brook, for 'As the hart panteth after the water brooks, so panteth my soul after thee, O God' (Psalms XLII, 1). The two familiar mosaics, however, are in the lunettes on the main axis, with St Laurence's martyrdom at the east end and the Shepherd, incidentally the last example in early Christian art, in the west. The scene of the Shepherd and His flock is in the Hellenistic tradition, with Shepherd, sheep and background all portrayed with some realism. Yet it is a mannered realism, and nature takes second place to religious significance. The sheep are posed round the central figure in almost perfect symmetry, while the Shepherd fondles one of the flock against a setting intended to be pastoral, but actually more in the vein of cultivated rusticity. The inspiration of such work is hard to trace, though a sophisticated city of the Eastern Mediterranean is likely.

79 Plan of the Mausoleum of Galla Placidia at Ravenna; this small cruciform building may have been a *martyrium* of St Laurence, who is the subject of one of its most interesting mosaics

30'0"

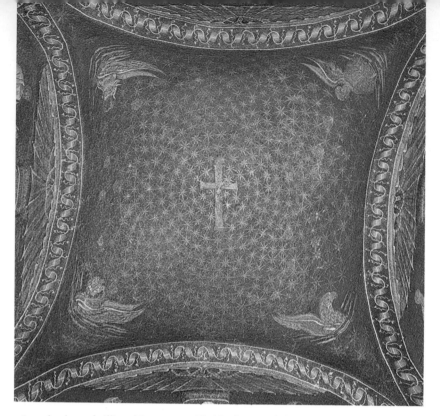

80 Against a brilliant blue star-studded background the central cross is balanced at the four corners by the beasts of Ezekiel's vision in the dome of the Mausoleum of Galla Placidia

82 More impressive still is the Baptistery of the Orthodox. A domed octagon with a concentric font, the decoration of the building is wholly aimed at emphasizing the importance of baptism and leading the viewer's eye to the centre of the dome, where Christ's baptism in *81* the Jordan is depicted. Stylistically, these mosaics, like those in the Mausoleum of Galla Placidia, are rooted in Hellenistic tradition; human figures have an essentially plastic quality, while the personification of the Jordan bathing in his own stream is entirely classical. Below the centre-piece is a continuous band of the Apostles, led by Peter and Paul, advancing with martyrs' crowns in hand towards the unseen presence of Christ. Of course they signify spiritual re-birth (in martyrdom), but are also important to the composition, as they articulate the interior of the dome into equal segments, the apex of

81 The scene of Christ's baptism in the Jordan is shown at the centre of the dome of the Baptistery of the Orthodox; radiating from it are the Apostles bearing martyrs'
crowns ▶

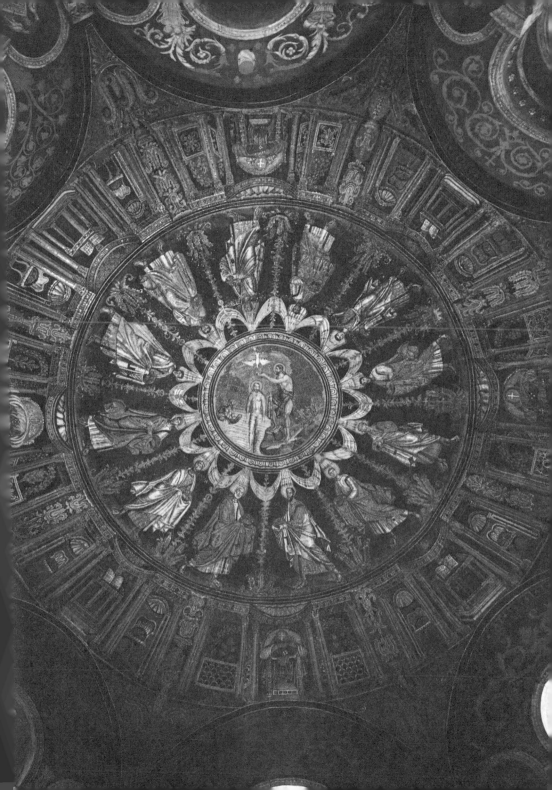

each pointing towards and so stressing the central scene. The lowest zone of eight architectural compositions in mosaic, each centred exactly over a wall of the octagon, have the same aim, for their absolute symmetry, both internal and in relation to one another, again draws attention to the centre of the dome, while linking it with the lower, octagonal part of the building. The architectural units of the lower zone are of two distinct and alternating types. In the one, a columnar *exedra* (apse) is flanked by porticoes, in both of which is a chair with embroidered cushions, while in the *exedra* itself is an altar with an open Gospel book on it. In the other type, there is a richly draped throne below a baldaquin, a vacant throne, for it symbolizes the preparation for the Second Coming of Christ (*Hetoimasia*). The side porticoes, fenced with decorative slabs, are here treated like little walled gardens. This bald description does scant justice to the imaginative treatment of the composition, and none to the rich colour scheme. In the mid-fifth century Ravenna was in full communication with Constantinople, and this contact is reflected in the elegance and courtly bearing of the Apostles, as well perhaps in the blend of two apparently conflicting stylistic canons. With Hellenistic realism the saints' drapery swings freely with their movement, yet their feet seem to have lost contact with the ground, this in a far-off echo of the Sacrifice of Conon at Dura Europos. The spikes of acanthus foliage which separate individual figures are purely ornamental, with no likeness to real vegetation.

Theodoric had probably been 'king' of the Italians for a decade or so when he commissioned his Arian Baptistery. The mosaic decoration was in conscious imitation of the Orthodox building, for again the Baptism of Christ occupied the roundel at the crown of the dome, with a lower zone of Apostles carrying martyrs' crowns; but, as there is no third decorative band, the throne of the *Hetoimasia* is made the focal point of the second, approached from either side by St Peter and St Paul, the one with a bunch of keys and the other with a scroll (the New Law). With these small differences, almost identical subjects were chosen for the Baptisteries, and the real contrast is stylistic.

Judged by the high standard of the earlier building, Theodoric's mosaics are remarkably pedestrian, and the impact of the central scene is dulled by its symmetrical arrangement and its over-emphasis

82 The interior of the Baptistery of the Orthodox at Ravenna, remarkable as a total architectural composition, and for the wealth of its mosaic and stucco decoration ▶

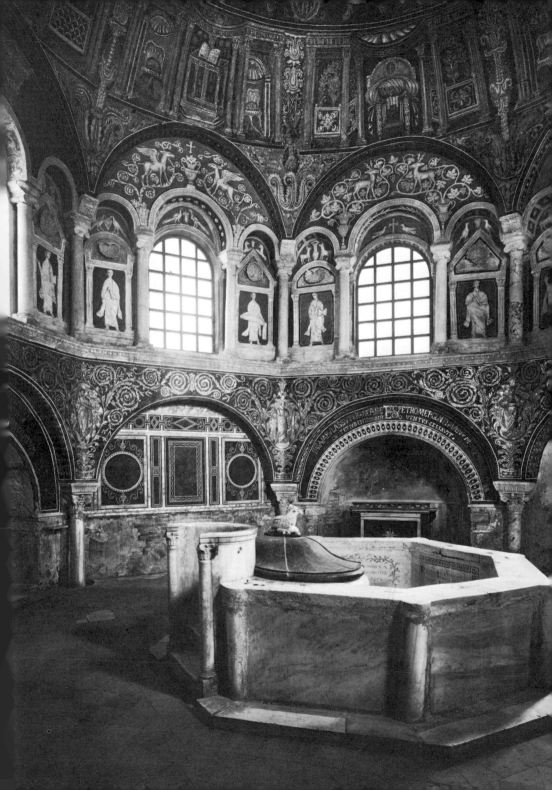

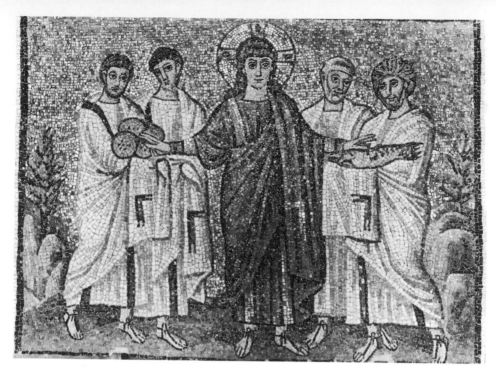

83 A simple but expressive scene executed under Theodoric: the Multiplication of the Loaves and Fishes, from Sant'Apollinare Nuovo, Ravenna

on the Jordan, here depicted as a life-size river-god. While, too, the Apostles in the Orthodox Baptistery are all swirling movement and elegance, those in the Arian building are stolid by contrast, their drapery heavy and without elasticity; their very crowns have a look of uncomfortable solidity. As a result, these mosaics have often been misprized for failing to achieve what the craftsmen never intended; rather it was their misfortune to be saddled with a decorative scheme unsuited to their style. For when they, or contemporaries of the same school, worked on the New Testament scenes in Sant'Apollinare Nuovo, this style proved most suitable for a simple narrative designed to make a psychological impact on the viewer. The south wall of this basilica is devoted to Christ's public life and particularly to His miracles, though a place is also found for the Last Judgment and for the famous parable of the Pharisee and the Publican. On the north wall are scenes illustrating the Passion and Crucifixion. In all the

98

panels the story is graphically told with as little distracting detail as possible. Thus four Apostles grouped round a Christ Who stretches out His hands to touch the loaves and fish represent the story of the Multiplication, and other scenes are just as uncrowded, simple and *83* convincing. By an artificial, but intelligible convention, the Christ of the Passion is sombre and bearded, but in scenes of his public life is depicted as the unbearded youth who appears so often on early frieze sarcophagi.

The last phase of mosaic at Ravenna, the reign of Justinian, is reserved for the next chapter.

PAINTING

Little now survives of fourth- and fifth-century Christian painting, little of much significance anyway. The reason is fairly obvious. Where churches were in continuous use, the wall plaster might crack or otherwise deteriorate and any painting with it. Where buildings fell into ruin, the elements took their toll.

After 313 the Roman Catacombs were less used, but post-Constantinian paintings in them show that different artistic canons could be observed side by side in the capital. In the Coemeterium Maius a starkly severe Virgin and Child in a frontal pose is reminiscent of paintings at Dura; in the Catacomb of Vigna Massimo, however, the *orans* is a plump lady with necklace, ear-rings and bangles, and though frontal, the harshness is entirely absent. Yet it is clear that both were heir to the same East Hellenistic tradition; it is a surprise that the ladies are near contemporaries. Their coiffure (worn short with a fringe) is all but identical.

The cycle of paintings in the synagogue and Christian house at Dura owe their preservation to being artificially buried under a glacis. In the dry North African climate, however, wall-paintings buried by the desert sand stood a fair chance of survival, and at Bawit in Upper Egypt and Saqqara in Lower Egypt many small funerary chapels have been recorded with decoration relatively intact. Most are of the sixth century or later, their art based on a Syrian and so, in the last resort, Byzantine tradition. This is what makes the paintings in the funerary chapel of El Bagawat in the Kharga Oasis *84* especially important, for the style is virtually unique for the fifth century to which they belong. The scene of the Exodus, from which

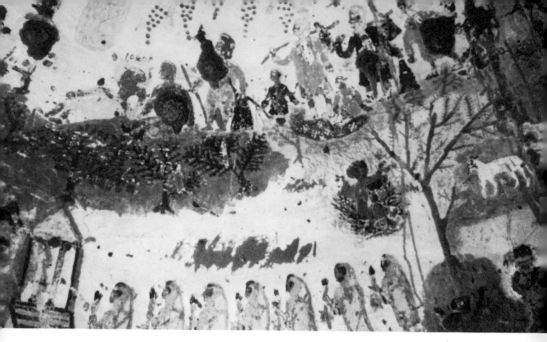

84 The seven wise virgins, detail of a painting from the funerary chapel of the Exodus, at El Bagawat in Egypt; naive, but appealing

the chapel derives its name, is full of naive charm. A long, straggling line of Israelites, mounted and on foot, is in the van; behind them is the Egyptian host, and the scene so leisurely that only the words 'Red Sea' written over the foremost of the Egyptians give a clue to the subject. As well as the Exodus there are other Biblical scenes, apparently randomly chosen and in no logical sequence, though most illustrate deliverance in the familiar way. One subject is of the seven Wise Virgins, who are represented like penguins in single file with lamps in their hands. No one source inspired the painter of this chapel; nor was he even an artist; but his childlike enthusiasm fully compensates for that.

85 Illustrated manuscripts of the early Christian period are rare, and are, a little surprisingly, of pagan authors. One of the earliest is the so-called Vatican Virgil, a work of the late fourth century. The painter was no genius, but his style is recognizable as of a type often to be found in the Catacombs. He certainly had a good eye for drama, and his painting of Laocoon's death is only less horrific than the first century BC sculptural group in the Vatican Museum which

Pliny characteristically called upon his contemporaries to approve as marking an artistic renaissance.

Justly famous too is the illustration of Dido's death on the pyre, a scene which is not without a certain dignity as well as pathos. It may be noted that the walls of the room in which a group of mourners surrounds the dying queen seem to have been decorated with a painted simulation of marble, as were the walls of so many of the less opulent church buildings of the fifth century.

85

85 The death of Dido, from the Codex Vergilius Vaticanus; the few illustrated manuscripts of this period (late fourth century) are of pagan authors

Very little sculpture in the round has survived from the early Church, and it has been conjectured, without any compelling reason, that it was thought to be included in the prohibition of graven images. At Rome it had long been customary to honour the imperial family and prominent citizens with portrait statues, and in Constantinople the practice continued. As Christianity gained ground, however, the character of portrait sculpture altered in conformity with a new concept of imperial power relative to the supreme authority of God. Thus there is a marked stylistic contrast between portraits of Constantine I and of members of the Theodosian dynasty.

47 The colossal head of Constantine now in the Museo dei Conservatori in Rome illustrates the survival of the Roman gift for portraiture in an era when stylization of individual features was in vogue. Also, since there is no smooth transition from the full to the profile view, the face makes an immediate impact of uncompromising sternness. Another colossal bronze portrait head of Constantine in Rome is softer, but conceived in the same stylized way; the head has been identified by some as that of Constantius II, but the features are unlike those on his coinage and seem closer to his father's. In point of detail, the treatment of eyebrows as arched ridges scored with diagonal lines is almost the same in each case.

If sculpture in the round is rare, relief sculpture on sarcophagi now becomes extremely plentiful and widespread. Fairly early in the fourth century the 'frieze' sarcophagus, with both lid and box carved in high relief, was popular in Rome and southern Italy. The choice of subjects still emphasized deliverance, baptism and the Eucharist, but scenes from Christ's life and ministry increased, and even scenes from the Passion (outside the Crucifixion) were permissible. The standard of artistry is rarely distinguished and often barely competent, but the crowded unpunctuated scenes have a vitality that makes them memorable.

86 The sarcophagus of Claudianus in Rome is a good type-specimen. Just below the epitaph in the centre of the lid is a female *orans* symbolizing the dead man's soul, while a bust of Claudianus is introduced into the Bacchic vintage scene on the right of the lid. The rest of the decoration is drawn from Christian literary sources, most of it canonical (e.g., the better known miracles), but also apocryphal

86 'Frieze' sarcophagi became popular early in the fourth century; this sarcophagus of Claudianus is crowned with scenes from the life of Christ. A female *orans* represents the dead man's soul

such as the baptism of the centurion Cornelius in water struck from a rock by a composite Moses/Peter figure. Another arrangement of episodes in the lower frieze would have made for better balance, for as it is, Christ appears but once to the left of the *orans*, and no less than four times to her right. The sarcophagus of Adelphia in Syracuse is even more crowded, and again there seems little didactic purpose in the random arrangement, and in the lower register of the box a potentially good contrast between the Adoration of the Magi and the refusal of the three youths to worship the idol set up by Nebuchadnezzar is weakened by the insertion between the scenes of the Miracle at Cana. The treatment of drapery recalls the *allocutio* relief on Constantine's Arch.

87

88

87, 88 Right: the sarcophagus of Adelphia in Syracuse; in the centre, portraits of Adelphia and her husband; on either side, scenes from the Old and New Testaments. The style recalls that of the relief on Constantine's Arch (below) showing the Roman people listening to a speech by the Emperor

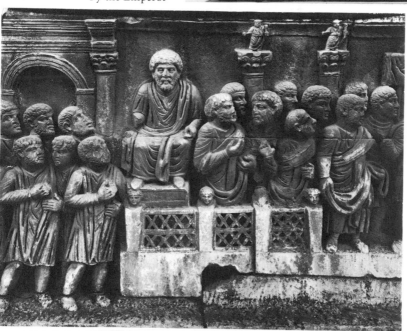

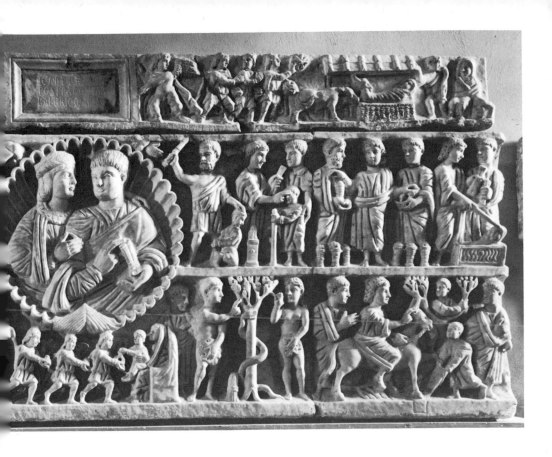

Another sarcophagus type became popular in the later fourth century. Here single figures and episodes are no longer part of a continuous frieze, but separated from each other by colonnettes. The source of the group is Asia Minor, where niched-columnar sarcophagi of the so-called Sidamara type were in pagan use, as attested by fine examples in the Museums of Istanbul and Konya. A fourth-century fragment (now in Berlin) which portrays Christ in a central niche and flanked by Apostles betrays no break in tradition. In Christian use, however, the type is commonest in Italy and southern Gaul (where the colonnettes are sometimes replaced by trees). Southern Gaul's ties with Asia Minor were of long standing, and many of the sarcophagi were doubtless imports, as were those found at Rome.

89

89, 90 Above: Christ between two Apostles, on a sarcophagus of the Sidamara type; here the figures are separated by colonnettes. Opposite: Corinthian columns divide the niches containing finely sculptured didactic scenes on the sarcophagus of Junius Bassus

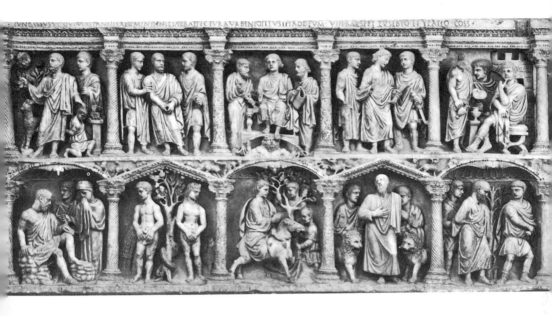

The symmetrical division of such sarcophagi into small zones made for more orderly presentation of subjects, and so for an easier emphasis on a specific article of faith. The elaborate sarcophagus of Junius Bassus in Rome well illustrates this point. The casket of this *praefectus urbi*, who died as a baptized Christian in 359, is divided into ten niches by two registers of Corinthian columns, of which the upper supports a flat architrave; the lower niches are alternately arched and gabled. The choice of subjects in the upper register betrays a didactic purpose. The central scene represents the *traditio legis*, the delegation by Christ Cosmocrator of supreme authority in the Church to St Peter and St Paul. Left and right of this, and to illustrate the trials which face Christians, are tableaux of the separate arrests of Christ and St Peter, while the two outer niches with the Sacrifice of Isaac and Pilate's Pretorium depict the suffering of Christ to assure victory over sin and death. The sculptural quality is, of course, higher than was normal just after the Peace of the Church; by 359 technical improvements were under way, improvements that culminated in the Theodosian renaissance. In any case, Junius Bassus was a man of high social standing. Simpler, yet moving, is

90

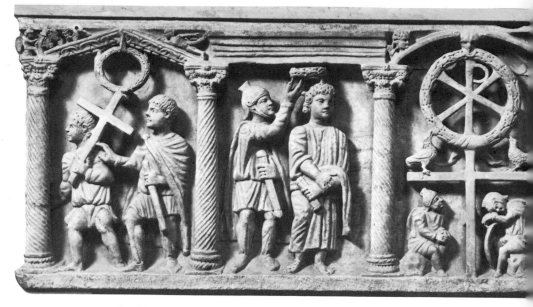

91 On this sarcophagus at Rome, Christ's triumph over death is symbolized by the wreaths of victory hanging over three of the scenes from the Passion

91 another sarcophagus in Rome, which stresses Christ's triumph over death even more impressively. On the right, the unhappy embarrassment of Pilate as he washes his hands contrasts strongly with the commanding presence of his Prisoner; to the left are the Crowning with Thorns and Simon of Cyrene carrying the Cross. Over two niches hangs a victor's garland, and the intended mockery of a crown of plaited thorns turns ironically against the scoffers who fail to see in Christ a true king. The triumphant message of the Resurrection is symbolized in the centre niche by a wreathed Chi-Rho soaring over the Cross, beneath which two soldiers idle the time away, unaware of the coming dawn and the emptiness of the tomb they guard.

 The so-called 'city gate' sarcophagus, in which the Biblical episodes have a continuous architectural background, are roughly contemporary with the works just described. Indeed the 'city gate' style is actually used on an otherwise orthodox niched columnar sarcopha- *92* gus in Rome. The front of the box is divided into seven niches by eight very ornate Corinthian columns, but on the short sides there is

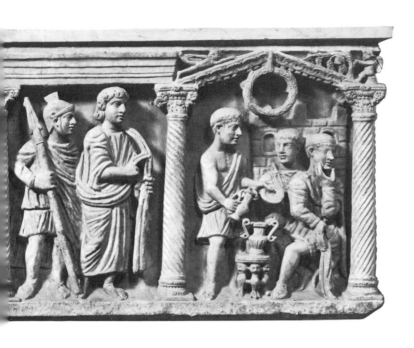

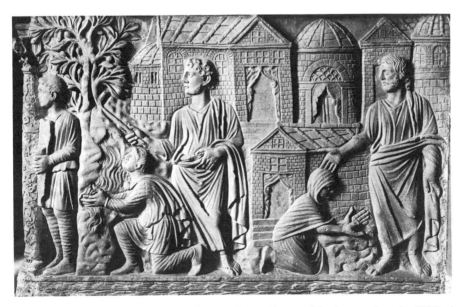

92 A sarcophagus of the 'city gate' type; the architectural background to the Biblical scenes is of particular interest

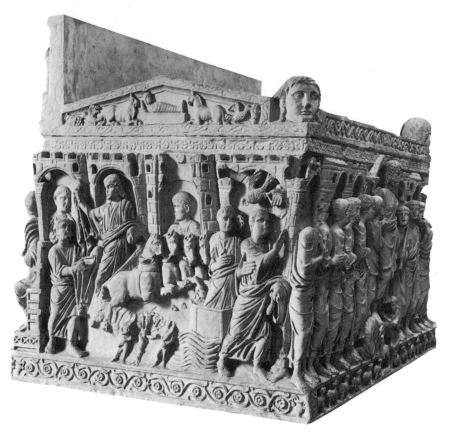

93, 94 Another 'city gate' sarcophagus, whose crowded scenes include Christ the

a 'city gate' background of considerable architectural interest, for in
it we may recognize typical fourth-century basilical churches and
centralized buildings, probably baptisteries and *martyria*. Since the
martyrium in association with a basilical hall is a known feature of
Levantine church architecture (as too was the piercing of the apse
wall with windows), it is surely likely that the ultimate inspiration of
the 'city gate' sarcophagus was East Hellenistic.

 Much more elaborate is the sarcophagus in the church of Sant'Am-
brogio in Milan, Theodosian in date, but untouched by the develop-
ments about to be described. Here the background on all four sides of

93, 94

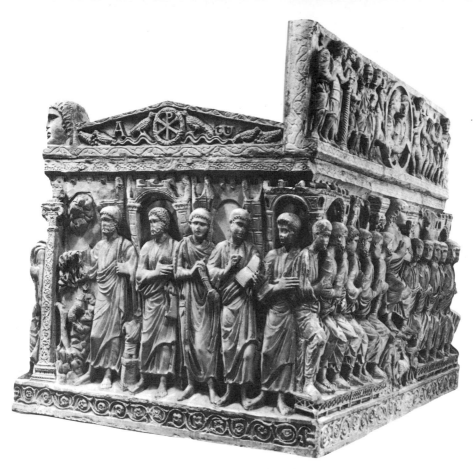

Teacher, Moses, the Ascent of Elijah and the Sacrifice of Isaac

the box is a fantasia of crenellated arcades without identifiable build-
ings. On the front is a *traditio legis*, featuring a seated, beardless
Christ; on the back it is a bearded Christ who stands among His
Apostles and instructs them. These two compositions are unified and
orderly in composition, but the medley of scenes at the ends is
confusing and somehow archaic, even if not intentionally so. On the
right is a genre scene of Christ the Teacher (?) and the Sacrifice of
Isaac: on the left are Moses on Sinai, Noah in the Ark, the Ascent of
Elijah and (again) Christ the Teacher. Jammed below the horses of
Elijah's chariot, as if an afterthought, is a diminutive scene of the Fall.

95 Theodosius I and his family are seen at the chariot races on this obelisk base at Constantinople. The sculptures, though much weathered, are vivid and characteristic of the Theodosian artistic renaissance

Within fifty years of Constantine's death, changing conditions and changing tastes under Theodosius I led sculptors to infuse the ideal of the 'Lord's Anointed' into imperial portraiture by endowing the subject with a timeless tranquillity.

A good general guide to Theodosian sculpture is the rectangular base set up about 390 on the spina of the Hippodrome in Constantinople to support an Egyptian obelisk from Karnak. On two sides are reliefs depicting the month-long struggle to erect the obelisk, while the others show Theodosius and his family at the chariot races. In the centre of the north-west side is the imperial box, in which are seated the emperor, his sons, Arcadius and Honorius, and his nephew Valentinian II. To right and left of the group are notable citizens and palace guards, while below are kneeling Persian and Dacian envoys carrying tribute. A similar imperial group, but depicted standing on this occasion, occupies the centre of the south-eastern relief. Theodosius holds a wreath to present to the winner of the race, while below are crowds of spectators with the dancers and musicians who entertained them. 95

Although much weathered after nearly sixteen centuries in the open air, the style of the reliefs is so original as to be relatively easy to evaluate. Frontality is even more marked than in the *allocutio* scene on the Arch of Constantine, not out of incompetence but of deliberate choice, for the dancers on the south-east side are full of vigorous movement. Again, there is such emphasis on the head and features, as expressive of inner, spiritual life, that the body seems an almost insignificant adjunct, to which concept the schematic treatment of drapery contributes also. Since the Hippodrome reliefs are so worn, a silver dish (*missorium*) made in 388 for the emperor's *decennalia* provides further valuable evidence for the Theodosian style. In front of an imposing architectural façade, the emperor is seated between Arcadius and Valentinian II, the two latter on lesser thrones. Below, in the exergue, reclines *Tellus Mater* (Mother Earth). The imperial scene records a real event – the presentation of a diploma – but it is also an allegory of the emperor's supreme earthly power as God's representative, even to the halo about his head. The frontality of the main figures, the economy of drapery folds and the emphasis on heads, especially Theodosius', all recall the Hippodrome reliefs; also the relatively good state of the Madrid *missorium* discloses a new 88 96

element of untroubled youthfulness in imperial portraiture. Other
works confirm this to have been indeed a new artistic convention.

97 One is a statue of Valentinian II from Aphrodisias, another a marble
98 head of Arcadius found in Istanbul. The latter is of slightly better
quality, but the treatment of the heads is very alike, designed to
evoke an idea of ideal youth, untouched by worldly cares, while the
refined features, the unclouded brow and thoughtful expression
enhanced by a slight upward glance combine to suggest sensitivity
informed by a *mens conscia recti*. Without doubt portraits, they still
represent too the poignant transience of youth and temporal author-
ity. The head of Valentinian II (?) in Toronto, though less well

96 Opposite: a *missorium* or silver dish representing Theodosius with his son and nephew; as in the obelisk reliefs, the frontal postures convey a sense of dignity and power, as does the emperor's halo

97, 98 The youthful sensitivity of the features is somewhat idealized in these sculptures of Theodosius' nephew, the Emperor Valentinian II (left) and son, Arcadius (below)

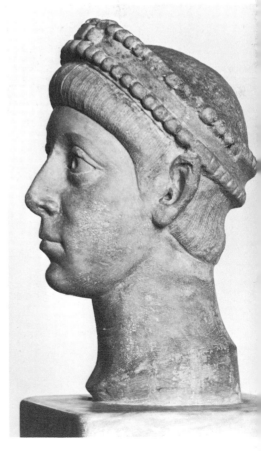

99 A crowned head,
which may be that of
Theodora, the consort
of Justinian

99 executed, is in the same genre. The head of an empress with a diadem of pearls has been thought by some to be that of Theodora, Justinian's consort; but neither style nor appearance support this view, and a late-fourth-century date is more feasible.

 Contemporary portraiture depicts Theodosius and his family as supporting the responsibilities of the highest office with youthful calm, but the faces of his officers are made to express age, responsibility and wisdom. The key to this related branch of Theodosian art may again be found in the Hippodrome base, where the rather coarse features of the bearded elders on the north-west relief contrast strongly with the idealized treatment of the emperor's and his family's. The portrait statue of a magistrate from Aphrodisias belongs to the same convention. Wearing a chlamys, which hangs in clumsy, unlikely folds, he holds the baton of office in his right hand; but the emphasis (as always in Theodosian sculpture) is on the head with its arrestingly troubled features. The brow is deeply furrowed, the eyes puffed and weary, and two deep lines score the cheeks from the nose to the corners of the mouth. Almost distressing in its realism, this work is probably almost contemporary with the idealized head of Arcadius described above.

100

98

116

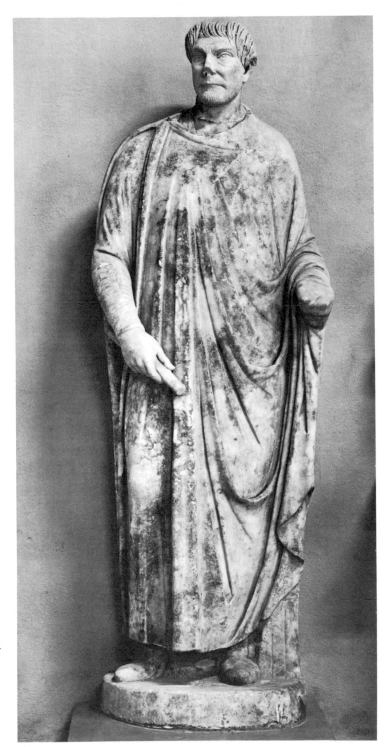

100 The statue
of a magistrate
from Aphrodisias.
Though the folds
of his garments are
unconvincing,
there is realism in
the troubled
expression of
the face

101 The Sarı Güzel sarcophagus of Istanbul; two graceful angels bear aloft a Chi-Rho symbol

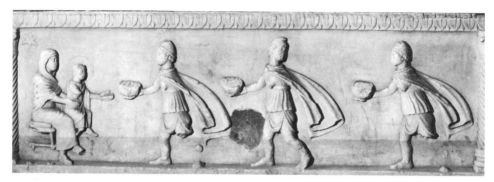

102 The Adoration of the Magi; this sculpture in San Vitale, Ravenna, resembles the Sarı Güzel sarcophagus in its simplicity

103 A tetramorph of the man, lion, ox and flying eagle, winged symbols of the Evangelists, from the lintel of the main west door of the Alahan basilica

The fifth century saw a steady decline in the importance of statuary, but relief sculpture was still in demand for the enrichment of churches, church furniture and sarcophagi, while wood- and ivory-workers kept their skills alive for lay and ecclesiastical purposes alike.

The so-called Sarı Güzel sarcophagus in Istanbul is a genuine *101* product of the Theodosian school; on each of the long sides is a pair of angels bearing aloft a wreathed Chi-Rho, their bodies so carved as to appear flying outwards from the ends towards the centre. The pair of saints on both of the ends are less elegant, and somewhat recall the Apostles in the lunettes below the cupola of the Mausoleum of Galla Placidia in Ravenna. Before the Vandals captured it in 476, Ravenna had been an imperial residence for nearly three-quarters of a century, and its ties with Constantinople were close. The simplicity of the Sarı Güzel sarcophagus is reflected in some roughly contemporary Ravennate examples, e.g., one in San Vitale with the Adoration of *102* the Magi carved with an economy that evokes an earlier period.

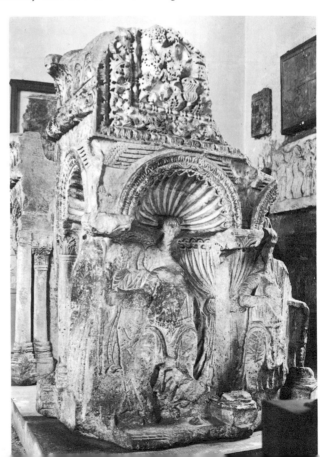

104 This fifth-century *ambo* or pulpit in Istanbul has stylistic affinities with the Sidamara sarcophagi of a century earlier

Relief had its place too in the enrichment of architectural features and church furnishings, but as its style developed in basically the same way (with due allowance for period and locality) as that described above, it should suffice to mention one or two outstanding pieces. The fifth century *ambo* (pulpit) in Istanbul is especially interesting for its relationship with the niched-columnar 'Sidamara' sarcophagi of the preceding century. Unique, too, for its period is the tetramorph of Ezekiel's four beasts in the fifth-century West Basilica at Alahan in Isauria. In purely 'architectural' sculpture (e.g., capitals, friezes and cornices), there was a general tendency to 'colourism', where the interest is focused less on the mouldings as such than on the scope that they gave to a sculptor for emphasizing a contrast between light and shade. This basically anti-classical tendency reached a climax in the exquisite work to be seen in the Church of Saints Sergius and Bacchus and of Santa Sophia in Istanbul, as well as at Ravenna in San Vitale.

For wood to survive exposure to a European climate, even a Mediterranean climate, is exceptional. That some fragments of the wooden door of Sant'Ambrogio in Milan, and numerous panels of the door of Santa Sabina in Rome are still preserved is most fortunate, since both are also datable within close limits, the first to the end of the fourth century and the second between 422 and 440. The

105 Scenes from the life of David as a shepherd, from the wooden doors of Sant'Ambrogio, Milan, luckily preserved to some extent; they have stylistic links with the sarcophagus in the same church

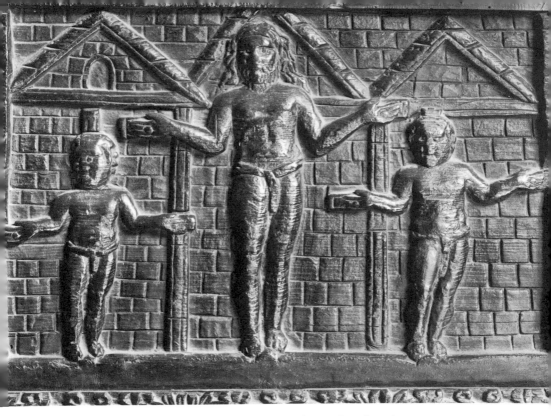

106　One of the first known portrayals of the Crucifixion, though an inaccurate one; this panel is on the remarkably well-preserved wooden door of Santa Sabina in Rome

Sant'Ambrogio fragments depict scenes from the life of David and, however sadly weatherbeaten, do at least provide an interesting stylistic parallel to the overcrowded scenes on the contemporary sarcophagus in the same church.

The cedar-wood door of Santa Sabina would deserve attention *106, 107* for its preservation alone, even without its rich store of scriptural narrative carved on panels of varying sizes and some rather original scenes. The Crucifixion is here portrayed, perhaps for the first time *106* (see ill. 117) as a horrible, yet triumphant ending to the Passion; horrible because the nailing of a living body is inhuman, yet triumphant in its serenity of atmosphere and in its remoteness from reality, for Christ and the two thieves were not crucified against an architectural background, but on a bare hillside. The large panel depicting

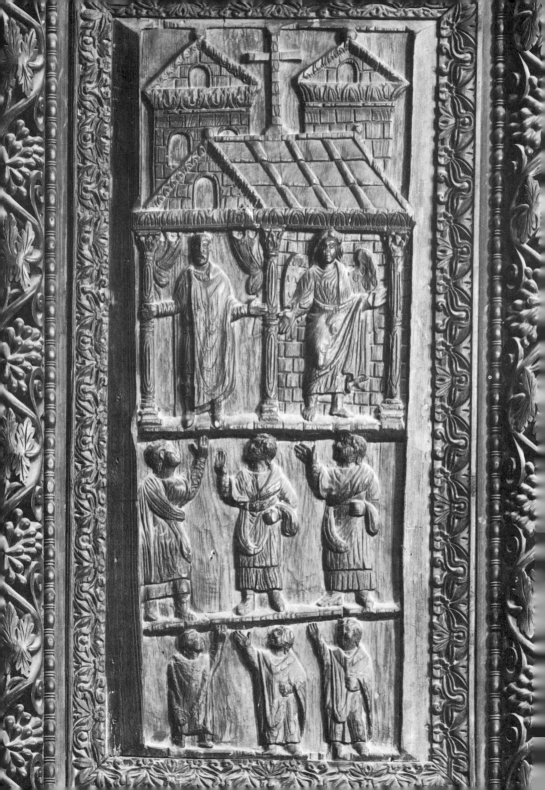

Zacharias and the Angel is unusual too, for it is unknown elsewhere. *107*
Christ's miracles are treated in the rather archaic manner of the frieze
sarcophagi of a century before, and the usual balance between Old
Testament and New is evident in the close association of Cana and
Moses striking the rock.

Ivory, a luxury material, is more durable than wood and so has
survived in considerable quantity. Also, since to recarve an object
involved loss and waste, many notable originals are preserved; while
masterpieces of metalwork are easily melted down and stone burned
to produce lime or simply refashioned to make masonry blocks. The
source of ivory could be either Africa or India, with Africa more
likely as being closer at hand to the Mediterranean world. Alexandria
was an important workshop, but ivory is easily transportable, so that
artists in other major Christian centres will certainly have worked in
that material.

Pagan traditions in ivory carving remained strong. A number of
ivory pyxides, small round or oval ivory boxes, have survived with
erotic or mythological scenes. The Bobbio pyxis, for instance, with *108*

◄ 107 Left: another panel
from the door of Santa
Sabina. Zacharias is struck
dumb before the temple,
a subject not treated
elsewhere

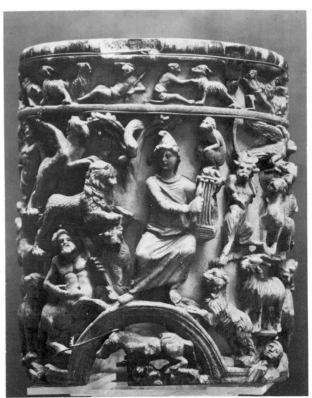

108 Right: the Bobbio
pyxis, with a scene of
Orpheus charming the
animals

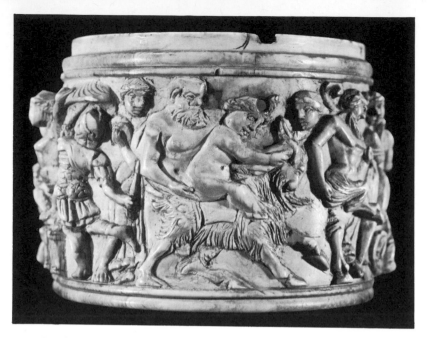

109 Another pagan subject, the birth and childhood of Dionysus, on an ivory pyxis

a scene of Orpheus charming the animals, is possibly late fourth century, and its colouristic treatment strongly suggests a Syrian provenance. In Bologna, a slightly later example, carved with scenes of *109* the birth and childhood of Dionysus, is probably the work of an Italian craftsman. Most individual, however, are those pyxides whose decoration shows a close affinity to the work of degenerate Hellenism in urban Egypt. The style is characterized by the overtly erotic intent of the subjects chosen and by the voluptuous treatment of the human nude. Two examples, one of Aphrodite and Adonis in Zurich, and the other in Florence with episodes from the myth of Artemis surprised in her bath by Actaeon are typical. These, and such a work as the ivory plaque of Apollo and Daphne at Ravenna, were no doubt made by pagans for pagans.

If the decoration of small ivory boxes in everyday household use was sometimes of rather low artistic calibre, this is not so of the diptychs issued by consuls on assuming office. The earliest consular *110* diptych is that of Probus who held office at Rome in 408, and the

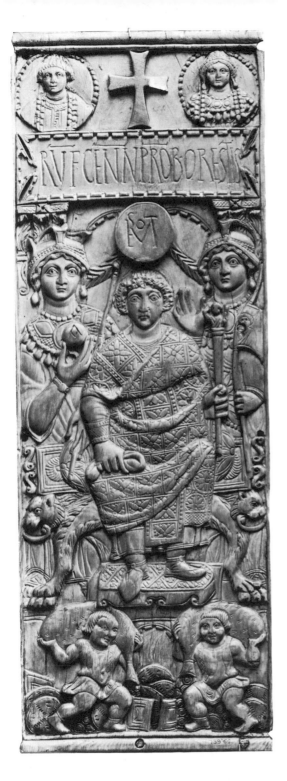

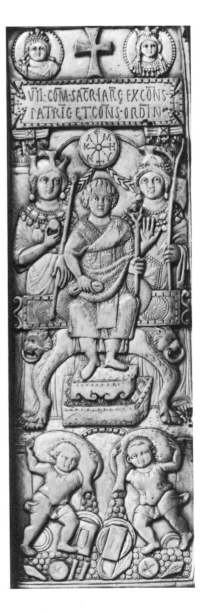

110, 111 Leaves from two consular diptychs in ivory: left, Probus; below, Clementinus. These diptychs were commissioned by high officials when they took office

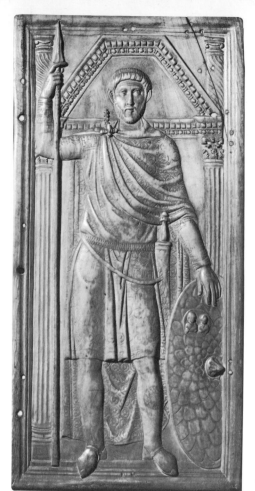

112 Left: one leaf of the diptych of Stilicho at Monza, a work which anticipates the style of the consular diptychs

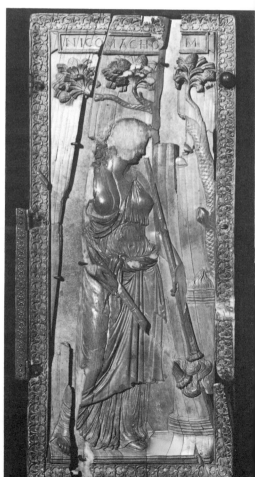

113 Right: a priestess of Ceres before the altar of Cybele, one leaf of the ivory diptych of the Nicomachi and Symmachi

126

series continued until the consular office was abolished in 541; these ivories, therefore, have a unique value as comparative dating material. In general, consular diptychs conform to a fairly strict type, with a few variations in detail, and of these the diptych of Areobindus (506) at Zurich and of Clementinus (513) at Liverpool are representative. The consul, richly dressed and seated on the *sella curulis* (the official seat of the highest ranking magistrate), holds a staff symbolizing his magisterial authority in his left hand, while his right grips the *mappa*, the napkin thrown down to start the races held in honour of his inauguration. He is often attended by civic dignitaries, or by personifications of Rome and Constantinople, while scenes from the amphitheatre or of genii distributing largesse from bulging sacks often occupied the foreground, as a reminder of the way whereby a consul might woo popular favour. It was also usual, and presumably in good taste, to find room for a portrait of one's colleague in office or of the empress. Though we cannot be sure, the diptychs were probably made in Rome or Constantinople where the consuls who commissioned them resided. Outside the series, but a notable work of art, is the wonderfully patrician diptych of Stilicho in Monza, an outstanding work of the Theodosian revival, also exemplified by the diptych (one leaf in Paris and the other in London), perhaps celebrating a marriage between the houses of Symmachus and Nicomachus, two aristocratic Roman families who had refused to renounce paganism.

111

112

113

A reminder that there was a taste for hideous brutality as well as for piety in the fifth century are the circus scenes on a Leningrad diptych. Beast baiting is often seen on the official diptychs issued by Consuls on assuming their magistracy, as a reminder to the people of the new man's liberality in providing a free show. The technique of the Leningrad diptych is superb, if the subject is disgusting, and recalls the neo-classicism of the late fourth century.

Both the pyxis and the diptych were taken over for the service of Christianity. Of the former, the greatest Christian masterpiece is the casket at Brescia (the so-called Lipsanotheca), which, with its wealth of scenes depicted on the lid and sides, constitutes a most valuable compendium of Christian iconography current during the third (?) quarter of the fourth century. On the lid is a continuous narrative of the Passion, reflecting, as do contemporary sarcophagi, the Church's

114, 115

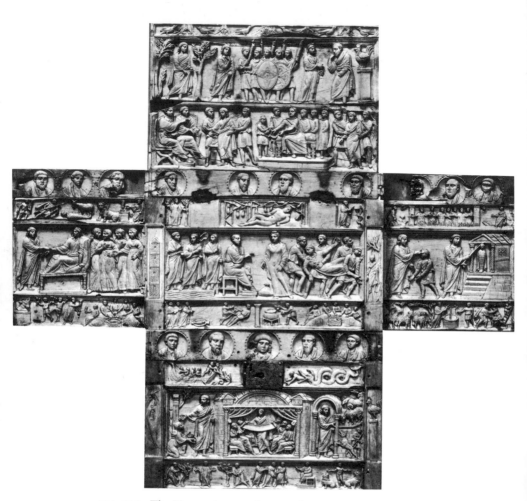

114, 115 The Lipsanotheca, an ivory casket bearing meticulously carved scenes of Christ's Passion. Above: the lid and four sides of the casket shown as if opened out. Right: the casket as it normally appears

growing preoccupation with the more painful aspects of the Redemption, though still fighting shy of the Crucifixion itself. Traditional is the treatment of the Raising of Lazarus, the Healing of the Man Born Blind and of the Woman with the Issue of Blood, while the Raising of Jairus' Daughter and the allegorical treatment of the parable of the Good Shepherd are interesting newcomers to the repertory. Proof of a fine sense of drama is the tableau of St Peter convicting Sapphira of lying, even as Ananias' corpse is being bustled out of the room. The small scenes above and below the main panels are derived from the Old Testament, and are lively enough to repay study. The picture derived from II Maccabees, 7, appears to be unique. The classical style of the whole work, with its faithful attention to detail, suggests North Italy, possibly Milan, as a likely place of manufacture.

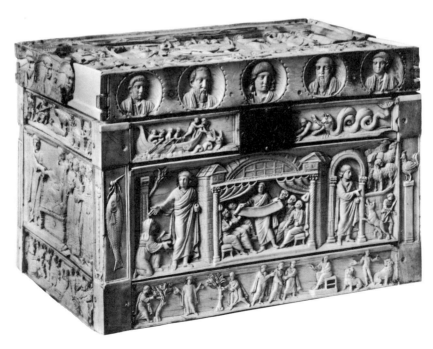

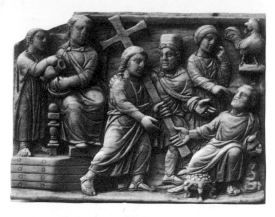

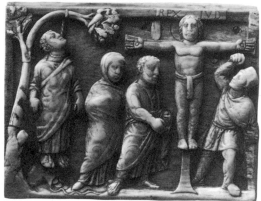

116, 117 Scenes of the
Passion from an ivory box
probably made in
southern Gaul. Above:
Pilate washes his hands,
and Christ carries the
Cross. Below: Judas
hanging himself, and the
first factual portrayal
of the Crucifixion

A lack of refinement and a stubborn insistence on Scriptural
116, 117 authority mark the square ivory box in the British Museum. For
once, too, the Passion forms the sole theme to be treated, from
Christ's confrontation with Pilate, through the Way of the Cross to
the Crucifixion itself, to the Holy Women at the Empty Tomb and
the Reappearance of Christ among the Apostles. This Crucifixion,
rather more terrible than the Santa Sabina panel, may even be
fractionally earlier, and dated about 400 with a possible provenance
in southern Gaul. The aristocratic atmosphere of the scene of Christ
118 among His Apostles on a pyxis in Berlin recalls the diptych of
Stilicho, for the imagined parallel between the heavenly and earthly
authority enjoyed by God and His vicegerent was never far from the
official mind.

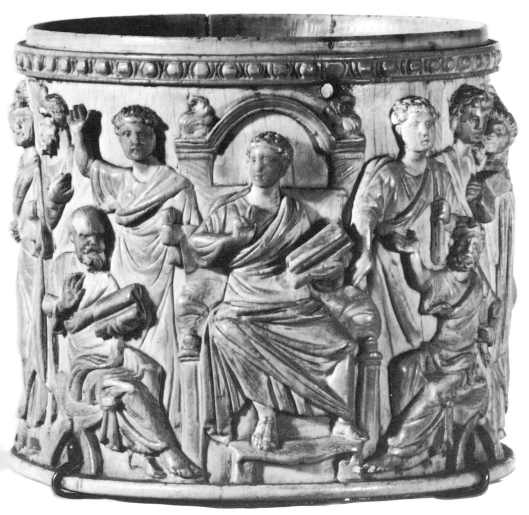

118 A formal and dignified portrayal of Christ as Teacher with the Apostles on an ivory pyxis in Berlin

119 Above: episodes from the story
of St Paul's stay in Malta, from
a diptych in Florence. The Saint is
recognizable by his long pointed beard
and receding hairline

120 Right: the Archangel Michael
on one leaf of an early sixth-century
diptych, heralding the mature
Byzantine style

The diptych in its Christian form embodied features taken from both the consular figures and the scenes that sometimes accompanied them. A famous diptych at Florence depicts on one side Adam as lord of creation, amongst the beasts, while the other features episodes from the story of St Paul's stay in Malta after his shipwreck. The *119* features of St Paul, with his pointed beard and widow's peak, were already standardized by this time, as too were the woolly hair and beard of St Peter. The style is Theodosian, and the execution so fine as possibly to be a product of Constantinople.

The first two decades of the sixth century form a prelude to the age of Justinian, marked by that successful compromise between eastern and western traditions that is the hallmark of true Byzantine art. Even in the early sixth century, an ivory plaque in the British Museum may be recognized as typically Eastern, probably Syrian *121* work. The marked frontality of the Virgin's figure and the contrasting patterns of light and shade in the carving are evidence enough. Probably contemporary, but quite other in spirit, is the ivory of *120* St Michael, in which the classical tradition predominates where the figure and its drapery are concerned; yet the architectural background is fanciful, and the feet make no realistic contact with the flight of steps. This fine work is, therefore, proto-Byzantine and probably made in Constantinople.

121 On this ivory plaque, probably from Syria, the Virgin and Child are seen attended by the Magi and an angel; below is the birth of Christ. The carving has a distinctively Eastern quality

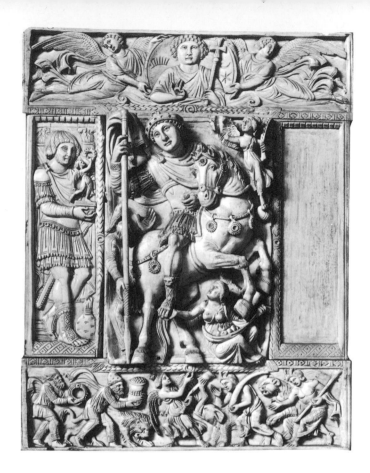

122 The Barberini
Ivory, showing the
Emperor Anastasius in
armour and on horse-
back

122 The famous Barberini Ivory is but one leaf of an imperial diptych, made originally of five panels, four of which survive. In the centre, beneath a victorious emperor mounted on his charger, is Earth bearing her tribute of fruit. The lowest panel depicts barbarians bearing tribute on the left, while to the right a band of elegant Indians bring gifts of ivory tusks and native animals. Anastasius fought many successful Balkan campaigns and in 496 received an embassy from India, and both style and subject suggest a date towards the end of the fifth century. Nearly contemporary must be

123 the so-called Diptych of Ariadne, successively the Empress of Zeno and Anastasius. The features recall those of the emperor on the Barberini Ivory; her rich costume and jewellery, her orb and sceptre

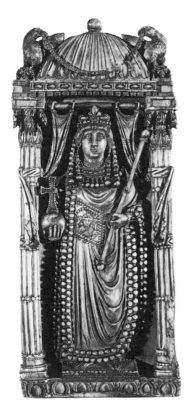
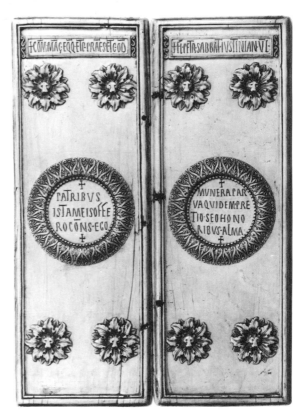

123, 124 Left: one leaf from a diptych of the Empress Ariadne from Florence. Right: a diptych of Justinian, very restrained in its ornamentation

are a guarantee of her imperial stature. There are two versions of this diptych, one in Florence, in which the empress stands below her canopy, the other in Vienna where she is depicted enthroned.

Justinianic art belongs by right to the next chapter, but the inclusion of a diptych to celebrate the consulate of the future emperor, made while his uncle still ruled, in 521, may perhaps be excused. It has often been observed that in later life Justinian showed a preference for aniconic art. It is not great sixth-century mosaics that catch the eye in the Church of Saints Sergius and Bacchus and in Santa Sophia in Constantinople. It is rather the exquisite use of stone, both as a material and as a means for abstract sculptural expression. The diptych of Justinian in Milan is, therefore, quite in character, for its *124*

only ornament apart from the consular inscription is a central wreath on either leaf with a rosette at each corner.

METALWORK AND JEWELLERY

Metalwork of the earlier centuries is a rarity, since gold and silver have been far too easily melted down by thieves or persons ignorant of a value beyond quantity or weight. Bronze or copper, however, are quite obviously bronze or copper, and so some objects (coins in particular) have been saved from the crucible by their apparently intrinsic worthlessness.

The finest early Christian metalwork is generally of eastern origin, for the good reason that much of it was buried during the first Arab incursions into the former Christian territories of the Near East, when its owners no doubt hoped to return one day and reclaim their property. Only now, as the treasure-seekers go to work, are some of the objects reappearing, often all too far from their place of manufacture.

Of portable church furnishings lamps and thuribles were often of bronze, and so stood a reasonable chance of survival. Chalices, patens and reliquaries had to be of costlier material for their sacred associations. Shapes were generally standardized, while iconography as always followed current local fashion.

Many of the lamps used in churches and homes will have been made of clay, and clay when fired is virtually indestructible and,

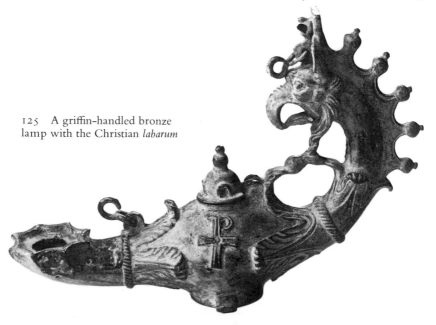

125 A griffin-handled bronze lamp with the Christian *labarum*

126 A bronze lamp shaped like a boat; the two figures may be Christ and St Peter

without overmuch effort, recognizable from its shape, decoration and fabric. A simple cross or Chi-Rho is usually the only positive evidence on a Christian clay lamp, and a Chi-Rho is the only distinguishing mark on the elaborate bronze griffin–handled lamp at 125 Hartford. Much more noteworthy is the double-spouted bronze lamp shaped like a boat in Florence, with the two figures on board 126 possibly representing Christ and St Peter. Two chains and a ring for attaching to a hook are a reminder that many lamps were simply hemispherical glass bowls with a small sump to absorb the lees of the oil, and that they were suspended, from arches for example, by hooks fitted to a flaring rim. Multiple lamps were sometimes fitted to elaborate metal stands, and candelabra also are known.

Thuribles were commonly of bronze, and seem often to have been carried by deacons. A perfect example, found at Dağ 127 Pazarı in Isauria, is now in the Adana Museum. Suspended by a single stout chain with a cross halfway down, the hexagonal bowl was secured by three smaller chains, each attached to a ring. On the sides of the hexagon are figures in relief of Christ attended by

127 Detail of a bronze
thurible from Dağ Pazarı;
the central figure is Christ,
raising His right hand
in blessing

adorant angels, while on the other three are monks warmly clad in hoods, to keep out the chill winds of the upper Taurus.

128 Of church vessels, the most showy, if genuine, is the so-called Antioch Chalice of silver and gilt in New York. The Good Shepherd suggests an early date, in fact dates between the late fourth and late sixth centuries have been suggested, while the deep undercutting of the vine motifs, with its distinctive interplay of light and shade, certainly suggests Syria as a likely place of origin.

129 The large and splendid silver reliquary at Milan is sometimes thought to have been given by Pope Damasus to St Ambrose to house the relics of the Apostles (whose church was then building). The quality makes it thoroughly worthy of the Theodosian revival. The equation, possibly subconscious, of Divine with Imperial power is evident in the posture of Christ enthroned among the Apostles, of the Virgin at the Epiphany, and (on a lower plane) of King Solomon and of Joseph, son of Jacob, in the scenes where they play the leading role. Theodosian too is the tendency to a leaning stance and the soft treatment of the drapery. Most distinguished too is the fine silver-gilt reliquary recently put on display in the Archaeological Museum in Salonika. Unquestionably of Theodosian date, it is an oblong box of which the four sides are decorated in repoussé with scenes of (a) a youthful Christ blessing Sts Peter and Paul, (b) the Three Hebrews in the Fiery Furnace, (c) Moses on Mount Sinai, (d) Daniel between two lions, one of which seems to be playfully standing on its head! The lid carries an Alpha and Omega with a centrally placed Chi-Rho.

128 The Antioch Chalice, a splendid silver and gilt goblet depicting the Good Shepherd among vineyard motifs

129, 130 Two silver reliquaries. Left: Christ enthroned among the Apostles on the lid of a casket from Milan. Below: on a reliquary from Çırga, the female saint may in each case be St Thecla with the lions. The figures in the roundel are probably St Peter and St Paul

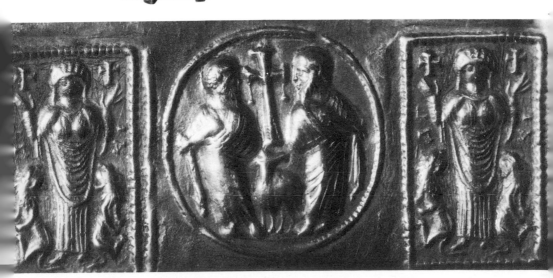

130 In contrast, the little reliquaries of Ayn Zarara in Numidia and of Çırga in Isauria are almost commonplace, yet it was such little boxes that housed the bones of lesser saints in the countless churches built in the first five Christian centuries. The Ayn Zarara casket with its decoration of two harts is a reminder of the popularity of Psalm XLII, 1 (see also the Mausoleum of Galla Placidia), while the Çırga reliquary (now in Adana) is chiefly of interest for its mention of Tarasis, founder of Alahan monastery, and for its possible representation, as suggested by André Grabar, of St Thecla with two lions, signifying the means of her martyrdom.

131, 132, 133 Only the inscription admonishing the bridal pair to 'live in Christ' proves that the silver casket of Secundus and Proiecta from the Esquiline Treasure (now in the British Museum), is not pagan. It is a wonderfully handsome piece of the Theodosian period, dating from about 380, and well illustrates the strength of the classical tradition as exemplified, for example, by the diptych of the Symmachi and Nicomachi (see above, p. 127). Specially fine are three sides of the lid, one featuring Aphrodite in a scallop shell, combing her hair and attended by Tritons, and the other two with Nereids, sea-monsters and dolphins. These pagan symbols of love are rendered with greater conviction than the more banal, because factual, procession of the bride. The front of the casket is reminiscent of an elaborate niched-
132 columnar sarcophagus, with the bride busy with her make-up and two girl servants in attendance. The fourth-century Concesti Amphora, originally found in Romania, but now displayed in Leningrad, has two centaurs for handles and a main frieze of an Amazono-machy.

There is no reason for excluding jewellery from a book on Christian art, and indeed every reason for including it, since some of the finest workmanship of the time went to the production of articles of adornment for ladies of fashion. Perhaps the marriage rings bring us into an almost intimate contact with the individuals who wore them. One outstanding example is now at Dumbarton Oaks, and is assigned by Marvin Ross to the late fourth century. It is of gold, with a bezel engraved with the busts of husband and wife facing each other below a cross. The rings were not always of gold; it was not everyone who could afford this. All the same, the marriage rings, often with the names of the couple inscribed also, were probably made in pairs, one

131 Lid of a casket in honour of a Roman couple, Secundus and Proiecta. The inscription reads 'Secunde et Proiecta vivatis in Christo', though Venus, Tritons and other pagan deities are depicted

134 A lady's gold
cross, early sixth
century, set with red
stones, to be worn on
a chain

for husband, one for wife. Very elegant is the gold and amethyst ear-
ring in Baltimore, with its little crosses crowning each pendant
stone; it belongs probably to the early sixth century, when religion
and religious objects could be fashionable as well as part and parcel of
134 everyday existence. In exquisite taste also is the simple gold cross
decorated with five red stones, probably designed to be worn with a
plain gold chain of the same date and in the same collection.

In the coins and medals of this period, many of magnificent
quality, one recognizes the continuation of a development that began
in pagan times. The silver coin struck by Constantine in 330 to
commemorate the foundation of Constantinople bears the same styl-
ized head that we have seen in large-scale sculpture, with on the
reverse the personification of the city still conceived in completely
pagan terms. The coins of Constantius II are of interest because they
135 reflect the regional styles of local mints. Julian the Apostate's face
on a bronze coin has a pathetic dignity that is no doubt consciously
classical, but after him the standard of craftsmanship tended to decline.
136, 137 Of the early Christian emperors and their consorts, only Theodosius I
and Flaccilla have a memorable beauty, in tune with the spirit of their
138 age. The huge, heavy pieces with which Anastasius celebrated a
return to monetary solvency have a reassuring, if gloomy solidity.

135, 136, 137, 138 Four coins of the fourth and fifth centuries. Top: Julian the Apostate (331–363). Centre: Theodosius I (379–395) and his wife Aelia Flaccilla. Bottom: Anastasius (491–517)

143

Justinian and after

On the night of 8/9 July 518, Anastasius died in Constantinople aged eighty. He was childless but, though he had three nephews, had named no heir. The next day, the unanimous if surprising choice of the Senate, Church, Army and People was Justin, an elderly Illyrian who had served in the Palace Guard under successive emperors and taken part in Anastasius' Isaurian and Persian campaigns. The new emperor, though shrewd, was no intellectual and overshadowed *139, 140* almost from the outset by his nephew Justinian whose name, with that of his wife Theodora, is invariably linked with the First Golden Age of Byzantium. Justinian's reign is, in fact, one of those rare periods in human history when momentous events and high achievement are stamped with the personality of a single man. Such had been the age of Periclean Athens and Augustan Rome; but Justinian's Byzantium was the less rarefied for its association with her whom the emperor liked to call his 'dearest charmer', his wife Theodora.

Financially Justin's reign got off to a good start. Anastasius' taxation reforms had left reserves in the treasury estimated by the historian Procopius at 320,000 pounds of gold. If this is not exaggerated, the same author's typically malicious statement that Justinian had run through it all before his uncle's death certainly is. Even so, it was obviously not enough to meet even a modest proportion of Justinian's military and civic expenditure in his long reign. When he died in 565, the empire had been bled white through crushing taxation, and he left no legacy of military victory to his successors, not even in the West where he made his gamble to recover the lost provinces of imperial Rome. It was not an affluent state that stood behind the first flowering of Byzantine art; rather was it an altogether logically based self-confidence which can be a nation's greatest asset.

If Justin might be reasonably grateful to Anastasius for a well-stocked treasury, he had less cause for satisfaction with his religious legacy. The old emperor had been a Monophysite, and so was

popular in Syria, Palestine and Egypt, where hierarchy and people had never happily accepted the decisions of Chalcedon; nor could he rely on the support of the Orthodox party in Constantinople, and was in open breach with the papacy, as had been his predecessor Zeno. It was therefore to a joyful populace assembled in Santa Sophia only a few days after his election that Justin announced himself champion of the Orthodox Faith, recalled several bishops exiled from their sees by Anastasius, and anathematized Severus, patriarch of Antioch, whose devotion to Monophysitism remained unshaken and dignified in the face of degradation and expulsion from his see. At length too began a rapprochement between Byzantium and the papacy, and after prolonged and canny exchanges the Pope actually travelled overland from Rome to New Rome to secure the assent of emperor and patriarch to the tenets of Orthodoxy. The Church was officially reunited and Justin, though never ruthless, began a rather 'correct' persecution of pagans, Jews and heretics, a policy endorsed by Justinian on his accession in 527. In this he showed a curious lack of judgment, in imagining that the old Roman empire could somehow be restored by the imposition of a common religion on all its component peoples. Chiefly he underestimated the tenacity of the eastern provinces whose commitment to Monophysitism was too strong to be deflected by persecution; indeed, less than a century after Justinian's death, these provinces were so disaffected that they fell easily to the Arabs. However, Theodora – herself a Monophysite, or at least extremely sympathetic to that

139, 140 A gold coin of the Emperor Justinian, obverse and reverse

doctrine – was at first a moderating influence, and tolerance of the Monophysites went so far as to provoke a protest from Rome. Justinian swung back to Orthodoxy, and later tried unsuccessfully to reconcile the factions within the Church; but though he never broke with Rome and remained nominally Orthodox until his death, the emperor was always a law unto himself.

ARCHITECTURE AND MOSAIC

In 532, during the famous Nika revolt, a basilica originally dedicated to the Divine Wisdom by Constantine I was gutted by fire. On the same spot, at the northern end of the Hippodrome, Justinian commissioned a new and more sumptuous Santa Sophia, which was completed and re-dedicated on Christmas Day 537. This splendid church, Justinian's special pride, survives to this day as a witness to his greatness and to the architectural genius of Isidorus of Miletus and Anthemius of Tralles. At its solemn opening, the emperor gave thanks to God for allowing him to surpass the glory of Solomon's Temple, and later generations, Christians and Moslems alike, have found in it a source of religious inspiration.

141, 143 Santa Sophia was conceived and built on a grand scale; but the rather drab brick exterior of the church provides no hint of the magic that it encloses. Though it was once approached through an *atrium* to the west, all that now remains of this is its eastern façade, pierced with three gates giving access to an exo-narthex and onwards to the narthex itself, from which (through nine doors) the church proper is entered.

To the visitor expecting a blaze of mosaic like that in Ravenna's San Vitale, the interior of Santa Sophia may at first be a disappointment, and such mosaics as are to be seen now are mostly later than Justinian. We know that gold mosaic was originally used to cover the dome, and that would have been handsome indeed; but as Justinianic art in the capital was probably largely aniconic (see pp. 135-6) much use was made of plaques of costly marbles so arranged as to provide a lively and harmonious colour scheme, with some slabs sawn in half and then laid side by side so that the veins are seen as a symmetrical pattern about a central axis. Columns of porphyry and verde antico were crowned with imposts and basket

142 capitals of white Proconnesan, and to contrast with the flat surface of

141 The interior of Santa Sophia, the great achievement of Justinian, unprecedented in its vastness and unsurpassed in its architectural brilliance ▶

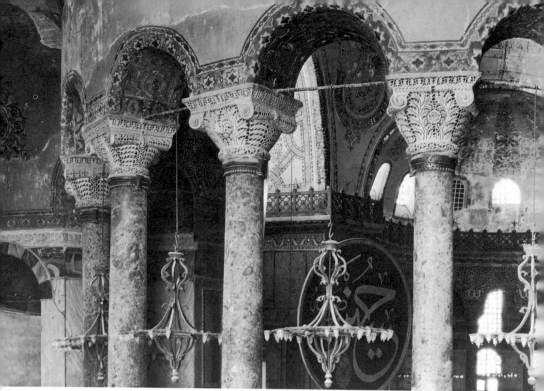

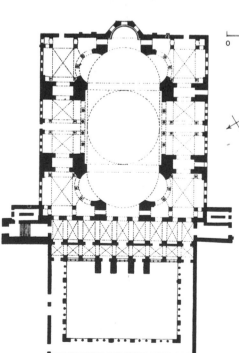

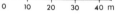

142, 143　Above: marble capitals in Santa Sophia, Byzantine carving at its most accomplished. Left: plan of Santa Sophia showing to the west the *atrium* which no longer exists; the focal point of the whole building is the great dome and the two semi-domes which buttress it

the walls, the spandrels of arcades were decorated with acanthus rinceaux, with the colouristic contrast emphasized (as on imposts and capitals) by deep drilling. Gold lamps illumined the church by night, and some of the church furniture was plated with silver. In this manner Justinian tried to create an aura of divine majesty, and this aim was enhanced by the superb organization of Santa Sophia's interior. High over the central nave, on the square bay formed by four huge arches, rises a dome supported on spherical triangular pendentives. North and south, the arches are closed by walls supported by arcades in two superimposed tiers, of which the lower gives access to the side aisles and the upper to the galleries immediately above them. East and west, each end of the nave is a semi-dome buttressing the central cupola, while each semi-dome is itself buttressed by a pair of columnar *exedrae*, once again at two levels. A central apse at the east end makes a trefoil niche abutment to the semi-dome at this end.

Arguments advanced to support theories for the architectural origins of Santa Sophia range from a hypothetical domed quatrefoil Armenian prototype to the more prosaic Basilica of Maxentius in Rome. Whatever the sources, however, Santa Sophia is a work of original genius. As Richard Krautheimer has summed it up, 'Structure, function and design are inseparable in H. Sophia, as they are in any great architecture. But they need not have the same historical origin.' So it remains a unique building in which it is the essential unity of design that is impressive. For there is an unbroken vista from the western hemicycle at the narthex end to the apsidal sanctuary in the east, a vista with its focal point the crown of the incomparably light dome, which still somehow represents, after fourteen centuries, the vault of heaven which is the dwelling-place of God Himself.

Two almost contemporary buildings with a strong family resemblance are the Church of Saints Sergius and Bacchus (now Küçük Aya Sofya) in Istanbul and San Vitale in Ravenna. Both seem to have been influenced by Constantine's famous Golden Octagon at Antioch (see above, p. 62) and both had a domed octagonal core enveloped by an ambulatory at two levels. The Church of Saints Sergius and Bacchus is the earlier, and was begun while Justinian was still heir presumptive. The site, chosen for its closeness to the future emperor's palace, was irregular, and the exterior of the church has a

144, 145
146
54

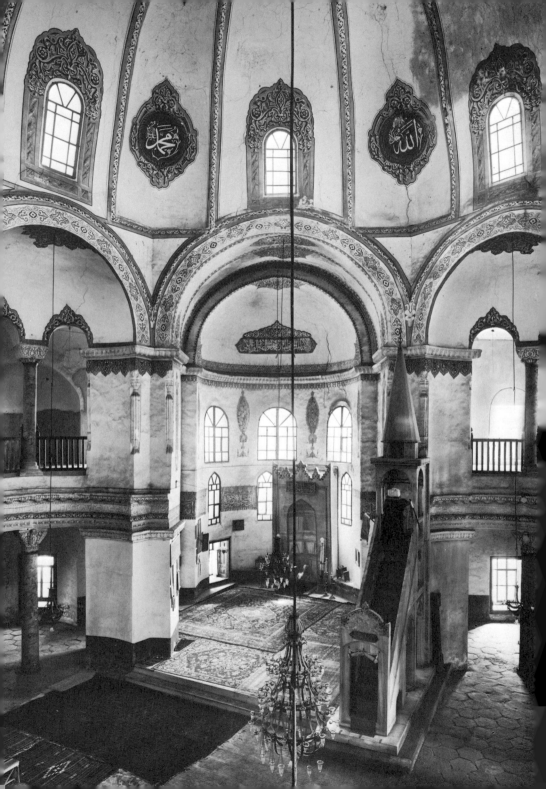

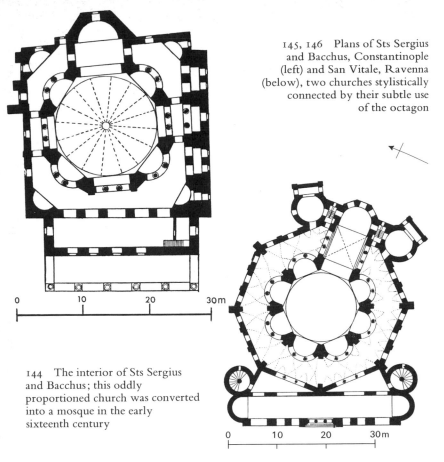

145, 146 Plans of Sts Sergius and Bacchus, Constantinople (left) and San Vitale, Ravenna (below), two churches stylistically connected by their subtle use of the octagon

144 The interior of Sts Sergius and Bacchus; this oddly proportioned church was converted into a mosque in the early sixteenth century

0 10 20 30m

0 10 20 30m

lopsided appearance. Inside, however, is a regular octagon, formed of eight piers linked to one another by columnar *exedrae* which give access to the aisles and galleries enveloping the central core at both ground and upper level. The *exedrae* on normal orientation are rectangular, except to the east, where there is a projecting apse, but the others, on the diagonals, are semi-circular. Over the octagon rises a shallow dome. The interior architectural mouldings are of notably high quality, particularly the column capitals, which much resemble those of San Vitale, and the ground-level entablature with its intricate colouristic treatment. Of mosaic there is very little, and that aniconic. Yet, despite excellence in detail, the building is unhappily proportioned, and is strangely earthbound in contrast with San Vitale.

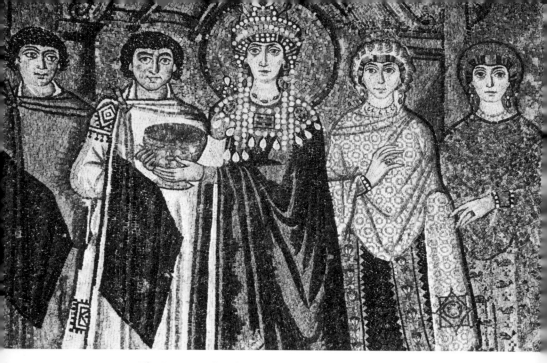

147 The Empress Theodora and her suite; she is richly robed and bejewelled and carries a golden chalice

148, 147 The mosaic portraits of Justinian and Theodora in the choir of San Vitale are deservedly among the more famous works of early Byzantine art, and indeed the imperial couple (their vital personalities as compelling in effigy as they certainly must have been in life), tend to draw attention away from the architecture, which is of great intrinsic merit. Begun under Theodoric and possibly as early as 522, it was not dedicated until 547; so while the Church of Saints Sergius and Bacchus is a likely influence on the general plan, certain features appear Western in origin. The building is basically an octagon within an octagon, and the inner core, defined by eight piers, supports a dome on squinches. Between each pair of piers is a semi-circular columnar *exedra* in two storeys, of which the upper is crowned by a semi-dome, except for the opening into the *presbyterium* and terminal apse in the east. Through the *exedrae* at both levels are the galleries encircling the inner octagon and acting, with buttresses on the outer walls, as an additional abutment to the central vault. The richest

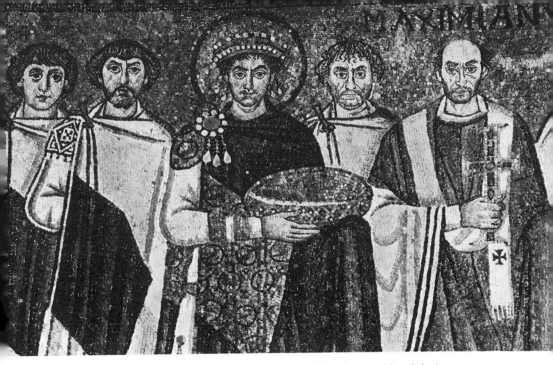

148 The Emperor Justinian, haloed, like his consort, and bearing a golden dish; in his suite are Archbishop Maximian of Ravenna and some palace guards

decoration is reserved for the core of the building, and for the *presbyterium*. *Opus sectile* paves the floor, piers are faced with slabs of fine marble, and the slender arches of the columnar *exedrae* spring from imposts supported on basket capitals of canonical Byzantine type. This Ravennate church has, then, a worthy place beside the churches of sixth-century Constantinople, lesser no doubt than Santa Sophia and very probably than the newly excavated and sumptuous church of St Polyeuctus at Saraçhane (currently being studied by Fıratlı and Harrison), but more satisfying in its harmonious proportions than the Church of Saints Sergius and Bacchus. Yet, though it would be wrong to suggest that San Vitale's greatness depends largely on its interior decoration, and on its mosaics especially, such opulence does obviously enhance the visitor's appreciation. It may also be remembered that the Arian Theodoric had ruled the Orthodox Italians from Ravenna as recently as 526, so that the *presbyterium* mosaics in which Justinian and Theodora take second

149

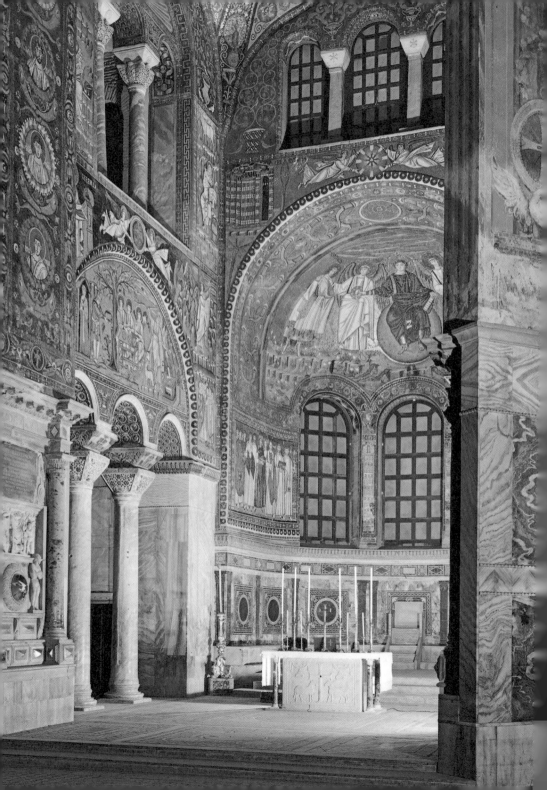

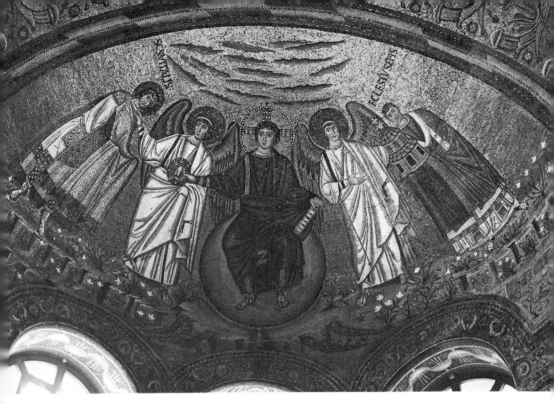

150 Apse mosaic in San Vitale : a young beardless Christ handing a martyr's crown to St Vitalis. On the right stands Bishop Ecclesius with a model of the church which he founded

place only to Christ, deliberately emphasize the triumph of the True Faith and of the emperor's temporal supremacy over the Church. On the other hand, the mosaics decorating the groined vault and lunettes had a doctrinal purpose. A foliate garland enclosing the Lamb of God against a star-spangled background fills the crown of the vault, while in each of the four quarters stands a supporting angel in a field of acanthus rinceaux inhabited by beasts and birds of the time-honoured Paradise scenes (see p. 000). This theme of the Sacrificial Lamb is followed up in the northern lunette by a scene of the entertainment of the three angels by Abraham and Sarah, integrated with the sacrifice of Isaac by his father; in the southern by Abel and Melchize-dek, symbolic figures of the priesthood, to either side of an altar. The apse mosaics form a climax and consummation to these – the 'types' of symbolic sacrifice being made explicit in Christ. The centre of the

157

◄ 149 The interior of San Vitale, Ravenna, looking east through the sanctuary (which penetrates the octagonal aisle, see plan) into the apse. The Justinian mosaic is on the left

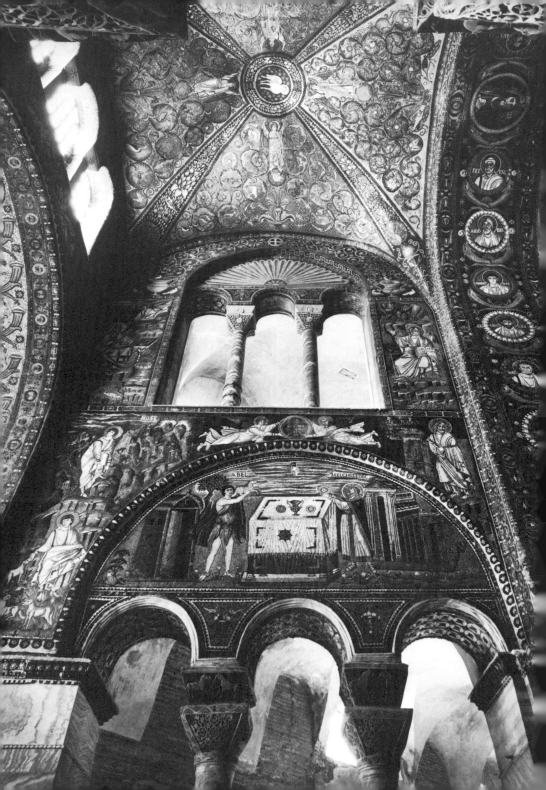

conch is occupied by a youthful, but authoritative Christ sitting on *150* the globe of the world and attended by angels. To His right stands St Vitalis ready to receive his martyr's crown, while the Bishop Ecclesius, founder of the church, comes up from the left with a model of the new building. Above a Paradise, where the four rivers flow through flower-strewn lawns, clouds float in a golden sky.

Thus is Christ Cosmocrator depicted as supreme patron of San Vitale (as of all other churches), while Justinian and his consort, in resplendent attire, reflect the earthly supremacy of the Orthodox emperor. The famous panels, one on either side of the apse, are possibly the latest mosaics in the church, and may even commemorate its consecration in 547; for Maximian, whose lean, ascetic figure is specially memorable, was bishop of Ravenna for only two years (546–548), while Theodora died of cancer that very year. With her tense, but distinguished features, she is in marked contrast with the ladies of her suite. It is idle to speculate on the possibility that these panels were designed to represent a genuine historical ceremony. It suffices that in their atmosphere of an imperial occasion they have the stamp of an absolute authenticity.

Well over a thousand miles south-east of Byzantium is the monas- tery of St Catherine in the middle of the Sinai desert. Built originally *152* to commemorate the site of the Burning Bush where the Lord revealed Himself to Moses, the original mosaics of the church built by Justinian still survive in the apse. In the dry heat of Sinai, even wood is impervious to decay, so that the very roof beams with their inscriptions (carved between 448 and 460, after Theodora's death and towards the end of the emperor's long life) have been almost miracu- lously preserved. It is at once apparent that the artist's main purpose was to use his mosaic to point the parallel between the dispensation of the Old Law to Moses on Sinai and of the New by Christ, transfigured on another mountain, Tabor, in the presence of three of His own disciples and, no less, of Moses and Elias. This is intelligible in the context of the number of Jews dispersed in the Arabian peninsula, and the undisputed owners of a large island in the Gulf of Eilat, where they continued to practise their own religion. The monks of Sinai were not out to preach only to the converted. Another sign of the importance, as well as respect, which a Christian of the sixth century could still feel towards his 'separated brethren'

◀ 151 The sanctuary of San Vitale looking south; in the southern lunette, the sacrifices of Abel and Melchizedek

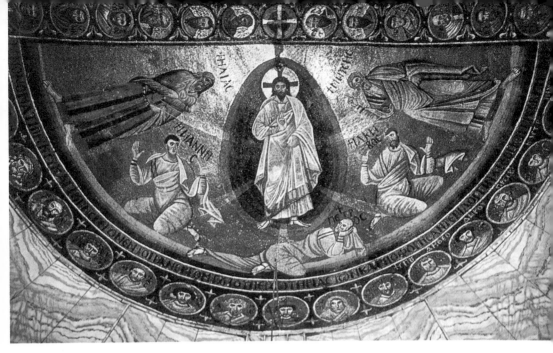

153 The Transfiguration, a fine mosaic in the apse of St Catherine's church; Christ in a mandorla, between Moses and Elias, with Sts James, John and Peter below Him

was the intentional likeness of the mosaic in broad outline to the Eternal Eye of the Synagogue.

The conch mosaic has the Transfigured Christ in an elliptical *153* mandorla as the central figure of the mosaic, the *pupillus oculi* as it were. The background is of gold, and to right and left of Christ are Elias and Moses respectively, with the three disciples who witnessed the scene below the main group; Sts James and John are kneeling with their arms raised in wonder, and St Peter lies prostrated. In medallions, framing the elliptical composition described, are the heads of the Apostles and martyrs, while above these, to right and left, are portraits of Justinian and his still dearly-loved empress. Higher still, in a re-emphasis of Sinai's associations with the Old Law, now renewed, are scenes of Moses at the Burning Bush and his reception of the Ten Commandments.

In flat country, about three miles south of Ravenna, stands the basilical church of Sant'Apollinare in Classe, dedicated in 549 by *154* Maximian and financed (like San Vitale) by Julius Argentarius, the banker. Apart from the mosaics in the apse and on the triumphal *156*

◄ 152 The monastery of St Catherine, founded by Justinian at the foot of Mount Sinai

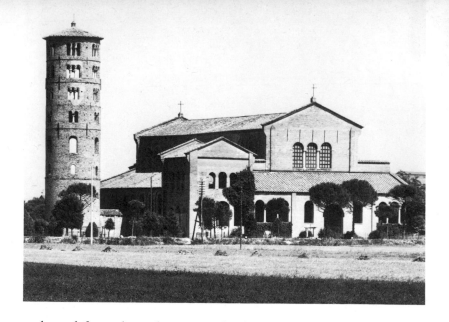

arch, and from the rather unusual column capitals, unusual because less obviously influenced by contemporary Byzantium than those of San Vitale, Sant'Apollinare in Classe is unassuming in its architectural simplicity. Of the mosaics, the one in the conch must be contemporary with the dedication, and depicts Saint Apollinaris 155 against a pastoral background interceding (in the by now rather archaic *orans* posture) for his flock. Above, and treated in a manner very different from that employed in St Catherine's monastery on Sinai, is a Transfiguration scene, where Christ is symbolized by an exalted cross flanked by Moses and Elias, while Peter, James and John are represented by three sheep. At the crown of the conch may be seen a hand, representing God the Father, while the transfigured Christ is to be recognized in the tiny head at the junction of the arms of the jewelled cross at the centre of the composition. Above the conch, on the triumphal arch, twelve sheep are shown issuing from the gates of two cities, possibly Jerusalem and Bethlehem, and at the highest point is a medallion with the bust of Christ attended by the four beasts of Ezekiel's vision (each one holding an Evangeliary), who float in a blue sky flecked with clouds of pink and white. The other mosaics on the triumphal arch, including two archangels and a scene of Emperor Constantine IV presenting Bishop Reparatus with his episcopal authority, probably belong to the later seventh century.

154, 155 Above: the exterior of Sant'Apollinare in Classe, Ravenna. Right: detail of the apse mosaic in the same church, showing St Apollinaris as a shepherd interceding for his flock; above the Saint is a huge jewelled cross with a central roundel of Christ

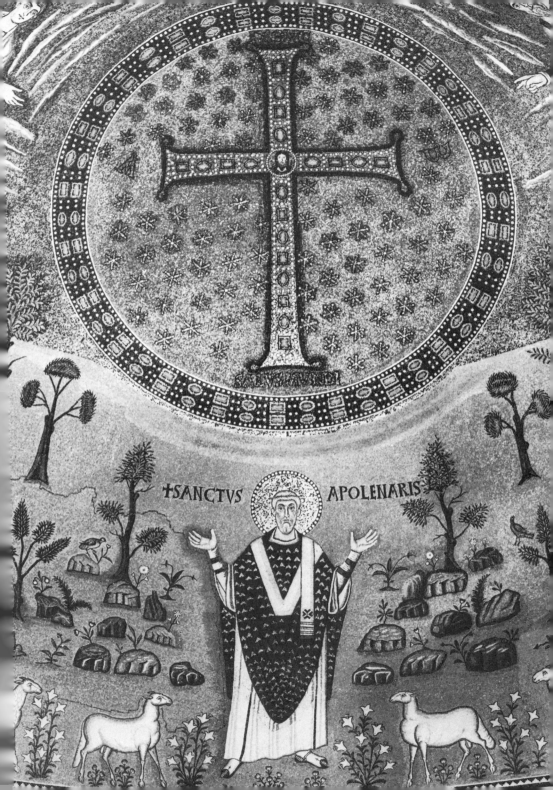

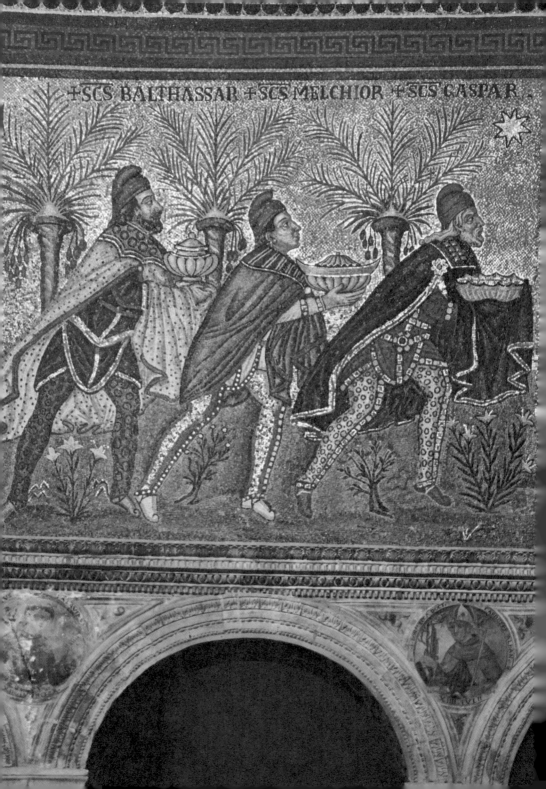

✝SCS BALTHASSAR ✝SCS MELCHIOR ✝SCS GASPAR .

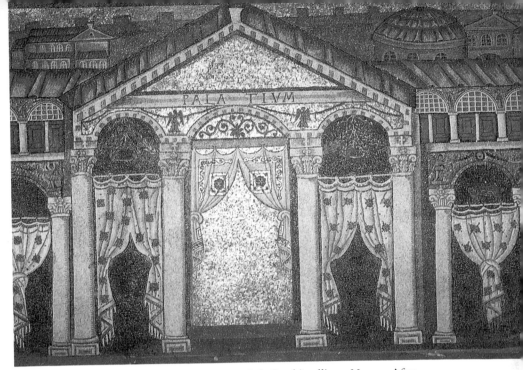

157 The palace of Theodoric at Classis in a mosaic in Sant'Apollinare Nuovo. After Justinian took Ravenna the portraits of Arian nobles, which formerly stood between the columns, were replaced by curtains

The tableau of emperor and bishop is perhaps consciously reminiscent of the Court panels in the apse of San Vitale.

Sant'Apollinare Nuovo was, of course, founded by the Arian Theodoric, and some of the mosaics of this first period, notably the panels above the windows of the clerestory, have survived because they were not apparently offensive to Orthodox susceptibilities after Ravenna's reconquest for Byzantium. Theodoric also commissioned mosaics for the areas above the two interior colonnades; on the north side is a procession from the port of Classis (a charming little vignette including ships at sea) towards an enthroned Virgin and Child with four attendant angels. The procession on the south side started from Theodoric's palace, and made its way to a similar supernatural goal, 157 that of Christ, attended also by four angels. In both cases the points of departure and the final groups were left undisturbed, though some figures who originally stood between the columns of Theodoric's palace must have been recognized as Arians and were expunged,

◀ 156 The three Magi bearing gifts, a detail from the mosaic in Sant'Apollinare Nuovo shown overleaf (ills. 158–60). This part of the mosaic dates from the time of Justinian

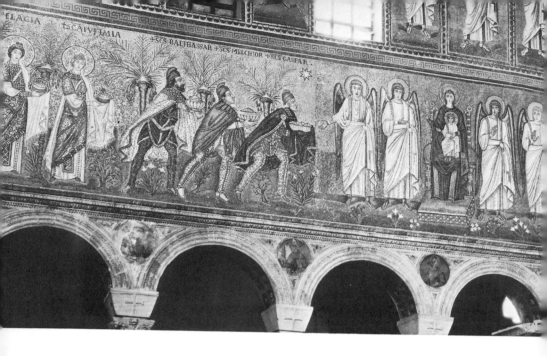

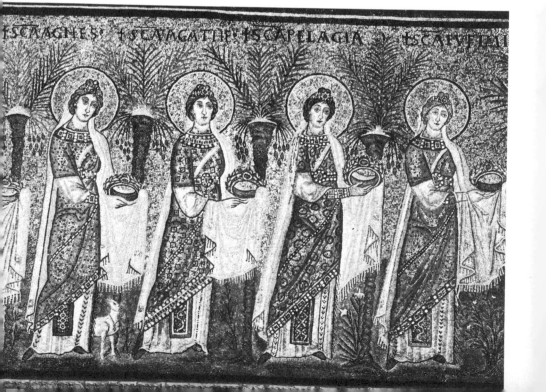

though not totally; a few hands, obviously raised in prayer, were forgotten and remain visible as an unhappy reminder of religious intolerance carried to extreme limits. The processions themselves, including even the Magi who carried gifts to the Infant Christ in the guise of suppliants, were entirely replaced, in the north by female martyrs, and in the south by male saints, each carrying his martyr's crown. These mosaics, though probably completed shortly after the old emperor's death, bear the authentic stamp of the Justinianic age. The background is, predictably, of gold, and the processions move with a slow rhythmic dignity (a rhythm enhanced by the colonnades below) against an artificially pastoral background of flowers and trees. The overall impression is one of continuing movement, with that of each figure temporarily arrested, for the slight variations in pose and drapery suffice to hold the viewer's total attention. The figures themselves are unaware of our presence, and are independent of temporal or spatial illusionism.

158
159
160

158, 159, 160 Above: against a gold background a procession moves towards the enthroned Virgin and Child (another survival from the reign of Theodoric) in this impressive mosaic in Sant'Apollinare Nuovo. Below: two details from the same mosaic, showing female martyrs (left) and male saints (right). These probably date from the late Justinianic period

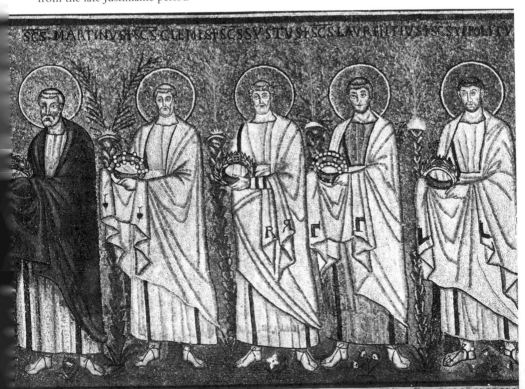

The Justinianic age was notable not only for its attempt to recreate the old Roman empire under the supreme authority of Christ; it was also an age of church building and of an artistic renaissance in the lay as well as in the ecclesiastical sphere. In this chapter, only the most famous churches in the capital and in the exarchate of Ravenna have been described in any detail. It should not be forgotten, however, that in other lands subject in name at least to the emperor, sixth-century foundations abound. At Sabratha in North Africa is the

basilica of Justinian, with not only its mosaic, but much of its original furniture still extant. At Jerash in Jordan, no less than seven churches were built in this period, and Harrison's recent researches in Lycia have shown that on the southern side of Alaca Dağ, a mountain immediately to the north of the ancient Myra, a number of monasteries and churches, notably at Karabel and Alacahisar, were probably of sixth-century date. In the monasteries just named, the church consists of a nave and two aisles with a trefoil sanctuary which acted partly as support for a dome, the rest of the stress being taken by the main transverse arch to the west – the crowns of arches and apses being linked by pendentives which provide the circular seating for the dome itself. At Alacahisar the trefoil sanctuary is cut from the living rock, but at Karabel the church is entirely free-standing and there is also an atrium to the south, complete with a well. Of the other monastic buildings, a baptistery was discovered to the north of

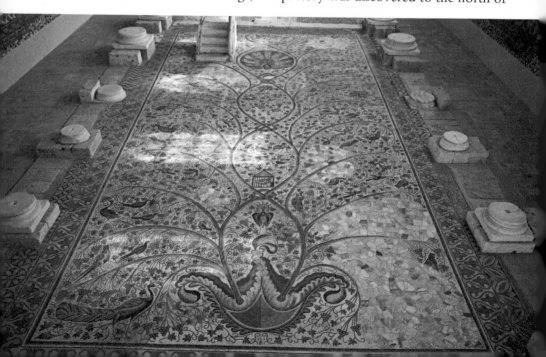

the church. In it was a cruciform font, with an inscription naming one Nicholas, who has been identified with St Nicholas Sionites, and the whole monastery with the monastery of Nicholas Sionites which was built under Justinian. In the west, the baptisteries at Nocera Superiore in Italy and at Grado in Istria are both sixth-century foundations; in France the baptisteries at Fréjus, Vaisons-la-Romaine and Nevers are evidence for a similar spate of religious building at this period, though Fréjus may be slightly earlier. At Vienne, in the Rhône valley, a small portion of the apse of St André-le-bas goes back to the sixth century, and the present Musée Lapidaire in the same place was originally the contemporaneous church of St Pierre. The latter was in fact the cathedral of Vienne before its destruction by the Moslem invaders of the eighth century.

SCULPTURE

Although the age of Justinian was one in which the fusion of a number of differing artistic traditions resulted in a truly 'Byzantine' art with recognizable characteristics, the ivory throne of Maximian, the bishop whose mosaic portrait in the apse of San Vitale at Ravenna is specially evocative of that First Golden Age, is anything but homogeneous. No one has yet satisfactorily placed its provenance, though the present writer believes, as did Talbot Rice, that Constantinople, that unique clearing-house of the early Christian artistic world, saw it commissioned and its various panels assembled, no matter where they were first carved. Certainly it was the work of several, at least four, hands, and considering that craftsmen from every corner of the Byzantine world were at hand to see the job through in Constantinople it seems unlikely that a Ravenna bishop would have had an ivory throne transported from Egypt or Syria. On the front *162* of the throne, just below the seat, is the monogram of Maximian in Latin between two peacocks forming part of an inhabited scroll, and carved in the tradition of contrasting effects of light and shade which began in Syria but was by this time general. Below this decorative border are five columnar niches, of which the central one houses an effigy of St John the Baptist, and the four others figures of the Evangelists. Constantinople has been suggested as the probable workshop in particular for these, the most exquisite panels of the throne; they are certainly very reminiscent of the St Michael leaf which *120*

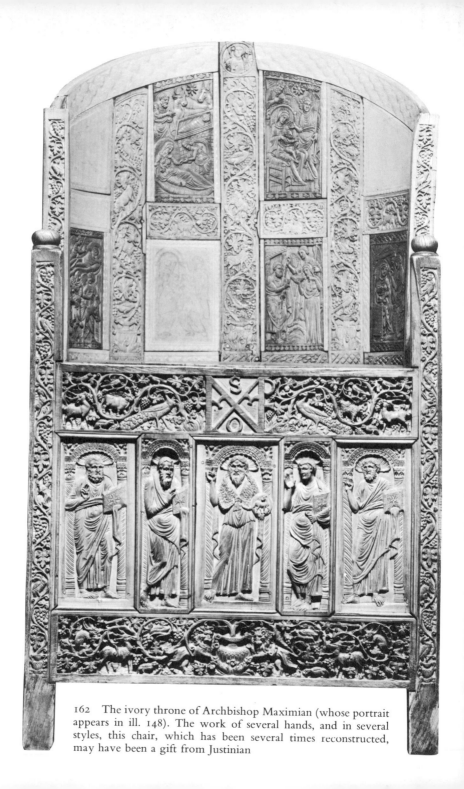

162 The ivory throne of Archbishop Maximian (whose portrait appears in ill. 148). The work of several hands, and in several styles, this chair, which has been several times reconstructed, may have been a gift from Justinian

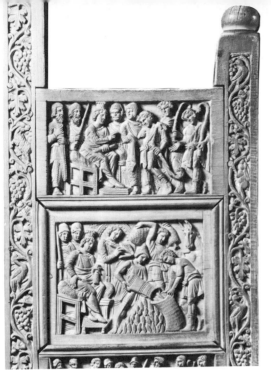
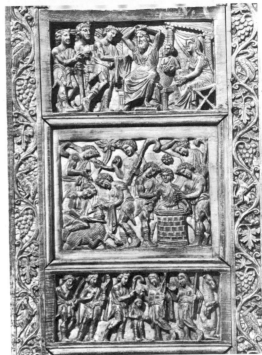

163, 164 Two details from the sides of Maximian's throne, both illustrating the life of Joseph in a series of vivid scenes

is now in the British Museum. Below the figures is another band of inhabited scroll, this time issuing from a central amphora. It seems very likely that it was by the same craftsman responsible for the other band. On the backrest the panels representing scenes from the New Testament are, on the other hand, somewhat insipid, and the relief is flatter and lacks contrast. On the rather dubious grounds that Alexandria may be associated with a 'picturesque' style, of which nothing is really known in the period of the throne, these panels have been assigned by some to Egypt, but more convincingly attributed to the same source are the panels illustrating the life of Joseph on both sides of the throne. Whereas the New Testament panels of the back are dryly factual within the limits of the super- *163, 164* natural events which they portray, the Joseph cycle has been done with obvious verve and sympathy on the part of the artist for his subject. The borders of the panels are all of inhabited scrollwork.

Despite the high quality of the component parts, it does the throne no injustice if we describe it as a pastiche.

What is very probably a companion piece to the throne of Maximian is the ivory diptych in the State Museum in Berlin. Indeed the similarity of the niches on the leaves of the diptych to the niched panels on the front of the throne is so marked that the conclusion that one workshop was responsible for both is almost inevitable, and one artist very likely. The treatment of ears and noses is identical and highly individual; the circular swirl of drapery in the stomach area is repeated in the Christ of the Berlin diptych and in the Evangelist figures on the throne. Note, too, the Semitic character of Christ's features in the diptych and of His cousin's in the contemporary ivory at Ravenna.

METALWORK

Precious metal, whether in the form of coinage or of objects in lay and religious use, is very often (indeed in the case of money almost invariably) stamped with the control mark of the issuing authority or manufacturer. The period immediately preceding the accession of Justinian and of more than a century after it is richly represented, and proves that the gold- and silver-smiths of Constantinople kept the classical style very much alive in works not designed for liturgical use. Unstamped, but possibly close in time to the Barberini ivory (see above, p. 134), is the large silver dish in Istanbul with a female personification of India as the central theme. The goddess is enthroned on a chair supported on elephant tusks, with a monkey to either side of her feet. An Indo-Bactrian artist of the Hellenistic age could not better have captured the Oriental spirit. A smaller silver dish, in the Hermitage at Leningrad, with a beautifully balanced pastoral scene of a goatherd taking his ease on a stone seat while one of his goats nibbles destructively at a young sapling, is datable to Justinian's reign, as also is the much less polished work on another silver dish in Leningrad, this time representing a specifically pagan scene of Aphrodite visiting Anchises in his tent. Beckwith has found this piece more in tune 'with a much freer and more simplified Hellenistic style' than the goatherd dish just described. Might it not equally be classified as more consciously archaizing? The style of the scene would not, *mutatis mutandis*, be so incongruous on a funerary stele of the fourth

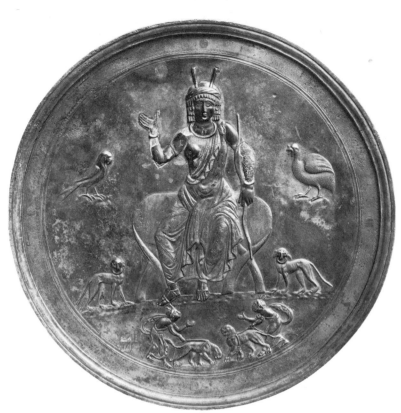

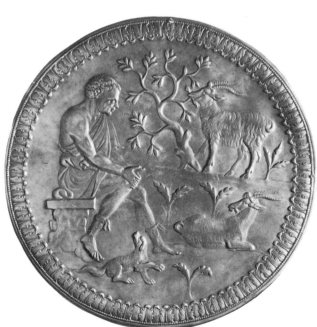

165, 166 Two silver dishes, one
(above) depicting a female
personification of India, the other
(right) a pastoral scene of a
goatherd and his flock, from
the time of Justinian

century BC. The fine silver and silver-gilt plate of a blatantly pagan
satyr and maenad enjoying a post-prandial dance actually belongs to
the age of Heraclius (610–41); the style is again classical, somewhat
mannered at this late date, but still full of *joie de vivre*.

The Emperor Leo III drew his own conclusions from the sudden
reversal of what had until then appeared to be a God-given dispensa-
tion, and instituted the Iconoclast policy which is now indissolubly
associated with his name and that of his son and successor, Constan-
tine Copronymus. In Constantinople itself, only the great cross
which was substituted for the earlier naturalistic composition in the
apse of St Irene remains as proof of the abhorrence in which icons
were officially held in the eighth century, though it may be noted that
Justinianic mosaics in the capital seem to have been largely aniconic.

The silver-gilt dish of Paternus, bishop of Tomi on the Black Sea,
is a paten, and so designed solely for religious use. Most probably it
was made under Justin I, certainly at Constantinople, and is now
in Leningrad, where so many of Christendom's Eastern antiquities
are housed. The decoration of the paten is aniconic, with a central
Chi-Rho flanked by an Alpha and Omega (all in repoussé work);
round the rim runs a border of inhabited vine-scroll. Two other
patens, one in Istanbul and the other in the Dumbarton Oaks collec-

167

170

168, 169

167 A dancing satyr
and maenad on a silver
dish of the age of
Heraclius, but
evoking a much earlier
period

168, 169 Though the styles are dissimilar, the same subject, the Communion of the Apostles, decorates these silver patens, one at Dumbarton Oaks (left), the other in Istanbul (right). In both cases Christ is shown twice

170 The aniconic Dish of Paternus, with a Chi-Rho monogram and an Alpha and Omega; birds and beasts inhabit the vine-scroll border

tion at Washington, DC, both date to the reign of Justin II (565–78). They are both decorated with the same scene, representing the Communion of the Apostles, and at first sight have a superficial resemblance. In each case a draped table beneath a baldaquin occupies the centre, and the figure of Christ is duplicated (one to the right, the other to the left) as He offers the host or chalice to groups of His disciples. There is, however, a marked difference in style, for there is a light, ethereal quality to the Istanbul example which is lacking in the down-to-earth factual narrative style of the other. It would be untrue to say that the essentially religious character of either is affected by these variations in style, for the instinctive use of Hellenistic naturalism is here interpreted according to the competence or taste of the maker, to represent an historical and, at the same time, a supernatural event. The discussion of provenance seems a little pointless, for the control stamps are of Constantinople and there was room for more than one style in such a city and at such a time.

PAINTING

171 One of the earliest illustrated Christian manuscripts is the copy of Genesis in the National Museum in Vienna. The text is on purple vellum, which denotes the high status of the individual or foundation to whom it belonged. The pictures, arranged in either a single or double register, are placed at the bottom of the page, exactly below the text to which they refer. It is generally agreed that the illustrations are the work of several artists, though authorities are unable to agree on the number; three, however, are specially distinctive in style, but in their fidelity to the text they share one notable characteristic. This is most marked perhaps in the case of the illuminator of the first six leaves, e.g., in the scene depicting the drunkenness of Noah (Genesis IX, 20–23), where 'Shem and Japheth took a garment, and laid it upon both their shoulders, and went backward, and covered the nakedness of their father; and their faces were backward, and they saw not their father's nakedness.' The scene of Rebecca at the well is familiar, and so typical of the artist's realism (Genesis XXIV, 15–18) that it may well be the work of another and more sophisticated painter; the picturesque background, the attention to natural detail and the Hellenistic touch of a nymph at the well suggesting a possible Alexandrine provenance. An equally literal

174

171 Eliezer and Rebecca at the well, from the Vienna Genesis. The female figure on the left is the nymph of the fountain

interpreter of a good story is the artist responsible for the illustration of much of Joseph's dramatic career, from his experience of fraternal treachery to his attempted seduction by Potiphar's wife. This was an artist who revelled in the histrionic possibilities afforded by the latter text (Genesis XXXIX, 11–13). 'And it came to pass about this time that Joseph went into the house to do his business; and there was none of the men of the house there within.' The illustration is highly graphic and made far more telling by the presence of a number of women and children. Less memorable is the wooden style of the painter who illustrated the closing episodes in Joseph's career. Joseph's meeting with his old father after years of separation could have inspired a moving picture. Instead, the angularity and harshness of the work is almost unsympathetic. The Vienna Genesis is probably a sixth-century work, and an example of what was then expected and produced for a wealthy patron of the Church. The so-called Cotton 174 Genesis (or what still remains of it in the British Museum) reflects in its illustrations the still charming, if vapid, manifestation of the late Hellenistic style that, in less competent hands, gave a naive and childlike appeal to some of the Catacomb paintings. The Cotton Genesis is of the early fifth century, yet the paintings show little trace

172 The Communion of the Apostles, from the Rossano Gospels; the figures and postures are rather stylized in the Byzantine manner

of the Theodosian renaissance which must have preceded it; they seem rather to have outlived their time, and to represent a way of thought and its expression that was on its way out.

172, 173 A superb evangeliary in the Archiepiscopal Museum at Rossano in Calabria is a parchment codex with the text in silver uncials on a purple background. Unlike those of the Vienna Genesis, the illustrations are more or less homogeneous, and the work should probably be assigned to sixth-century Constantinople. The rather squat figures with their stylized drapery and mannered gestures suggest, however, that the artist may have been a native of Asia Minor. But however generally homogeneous the illustrations, a distinction should probably *172* be made between the illuminator of the Communion of the Apostles and the painter of the scene in Pilate's Judgment Hall when Christ *173* and Barabbas are haled into the procuratorial presence. In the Communion, the Byzantine tradition is dominant, with the obeisance of the two communicants reminiscent of the posture *127* of the adorant angels on the Dağ Pazarı thurible; on the other hand, the absence of a third dimension or of any background detail, except an almost level base-line, somehow recall the technique of the late archaic or early classical Greek pot-painter, whose

176

173 Another illustration from the Rossano Gospels, Christ and Barabbas brought before Pilate, which is more in the Hellenistic style than the Communion opposite

characters play their roles as if against a backcloth. Hellenistic and more dramatically picturesque, with even the suggestion of a third dimension, is the confrontation of Christ, the innocent victim, and Barabbas, the convicted bandit who was destined to be freed. The contrast between Christ Who, even at this moment of human degradation, is master of the situation, with the physically repulsive criminal, is a brilliant piece of characterization. Relentlessly cruel is the depiction of the vindictive rabble of fanatics jabbing their forefingers at the weak but conceited official, to underline the threat that turned the scale against Christ. 'If thou let this man go, thou art not Caesar's friend!' (John, XIX, 12).

This scene from the Rossano Codex is intentionally unnerving; but it is a strange coincidence that the earliest known fragment of any part of the New Testament should be a passage from the same sequence of St John's Gospel (XVIII, 37), and that by contrast it should be totally reassuring. It is a scrap of papyrus, copied in Egypt in the mid-second century and now in the John Rylands Library in Manchester. On it, though with many *lacunae*, are the unforgettable words 'To this end was I born, and for this cause came I into the

174 A fragment from the Cotton Genesis; its origin is in doubt but appears to be Alexandrian

world, that I should bear witness unto the truth. Every one that is of the truth heareth my voice.' Even out of context, the passage would be arresting, for the claim made in it is all-embracing, a claim demanding scrutiny. On the other hand, had the words preserved been part of the opening section of St Matthew's Gospel (I, 1–17), they might have excited the interest of a professional genealogist, but surely of few others. Incidentally, the reading of the John Rylands fragment is not in doubt, since wherever it can be checked, and such a check is not hard to make, it conforms, word for word, with the established text of later codices.

If the illuminations of the Rossano Codex have a massively reassuring quality for the often literal-minded Westerner, those of the Rabbula Gospels (an evangeliary written and illustrated in 586 by *175, 176* monks at Zagba in eastern Syria) are more imaginative and colourful, if less sophisticated stylistically. Considering the relatively late date of the manuscript, its illustrations might perhaps be expected to reflect the Syrian attitude to the Monophysite controversy; but however much dogma might be in dispute, there is no evidence that the validity of the Christian scriptures was open to doubt before the rise of Islam. The illuminations of the Rabbula Gospels are therefore of iconographic rather than of sectarian importance.

The text of the Rabbula Gospels is in Syriac, but the style of the paintings, though essentially Eastern, owed not a little to Hellenism. For example, the name of the soldier, Longinus, who pierced the side of the crucified Christ, is written in Greek, and the cultivated pastoralism of Gethsemane is more reminiscent of the Mediterranean littoral (Antioch perhaps) than of the stern Syrian hinterland. Of the completely illustrated pages of the evangeliary, some were Canon Tables, or concordances of the contents; others represented the Crucifixion, the Ascension, the first Pentecost and Christ in Glory. *175, 176* Of the two artists involved, the painter of the Ascension was specially effective. He depicts Christ in a mandorla, attended by adorant angels and raised aloft on a throne provided by the winged beasts of Ezekiel's vision (Ezekiel, I, 5–27), the account of which was, very appropriately, read on Ascension Day in the churches of Syria. Below the vision is the Theotokos, who represents here the Church on earth in the absence of its divine founder; she is depicted as an *orans*, as she continues to be when playing this role in Near Eastern

179

art (cp. the Virgin *orans* in the painting dating from the late eleventh or early twelfth century in the apse of the rock-cut church at Eski Gümüs in southern Cappadocia). To the right and left of her are the Apostles, 'and while they looked steadfastly toward heaven as he went up, behold, two men stood by them in white apparel' (Acts, I, 10). This combination of a factually rendered scriptural account with the symbolic representation of the supernatural is not uncommon in contemporary Byzantine art (cp. the apse mosaic of Sant'Apollinare in Classe) and contains more than is sometimes allowed of Hellenistic naturalism. Drapery follows bodily form and does not defy gravity. A three-quarter view is happily achieved, and the eyes not only see, but see intelligently.

The Crucifixion and Resurrection scenes are arranged in two registers, as if the second artist, whose work it is, was copying from an illustrated *rotulus*. He was also a less competent painter than the other, and appears too to be more interested in absolute fidelity to the scriptural narrative than in the inner significance of the events depicted. The scale of the figures varies according to their importance in the scene, so that even the two crucified thieves are of the same proportions as Christ Himself, though He is raised higher than they and wears the long robe (*colobium*) of a person of consequence rather than the loin-cloth of the criminal.

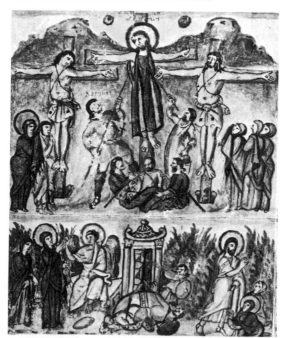

175, 176 Two vivid though unsophisticated scenes from the Rabbula Gospels, an evangeliary from Syria. Left: the Crucifixion, and the Resurrection below. Opposite: the Ascension, with Christ in a mandorla, and the Virgin in the posture of an *orans*

177 A fresco of the Crucifixion in Santa Maria Antiqua in Rome is so completely Oriental in its iconography that only its Latin legends and eighth century date betray its origin as the work of monastic refugees from Iconoclasm. As in the Rabbula Gospel illustration, Christ wears the *colobium*, and the title above His head is in fact in Greek; the Virgin on His right and St John on His left, both with a Latin identification, are the only concession to an alien, if orthodox, population. It may be salutary to recall the fact that when Pilate had the title written 'it was written in Hebrew, and Greek, and Latin.'

Another form of painting, especially associated with the Eastern Church, is that of the icon. The icon may well have originated in Egypt, where it was common pagan practice to adorn mummy cases with portraits of the dead, or to fix wooden plaques painted with their likeness over the shrouds of the less wealthy. For these portraits the encaustic process of burning coloured wax into the surface of the wood was used, a technique which had the advantage of producing a very tough finish which, combined with the climate of Egypt, made the portraits well-nigh indestructible. The earliest known Christian icons are examples from St Catherine's monastery in the Sinai, so it seems not unlikely that the pagan Egyptians' veneration of the likenesses of their dead was later transferred to Christ, the Virgin and the saints. That the icon is held in special reverence in some Eastern liturgies, to the extent that the sacred image is still treated almost as a 'real presence', is perhaps confirmation of the continuity of tradition. Furthermore, monasticism first took root in Egypt, and it is note-worthy that the fiercest opponents of the Iconoclast movement were the monks.

179 The earliest known icon, of the sixth century, represents the Virgin, enthroned and wearing imperial purple, as a young mother of highly individual features and positive personality. The frontality of the figure is relieved by the leftward glance of her eyes and by the relaxed posture of the Infant Christ Whom she supports in her lap. As Weitzmann has so justly observed, the head of the Child 'with its oversized forehead bespeaks great intellect. In this fashion the Byzantine artist pictorially expressed his belief in the human and divine natures in Christ.' The two soldier saints, George and Theodore, who flank the central group, may be thought perhaps to symbolize the readiness of the Church to defend its beliefs, as all too soon it was

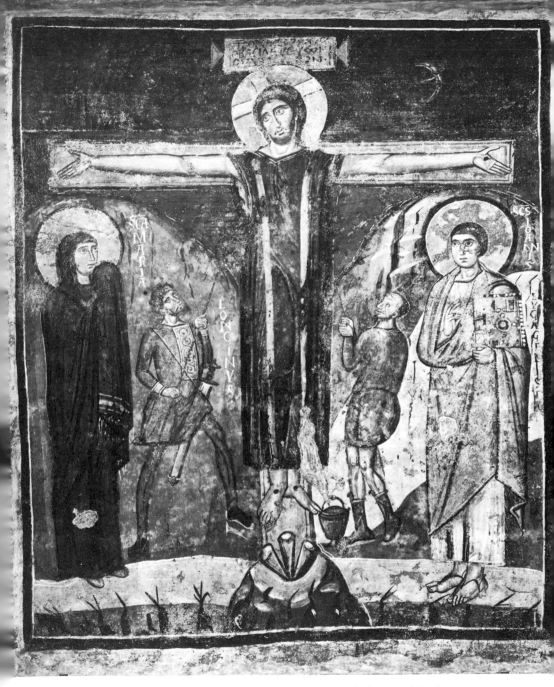

177 The Crucifixion, a fresco in Santa Maria Antiqua. Both here and in the
Rabbula Crucifixion Christ wears a *colobium*, or long robe denoting rank, instead of
a loin-cloth (the latter was offensive to the rather puritanical Eastern mind)

179 Another icon
from St Catherine's
monastery, the
Virgin and Child
enthroned between
Sts George and
Theodore, an
intensely expressive
group ▶

178 St Peter, an
icon from the
monastery of
St Catherine on
Mount Sinai.
The Saint, bearded
and with a halo,
is dignified and
authoritative

178 fated to do. It is this fact perhaps that makes the strikingly beautiful icon of St Peter, also in St Catherine's monastery, a little poignant, for it was painted in the seventh century, when the Mediterranean world stood on the threshold of a new era. This St Peter, a figure of towering authority, with his keys and pilgrim's cross, is the very embodiment of the rock on which Christ built His Church. Just as on a consular diptych, the dignity of office is stressed by a small roundel enclosing a portrait of the reigning emperor, so the heads of Christ, the Virgin and (very probably) St John portrayed at the top of the icon give added strength to the Prince of the Apostles. St John, if it is he, is portrayed as very young, and is perhaps intended to represent all mankind in the renewed innocence of the Redemption, recalled in Christ's own words from the Cross, 'Woman, behold thy son!' (John, XIX, 26).

184

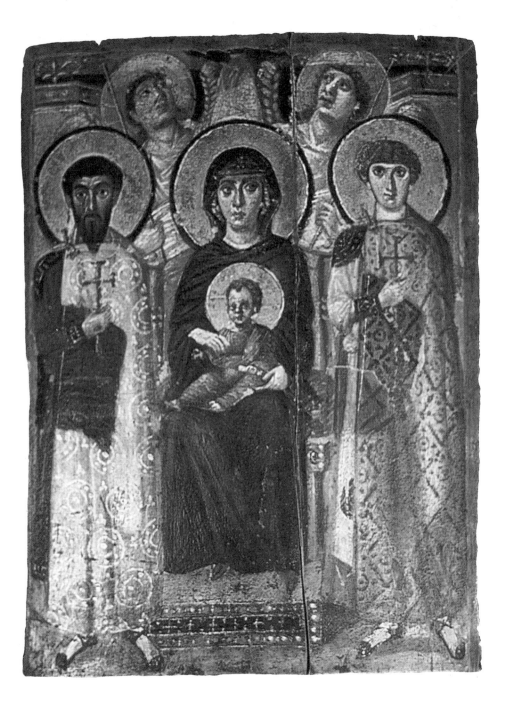

That there was a renaissance in Italian art inspired by refugees from Iconoclasm is beyond doubt. The fresco in Santa Maria Antiqua is a case in point, and the debt to Byzantium is clear, and so it continued to be, even if the interpretation became Italianized in the course of time. There was also, of course, a native Italian art of which very little has survived before the introduction of a renewal from the East. True to his native heritage of *Romanità*, the Italian artist was usually more interested in a story than in its significance. Indeed, it is something of a reflection on the competence and inspiration of Italian art in the seventh century that the most admired and illustrated work should be the painting of the Virgin and Child on a wooden panel in Santa Maria Nova in Rome. Even granted its poor condition (it had been overpainted and then recovered by modern methods of stripping), the picture is hard to admire. Clearly the artist aimed at an atmosphere of spirituality at the expense of realism, but fell between two stools. The Virgin is insipid and wraith-like, her long face floating above the drapery, while the low forehead and eyebrows forming a continuous line with the nose shadow produce an almost grotesque appearance. It is sadly clear that Italy had too long been out of touch with Hellenistic refinement and that dash of Semitic emotionalism that gave to Byzantine art its special savour and *élan*. By the time that the paintings in San Clemente were commissioned in the ninth century under Pope Leo IV, Italy was alive again; but this is outside the scope of this book.

CHRISTIAN ART IN BRITAIN

The sudden and exciting revival of civilization in the Atlantic West, after the dismally protracted collapse of the old order imposed by Roman imperialism for over a half millennium, sprang from an unexpected source, a land that the legions had never penetrated, a land finally overcome not by the organizational genius of Rome, but by the inherited genius of the Christian Church. Ireland was, in fact, the only effective link during the so-called Dark Ages between the old Mediterranean world and encroaching barbarism. St Ninian in Galloway and St Patrick in Ireland were well aware that they were missionaries of a Church whose headquarters were in Rome; on the other hand it is most unlikely that either understood his journey to

the distant Celtic West as a renewal of an old prehistoric pattern, a pattern interrupted only briefly, in terms of world history, by an aggressive Mediterranean power. Christianity had, of course, reached Britain while that island was still a Roman province; but such art as it possessed was at second hand, and the paintings at Lullingstone and the mosaics at Hinton St Mary do not persuade us of a Romano- British ecclesiastical art. No more essentially British is the little basilica at Silchester. It is true that St Augustine was surprised to find that the England he had been instructed to convert was, at the end of the sixth century, not entirely pagan; but it was Ireland, unlettered and barbarous so shortly before, that was to rekindle the *lux aeterna* which Constantius Chlorus had claimed to restore in 296 after the overthrow of the British pretenders, Carausius and Allectus.

61

It is possible that St Patrick, whose mission transformed Ireland from a backward country in the fifth century to the centre of North European culture in the seventh and eighth, stayed for a while at Lérins, near Cannes, where the monastery was organized on Coptic lines, and this would help to explain why Irish Christianity seems from the first to have owed a considerable debt to the East. The countryside was undoubtedly primitive, but priests and scholars, in this case probably synonymous, were familiar with the language and literature of the classical world, and by the sixth century at latest a distinctive Irish script already existed, and with it a type of ornament which had much in common with the art of Celtic paganism, from which it was in direct descent. It was not, however, until the seventh century that Irish Christian art entered its own golden age.

It may be recalled that an important contribution to the life of the early Church was ascetic monasticism as practised by the Copts of Egypt. That this was largely a reaction to the licence and depravity of the Greek communities in Egypt has already been explained (see above, p. 16), and it is likely that a western migration of some of the monks was already under way before the Arab invasions of Egypt and the rest of North Africa gave impetus to such a movement. Such people would have brought with them their own copies of the scriptures as well as other portable objects, and some of the earliest illuminated Irish manuscripts are clear evidence of this fact. A further complication in any appreciation of the golden age of Irish art is that monasteries, which were united by their allegiance to St Columba's

180 One of the symbols of the
Evangelists from the Book of
Durrow–St Matthew, represented
by a man

181 A 'carpet page' from the
Book of Durrow, showing both
Coptic and Anglo-Saxon
influences in its design ▶

rule, were widely separated in space, so that an intrusive Anglo-
Saxon contribution may combine with the equally intrusive Oriental
and fundamental Celtic to produce an amalgam enigmatic enough to
make a decision on provenance hazardous without definitive evi-
dence.

180, 181
181

180

Before it was presented to Trinity College, Dublin, the Book of
Durrow was housed in the Columban monastery in Co. Offaly. It
displays all those diffuse characteristics just described, for on the so-
called 'carpet page' at the beginning of St John's Gospel are motifs
drawn from other than Irish sources. Coptic is the interlacing dia-
gonal and circular design, while the continuous band of stylized
animal is copied directly from Anglo-Saxon models. The only com-
mon element in the whole work is its uncompromising rejection of
naturalism. All the same, the Evangelist symbols which presumably
set a seal of authenticity on the Gospel in question are unquestionably
Mediterranean in inspiration. Rather conveniently, St Matthew's
symbol is that of a man, so that it is easier perhaps to judge the

188

competence of the Durrow illuminator in this case than if a lion, ox or eagle were to be depicted. As it is, the style used to portray this 'man' is totally devoid of illusionism, and rather approximates to the two-dimensional ornament of pre-Christian (La Tène) Celtic metal-work.

At the monastery of St Gall in Switzerland, Irish manuscript illumination was being done in the mid-eighth century, and it is somehow rather weird that in a centre so much nearer the Mediterranean than Ireland, the Evangelist symbols in Codex 51 are no less naive than in the Book of Durrow, and the interlace patterns unconvincing and almost banal. Nevertheless the St Mark page is quite charming, the figure of the Evangelist an exercise in calligraphy rather than a painting, while the four framed symbols at the corners of the page suggest to the irreverent superb designs for enamelled brooches or clasps.

182

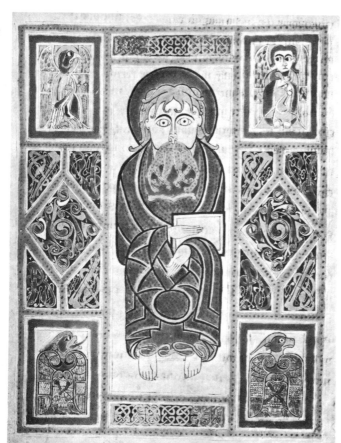

182 St Mark, from the St Gall Codex 51, more a pleasantly decorative design than a portrait

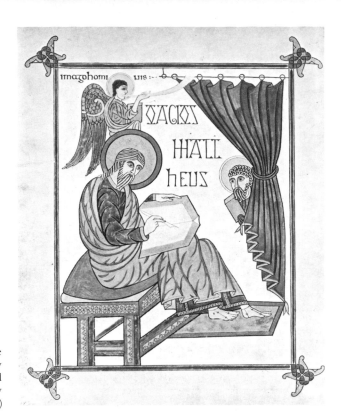

183 St Matthew in the
Lindisfarne Gospels, clearly
derived from the 'seated
philosopher' of early
iconography (see ill. 16)

Illuminated earlier in the eighth century is the Gospel Book from
Lindisfarne in Northumberland, perhaps the most beautiful, and
certainly the most sophisticated, example of Hibernian art. Where the
carpet page of the Book of Durrow is relatively simple and its scope
limited to rather few motifs, an ornamental page from the Lindisfarne
Gospels is as richly inventive and exciting as a fine Persian carpet.
Moreover, the various elements of the design (whether originally
Irish, East Mediterranean or Nordic) are here amalgamated into a
coherent and symmetric whole and, as a masterpiece of abstract art,
remains, in the present writer's view, unsurpassed. It is hard to
consider such work 'barbaric', except in so far that some of the
motifs used were native to peoples who had only recently been
weaned by Christianity from barbarism. The Evangelist portrait-
pages are no less surprising in their obvious debt to Byzantine
sources. There is no doubt that the ultimate prototype for the St

183, 184

184

184 A 'carpet page' from the Lindisfarne Gospels, even more elaborate and striking
than that of the Book of Durrow (ill. 181)

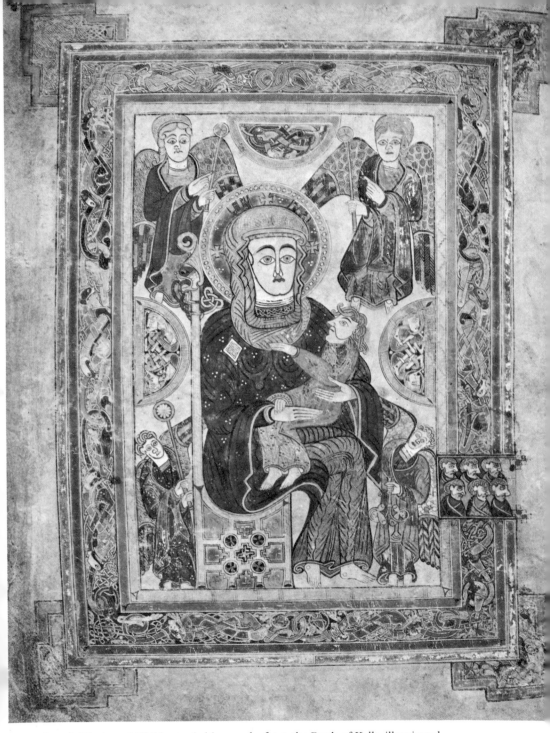

185 A Virgin and Child attended by angels, from the Book of Kells, illuminated on Iona in the early ninth century

Matthew figure is the 'seated philosopher' who appears frequently
183 on late pagan and early Christian sarcophagi, nor that some enthroned
imperial figure was the model for the St John. There is no apparent
horror vacui, and there is a very real attempt made, however unsuccess-
ful, to achieve an illusion of perspective. Furthermore, the deep
spiritual quality of the portraits and the lack of naivety suggest an
East Mediterranean source, even if (as Talbot Rice suggests) at
second hand. This hypothesis becomes the more attractive when the
descriptive legends are examined, for the originals were clearly in
Greek. Why otherwise should *hagios* (the Greek word for 'saint') be
retained but carefully transliterated into the Latin script familiar to a
monk of the Western group of churches? The scribe's attention
wandered on the St John portrait page, where he misspelt the
Evangelist's symbol as *imago aequilae* (instead of *imago aquilae*).

Perhaps the most colourful of all Irish manuscripts is the so-called
185 Book of Kells, which was probably illuminated in about 800 and is
now in the library of Trinity College, Dublin. This profusely illus-
trated and profoundly original work was probably brought to a new
monastery at Kells in Co. Meath, after Iona had been overrun by the
Norsemen at the beginning of the ninth century. Less refined than
the Lindisfarne Gospels, the Book of Kells is almost overwhelming in
its colourful elaboration, for it seems to have drawn from the whole
available range of contemporary models, and so forms by itself
something like a compendium of all the iconography known to the
Irish illustrators of the golden age. The first page, with its cruciform
design and the Evangelist symbols occupying the quarterings made
by the arms of the cross, is recognizably Irish. Originally from
Byzantine/Syrian sources (though it fairly soon gained currency
throughout Christendom) is the arcaded Canon Table which follows
it. A Virgin and Child attended by angels owes a clear debt, at
however distant a remove, to East Mediterranean models. The range
of colours used is dazzling in its elaboration, but the atmosphere of
barbarism is far stronger than in the portrait pages of the Lindisfarne
Gospels.

Even the sketchiest account of the Irish golden age would be
187 incomplete without a mention of the Ardagh Chalice. This eighth-
century masterpiece seems far more at home in its native Ireland than
do even the manuscripts, with their picture-pages, at least, dependent

194

on the alien art of the Eastern Mediterranean. The cup itself is made of silver, though some of the decoration is of gold wire or foil, and enamel or glass is used to highlight the studs and panels on the ornamental band below the rim and the two handles. Except in the intrinsic value of the different metals used in their manufacture, the Ardagh Chalice can be seen as a direct linear descendant of the first-century Battersea shield. Filigree seems to be an import from the Anglo-Saxon world; but there is little other innovation to suggest the passage of so many centuries between the shield and the chalice.

From Athlone a bronze plaque of the Crucifixion, possibly attached *186* originally to the cover of a bound *codex*, is more or less contemporary

186 A bronze plaque of the Crucifixion from Athlone, which may once have been attached to a book-cover, ornamental rather than iconic

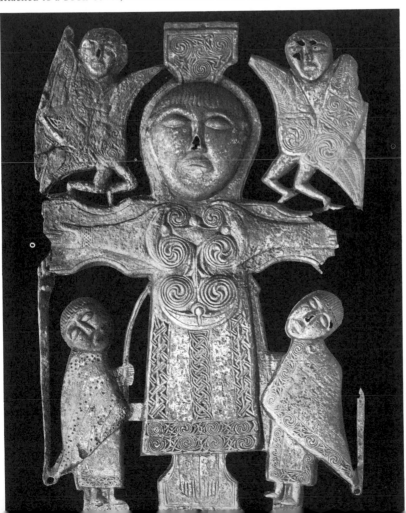

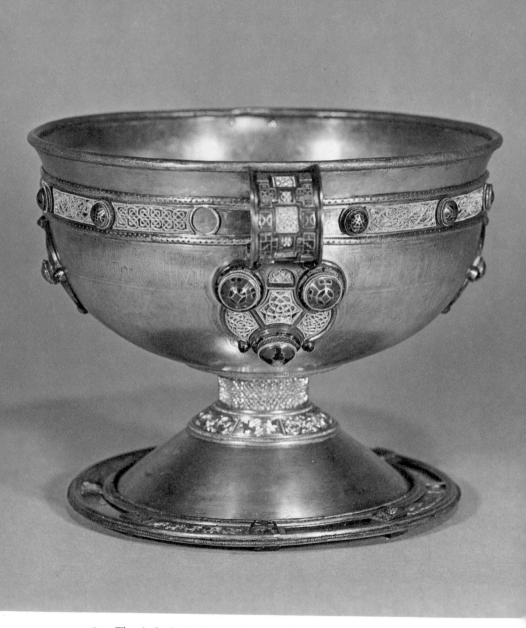

187 The Ardagh Chalice, a silver cup delicately ornamented with filigree and
studded with enamel and glass—an example of the best of Irish art

188 Detail of carved spiral ornamentation on the North Cross at Ahenny

with the Ardagh Chalice. The subject, though clearly inspired by a
Coptic or Syrian source, is treated as two-dimensional ornament,
with no real concession made to nature. Christ is clad in the *colobium*
of Eastern tradition, but the garment itself is no more than a back-
ground to recognizably Celtic ornament.

From the eighth century onwards carved stone slabs and crosses
were also set up in the Celtic world. Their origin unknown, they
may have been in descent from the pagan menhirs, the standing
stones of prehistoric times. Christian influence on their decoration
may have been imparted by Coptic refugees from Iconoclasm as well

197

189, 190 Two stone crosses on the Anglo-Scottish border, one at Bewcastle (left), the other at Ruthwell (right)

as from the Arabs, for such decorated slabs were known in Egypt as well as in the West. Native Irish and imported Anglo-Saxon motifs also had their part to play. Amongst the earliest known Irish crosses (probably of the eighth century) are those at Ahenny in Co. Tipperary. The decoration of both is strongly reminiscent of metalwork, *188, 191* though on the base of the North Cross is a gamut of Pictish-style animal motifs, which suggests that St Ninian's mission to Galloway may have had ramifications beyond the Irish Sea. In the Celtic spiraliform decoration of the same cross too are intrusive animal interlace designs from the Anglo-Saxon world.

On the Anglo-Scottish border are two more stone crosses, one at *189* Bewcastle in Northumberland, the other at Ruthwell in Dumfries-*190* shire. Their date is probably the early eighth century, and their figural decoration, of Christ treading down the asp and basilisk, is much more plainly influenced by classical models than anything of

191 The North Cross at Ahenny; the animal carvings on the base suggest Pictish influence

like date from Ireland. Abstract design plays its part, especially at Bewcastle; but the sculptor was no more trapped by its all-pervading influence than was the illuminator of the Evangelist pages of the Lindisfarne Gospels when contrasted with the artist of a picture page (e.g., the Temptation of Christ) in the Book of Kells.

EPILOGUE

During the seventh century Syria, Palestine, Egypt and North Africa fell to the Arabs, and a large tract of southern Asia Minor was also overwhelmed. Spain was conquered and southern France threatened in the early eighth century, and only a crushing victory by Leo III in 718 saved the 'God-guarded' city of Constantinople itself from Arab occupation. Thereafter, the diminished empire of Byzantium became the main repository of the cultural legacy of Greece and Rome and, although the approaches to the Atlantic from the Western Mediterranean were as good as closed by Arab corsairs, a tenuous Byzantine contact was maintained with Celtic Ireland and with north-western Europe, a contact which prevented the complete eclipse of the representational style in those areas and so paved the way for the Carolingian renaissance.

On Christmas Day of the year 800, when the Frankish king Charlemagne was crowned by Pope Leo III as Charles Augustus, Emperor of the Romans, in St Peter's basilica in Rome, the fortunes of Byzantium, champion of the Christian East, were at low ebb. For the first time in its history the throne of Constantine, Justinian and Heraclius was occupied by a woman (the Empress Irene), and only two years before the Empire had been forced by Harun-al-Rashid to renew its tribute to the Arabs. It is true that long before the ninth century was out Byzantine greatness was to be restored by the brilliant Macedonian dynasty, but in 800 the coronation of a barbarian king as successor to the emperors of imperial Rome must have appeared a gratuitous affront. For the Pope and for Charlemagne himself the situation was quite other, for although Western Europe had long grown used to its Germanic masters, its peoples still considered themselves as being somehow a part of the old Roman empire, and so with an allegiance to the Augustus in distant Constantinople. No doubt to the great satisfaction of Charlemagne, this allegiance could now be transferred from the shadow to the substance; and still

better, from the legalistic standpoint there was no emperor at the Eastern capital.

Charlemagne's coronation inaugurated a new era during which the separation of Western from Eastern Christendom became ever more inevitable. For over three centuries a succession of German rulers had controlled the greater part of Italy, but no one had claimed, or been accorded by the papacy, more than the status of 'king', a title with pejorative overtones to the Roman ear. Charles' case was far different. As a new Augustus he enjoyed an authority in spiritual matters second only to the Pope's, as well as absolute temporal power, and his attempt to model the empire on St Augustine's *Civitas Dei* became the inspiration of medieval Europe and was only abandoned with the advent of the Protestant reform movements. But if Charlemagne's position at Rome and in the West was strong, *vis-à-vis* Byzantium it was precarious, since he had no authority in the Eastern empire, and was not even recognized by Constantinople as emperor of the West until twelve years after his coronation. Theoretically this recognition implied the restoration of a single Roman empire with two equal rulers; in fact it rather pinpointed the differences, cultural and ethnic, that divided the eastern and western halves of this artificial unit.

Particularly in Western Europe, 800 was also an important turning-point in the history of Christian art. As we have seen, during the period of the migrations and its aftermath, representational art lost ground, often to be replaced by its antithesis, an art in which formal decoration had pride of place. The carpet pages in the Book of Durrow are good examples of this abstract type of art. However, sporadic imports of portable *objets d'art* from the Eastern Mediterranean also had their influence on local schools, and Coptic Egypt seems to have contributed not only decorative motifs but a limited repertory of naturalistically conceived figures and scenes suitable for Christian use. The reliefs on the seventh-century crosses at Ruthwell and Bewcastle can hardly be explained otherwise. However, it was only with the establishment of the Carolingian empire that the wheel turned full circle again, and that representational art again became the common currency of Western Europe.

There was no such break with old tradition in the Byzantine world of this period, for the eighth-century Emperors Leo III and

Constantine V proscribed only the portrayal of Christ, the Virgin and the saints, while leaving secular art unaffected by the iconoclast ban. Moreover, many religious artists left the capital to continue their work in the churches of southern and central Italy.

At the beginning of the ninth century, iconoclasm was drawing to its end as an official imperial policy. Long before that century was out a new artistic revival had begun under the Macedonian dynasty, and in spite of changes and setbacks from time to time, the story continues uninterrupted. The reason for this persistence in Christian art can best be explained in the infinite variety of themes that its subject offers, a source of which St John wrote (XXI, 25), 'I suppose that even the world itself could not contain the books that should be written.'

Bibliography

In this bibliography I have unashamedly followed the system adopted by the late David Talbot Rice in his *Art of the Byzantine Era*, an earlier volume in this series. I have therefore confined myself to works in English, French, German and Italian, and reluctantly omitted books (often extremely important) written in less familiar languages like modern Greek, Serbo-Croat, and Turkish. Apart from the books suggested, the reader intending to go further into the subject of early Christian art is advised to consult articles from such journals as *Anatolian Studies, Dumbarton Oaks Papers, Journal of Roman Studies, Cahiers Archéologiques, Byzantion, Byzantinische Zeitschrift, Bollettino d'Arte,* and *Rivista di Archeologia Cristiana.* Also extremely useful are *Belleten* (Ankara) and *Byzantinoslavica* (Prague), both of which publish articles and summaries in more familiar languages of Western Europe, *Revue Archéologique* and *Journal des Savants* (Paris).

As for the books recommended, I have divided these into two categories; the first designed as further background reading, the second representing more specialized aspects of the subject, e.g. Architecture, Ivories, Jewellery, Metalwork, Mosaic, Painting, Sculpture and, in some cases, individual items within those subheadings. In both cases I have listed the authors in alphabetical order, regardless of the language in which the books are written.

FURTHER READING

J. BECKWITH, *The Art of Constantinople*, London, 1961.

Cambridge Mediaeval History, Vol. IV, Pt. ii, pp. 306/326, Cambridge, 1967.

F. W. DEICHMANN, *Ravenna, Hauptstadt des spätantiken Abendlands*, Vol. I, Wiesbaden, 1969.

M. & L. DE PAOR, *Early Christian Ireland*, London, 1958.

M. GOUGH, *The Early Christians*, London, 1965.

A. GRABAR, *Martyrium: Recherches sur les Cultes des Reliques et l'Art chrétien antique*, 3 Vols., Paris, 1943/6.

A. GRABAR, *Byzantium from the Death of Theodosius to the Rise of Islam*, London, 1966.

A. GRABAR, *Christian Iconography and a Study of its Origins*, London, 1969.

F. HENRY, *Irish Art*, London, 1965.

R. F. HODDINOT, *Early Byzantine Churches in Macedonia and Southern Serbia*, London, 1965.

E. KITZINGER, *Early Mediaeval Art*, pp. 1/35, London, 1955.

J. LASSUS, *Sanctuaires chrétiens de Syrie*, Paris, 1947.

M. LAURENT, *L'Art chrétien des Origines à Justinien*, Brussels, 1956.

W. LOWRIE, *Art in the Early Church*, New York, 1969.

C. MANGO, *The Art of the Byzantine Empire 312–1453*, pp. 3/145, Toronto, 1972.

C. R. MOREY, *Early Christian Art*, Princeton, 1942.

G. OSTROGORSKY, *History of the Byzantine State*, Oxford, 1956.

H. PIERCE & R. TYLER, *Art Byzantin*, Vol. I, Paris, 1932.

D. TALBOT RICE, *The Beginnings of Christian Art*, pp. 19/83, London, 1957.

D. TALBOT RICE, *The Art of Byzantium*, pp. 1/42, London, 1959.

D. TALBOT RICE, *Art of the Byzantine Era*, pp. 7/69, London, 1963.

J. STRZYGOWSKI, *Kleinasien ein Neuland der Kunstgeschichte*, Leipzig, 1903.

J. STRZYGOWSKI, *The Origins of Christian Church Art*, Oxford, 1923.

F. VAN DE MEER & C. MOHRMANN, *Atlas of the Early Christian World*, London, 1959.

F. VAN DE MEER, *Early Christian Art*, London, 1967.

W. VOLBACH & F. HIRMER, *Early Christian Art*, London, 1961.

K. WESSEL, *Coptic Art*, London, 1965.

SPECIALIZED READING

A. ALFÖLDI, *The Conversion of Constantine and Pagan Rome*, Oxford, 1969.

E. ALFÖLDI, *The Necropolis of Anemurium*, pp. 110/117, Ankara, 1971.

L. BREHIER, *La Sculpture et les Arts mineurs – Histoire de l'Art Byzantin*, Paris, 1936.

G. BOVINI, *Mosaici di Ravenna*, Milan, 1956.

G. BOVINI & L. OTTOLENGHI, *Avori dell'Alto Medio Evo*, Ravenna, 1956.

G. BOVINI, *San Vitale di Ravenna*, Milan, 1955.

G. BOVINI, *The Ancient Churches of Ravenna*, 1957.

P. DU BOURGUET, *Early Christian Painting*, London, 1965.

C. CECCHELLI, *I Mosaici della Basilica di S. Maria Maggiore*, Turin, 1955.

C. CECCHELLI, *The Rabbula Gospel*, Olten-Lausanne, 1959.

J. DANIELOU, *Primitive Christian Symbols*, Baltimore, 1964.

J. G. DAVIS, *Early Christian Church Architecture*, London, 1952.

G. DE ANGELIS D'OSSAT, *Problemi di Architettura Paleocristiana*, Ravenna, 1962.

A. GRABAR, *Byzantine Painting*, London, 1953.

A. GRABAR & M. CHATZIDAKIS, *Greece: Byzantine Mosaics*, Paris, 1959.

A. GRABAR, *Sculptures Byzantines de Constantinople*, Paris, 1963.

M. GUARDUCCI, 'Le Reliquie di Pietro sotto la Confessione della Basilica Vaticana', *Archeologia Classica*, Vol. 19, Rome, 1967.

L. HERTLING & E. KIRSCHBAUM, *Le Catacombe Romane e i loro Martiri*, Rome, 1949.

E. HERZFELD & S. GUYER, *Monumenta Asiae Minoris Antiqua*, Vol. II, Manchester, 1928.

J. KOLLWITZ, *Die Lipsanothek von Brescia*, Berlin, 1933.

R. KRAUTHEIMER, *Early Christian and Byzantine Architecture*, Harmondsworth, 1965.

M. LAWRENCE, *The Sarcophagi of Ravenna*, New York, 1949.

T.F. MATTHEWS, *The Early Churches of Constantinople*, Penn. State UP, 1971.

M. ROSS, *Catalogue of the Byzantine and Early Medieval Antiquities in the Dumbarton Oaks Collection*, Vol. I, pp. 1/74, New York, 1962. (Metalwork)

M. ROSS, as above, Vol. II, pp. 1/70, New York, 1965. (Jewellery)

J. TOYNBEE & J. B. WARD-PERKINS, *The Shrine of St Peter*, London, 1957.

W.F. VOLBACH, *Metallarbeiten des Christlichen Kultes in der Spätantike und im frühen Mittelalter*, Mainz, 1921.

W.F. VOLBACH, *Elfenbeinarbeiten der Spätantike und des frühen Mittelalters*, Mainz, 2nd ed., 1952.

V. WEIDLE, *Mosaïques Paléochrétiennes et Byzantines*, Milan, 1954.

J. WILPERT, *Die Malereien der Katakomben Roms*, 2 Vols., Freiburg im Breisgau, 1903.

J. WILPERT, *I Sarcofagi Cristiani Antichi*, 5 Vols., Rome, 1929/32.

List of Illustrations

24 Plan of the Christian building, Dura Europus, Syria; 3rd century. After *The Excavations at Dura Europus, Preliminary Report of the Fifth Season of Work*, October 1931–March 1932, New Haven, Yale University Press, 1934, pl. XXXIX.

25 Ascension, on a Coptic tombstone; 5th century. Ikonenmuseum, Recklinghausen.

26 Bird and cross design on the limestone Coptic tombstone of Sophrone; 7th century. Courtesy of Trustees of the British Museum, London.

27 The Fall and the Good Shepherd and his Flock, wall painting from the Baptistery of Dura Europus, Syria; early 3rd century. Yale University Art Gallery, New Haven, Conn.

28 Christ and St Peter walking on the water, wall painting from the Baptistery of Dura Europus, Syria; early 3rd century. Yale University Art Gallery, New Haven, Conn.

29 Old and New Testament scenes on a sarcophagus; late 3rd century. Velletri Museum. Photo: Gabinetto Fotografico Nazionale.

30 Old and New Testament scenes on a sarcophagus; late 3rd century. Lateran Museum, Rome. Photo: Hirmer.

31 Noah in his ark, detail of a sarcophagus; late 3rd century. Lateran Museum, Rome. Photo: Hirmer.

32 Moses striking the rock, wall painting from the *cappella greca* of the Catacomb of Priscilla, Rome; after 200. Photo: Pontificia Commissione di archeologia sacra.

33 Susanna and the Elders, wall painting from the *cappella greca* in the Catacomb of Priscilla, Rome; 3rd century. Photo: Mansell-Alinari.

34 Three Hebrews in the fiery furnace, wall painting from the Chamber of the 'Velatio' in the Catacomb of Priscilla, Rome; early 4th century. Photo: Hirmer.

35 Daniel in the lion's den, wall painting in the vaults of the Crypt of Lucina, Catacomb of Callixtus, Rome; c. 200. Photo: Pontificia Commissione di archeologia sacra.

36 Jonah being swallowed, marble statuette from a group; late 3rd century. The Cleveland Museum of Art, John L. Severance Fund.

37 Jonah cast up, marble statuette from a group; late 3rd century. The Cleveland Museum of Art, John L. Severance Fund.

38 Adoration of the Magi, wall painting from the *cappella greca* in the Catacomb of Priscilla, Rome; first half of the 3rd century. Photo: Pontificia Commissione di archeologia sacra.

39 Raising of Lazarus, wall painting from the Catacomb of Callixtus, Rome; 3rd century. Photo: Pontificia Commissione di archeologia sacra.

40 Healing of the Paralytic, wall painting from the Catacomb of Callixtus, Rome; 3rd century. Photo: Pontificia Commissione di archeologia sacra.

41 Old and New Testament scenes and bust of a husband and wife on a gold glass; beginning of the 4th century. Ashmolean Museum, Oxford, Pusey House loan.

42 Baptism, wall painting from the Crypt of Lucina, Catacomb of Callixtus, Rome; 3rd century. Photo: Pontificia Commissione di archeologia sacra.

43 Baptism, wall painting from the Catacomb of Callixtus, Rome; 3rd century. Photo: Pontificia Commissione di archeologia sacra.

44 Eucharist, wall painting from the Chapel of the Sacraments, Catacomb of Callixtus, Rome; first half of the 3rd century. Photo: Pontificia Commissione di archeologia sacra.

45 Eucharistic meal on a sarcophagus fragment; 3rd–4th century. Museo delle Terme, Rome. Courtesy Mr Islay C. de Lyons.

46 *Refrigerium*, detail of sarcophagus of Baebia Hermophile from the Via Tiburtina, Rome; late 3rd century. Museo delle Terme, Rome. Courtesy Mr Islay C. de Lyons.

47 Colossal head of Constantine the Great; 324–61. Palazzo dei Conservatori, Rome. Photo: Hirmer.

Alahan Monastery basilica, Turkey; mid 5th century. Photo: courtesy David Cheshire, BBC.

104 Marble *ambo* from St George, Salonika; mid 5th century. Museum of Antiquities, Istanbul. Photo: Hirmer.

105 Scenes from the life of David as a shepherd, fragment of the cedar wood doors of Sant'Ambrogio, Milan; *c.* 386. Museo di Sant'Ambrogio, Milan. Photo: Hirmer.

106 Crucifixion, detail of the wooden doors of Sta Sabina, Rome; *c.* 432. Photo: Anderson.

107 Zacharias struck dumb before the temple, detail of the wooden doors of Sta Sabina, Rome; *c.* 432. Photo: Hirmer.

108 Orpheus charming the animals, ivory pyxis; end of the 4th century. San Colombano, Bobbio. Photo: Hirmer.

109 Childhood of Dionysus, ivory pyxis; 5th century. Museo Civico, Bologna.

110 Ivory consular diptych of Probus; 10th century. Victoria and Albert Museum, London.

111 Ivory consular diptych of Clementinus; 513. Archaeological Museum, Liverpool. Photo: Hirmer.

112 Stilicho as consul and *magister militum*, right panel of ivory diptych of Stilicho and Serena; *c.* 400. Cathedral Treasury, Monza. Photo: Hirmer.

113 Priestess of Ceres before the altar of Cybele, left panel of ivory wedding diptych of the Nicomachi and the Symmachi; end of 4th century. Cluny Museum, Paris. Photo: Hirmer.

114 Old and New Testament scenes on an ivory reliquary casket (arranged in form of a cross); 4th century. Museo Civico Cristiano, Brescia. Photo: Mansell-Alinari.

115 Old and New Testament scenes on an ivory reliquary casket, from north Italy or Rome; 4th century. Museo Civico Cristiano, Brescia. Photo: Hirmer.

116, 117 Scenes from the Passion, two sides of an ivory pyxis, probably made in southern Gaul; early 5th century. Courtesy the Trustees of the British Museum, London.

118 Christ among the Apostles, on an ivory pyxis; *c.* 400. Staatliche Museen, Berlin. Photo: Hirmer.

119 St Paul on Malta, panel of ivory diptych; 380-400. Museo Nazionale, Florence. Photo: Alinari.

120 Archangel Michael, panel of ivory diptych; between 519 and 527. Courtesy the Trustees of the British Museum, London.

121 Adoration of the Magi, ivory panel from Syria; 6th century. Courtesy the Trustees of the British Museum, London.

122 Emperor Anastasius (?), called the Barberini Ivory from Constantinople; *c.* 527. Louvre, Paris. Photo: Hirmer.

123 Empress Ariadne, panel of ivory diptych from Constantinople; *c.* 500. Museo Nazionale, Florence. Photo: Soprintendenzia alle Gallerie, Florence.

124 Ivory diptych of Justinian; 521. Museo Castello Sforzesco, Milan. Photo: Hirmer.

125 Bronze griffin-handled lamp with *labarum* from Caltagirone, Sicily; 4th century. Courtesy Wadsworth Atheneum, Hartford, Conn. Photo: E. Irving Blomstrann.

126 Bronze boat-shaped lamp from Rome; 4th century. Museo Archeologico, Florence. Photo: Hirmer.

127 Christ blessing, detail of a bronze thurible, from Dağ Pazarı, Turkey; 5th century. Adana Museum. Photo: Michael Gough.

128 The Antioch Chalice, silver-gilt; late 6th or early 7th century. Metropolitan Museum of Art, New York. Photo: Giraudon.

129 Christ and the Apostles, lid of silver reliquary casket from Rome; *c.* 382. San Nazaro Maggiore, Milan. Photo: Hirmer.

130 St Thecla (?) with lions, silver reliquary from Cırga, Turkey; *c.* 475. Adana Museum.

131 Lid of silver bridal casket of Secundus and Proiecta, found in Rome, part of the Esquiline Treasure; *c.* 380. Courtesy the Trustees of the British Museum, London.

165 Female personification of India, on a silver dish from Constantinople; 6th century. Archaeological Museum, Istanbul. Photo: Giraudon.

166 Goatherd on a silver dish from Constantinople; 527-65. Hermitage, Leningrad.

167 Dancing satyr and maenad on a silver dish from Constantinople; 610 29. Hermitage, Leningrad.

168 Communion of the Apostles on the Riha Paten from Constantinople, silver repoussé with gilding and niello; 565-78. The Dumbarton Oaks Collection.

169 Communion of the Apostles on the Stuma Paten, from Constantinople, silver and silver-gilt; between 565 and 578. Archaeological Museum, Istanbul.

170 Dish of Paternus, Bishop of Tomi (c. 517-20), from Constantinople, silver and silver-gilt; c. 518. Hermitage, Leningrad. Photo: Hirmer.

171 Eliezer and Rebecca at the well, miniature from the Vienna Genesis; 6th century. MS Theol. gr. 31, f. 36. Österreichische Nationalbibliothek, Vienna.

172 Communion of the Apostles, detail of miniature from the Rossano Gospels; 6th century. Codex Purpureus, f. 61. Museo Diocesano, Rossano. Photo: Hirmer.

173 Christ and Barabbas before Pilate, miniature from the Rossano Gospels; 6th century. Codex Purpureus, f. 16. Museo Diocesano, Rossano. Photo: Hirmer.

174 Fragment of a miniature from the Cotton Genesis; early 5th century (?). Cotton MS Otho B. VI, f. 4. Courtesy the Trustees of the British Museum, London.

175 Crucifixion, miniature from the Rabbula Gospels; completed at Zagba, c. 589. MS Plut. I. 56, f. 13a. Biblioteca Mediceo-Laurenziana, Florence.

176 Ascension, miniature from the Rabbula Gospels; completed at Zagba, c. 589. MS Plut. I. 56, f. 13b. Biblioteca Mediceo-Laurenziana, Florence.

177 Crucifixion, wall painting in the chapel of Theodotus, Sta Maria Antiqua, Rome; between 741 and 752. Photo: Gabinetto Fotografico Nazionale.

178 St Peter, painted icon from Constantinople; 6th or 7th century. Monastery of St Catherine, Mount Sinai. Photo: Roger Wood.

179 Virgin and Child between St George and St Theodore and two angels, painted icon from Constantinople; 6th or 7th century. Monastery of St Catherine, Mount Sinai. Photo: Roger Wood.

180 Symbol of St Matthew the evangelist, miniature from the Book of Durrow; 7th century. Trinity College, Dublin.

181 Carpet page, miniature from the Book of Durrow; 7th century. Folio. 192 v. Trinity College, Dublin.

182 St Mark, miniature from the St Gall Gospel Book; 8th century. Codex 51, f. 78. Stiftsbibliothek, St Gall.

183 St Matthew, miniature from the Lindisfarne Gospels; late 7th century. Cotton MS Nero D. IV, f. 25v. British Museum, London.

184 Carpet page, miniature from the Lindisfarne Gospels; late 7th century. Cotton MS Nero D. IV, f. 2. British Museum, London.

185 Virgin and Child, miniature from the Book of Kells, 8th century. Folio 7v. Trinity College, Dublin.

186 Crucifixion, bronze plaque from Athlone, Co. Westmeath, Ireland; 8th century. National Museum of Ireland, Dublin.

187 The Ardagh Chalice from Co. Limerick, Ireland, silver, gold, brass and glass; early 8th century. National Museum of Ireland, Dublin.

188 Carved spiral ornament on North Cross, Ahenny, Co. Tipperary, Ireland; 8th century. Photo: Commissioners of Public Works in Ireland.

189 Stone cross at Bewcastle, Cumberland; c. 700. Photo: National Monuments Record.

190 Stone cross from Ruthwell, Dumfries, Scotland; c. 700. Photo: National Monuments Record.

191 North Cross, Ahenny, Co. Tipperary, Ireland; 8th century. Photo: Bórd Fáilte Éireann.

Index